Toward
Forever

Radical Reflections on History and Art

Toward Forever

Radical Reflections on History and Art

Tony McKenna

Winchester, UK
Washington, USA

JOHN HUNT PUBLISHING

First published by Zero Books, 2020
Zero Books is an imprint of John Hunt Publishing Ltd., No. 3 East St., Alresford,
Hampshire SO24 9EE, UK
office@jhpbooks.com
www.johnhuntpublishing.com
www.zero-books.net

For distributor details and how to order please visit the 'Ordering' section on our website.

Text copyright: Tony McKenna 2019

ISBN: 978 1 78904 357 0
978 1 78904 358 7 (ebook)
Library of Congress Control Number: 2019939103

A CIP catalogue record for this book is available from the British Library.

Design: Stuart Davies

UK: Printed and bound by CPI Group (UK) Ltd, Croydon, CR0 4YY
US: Printed and bound by Thomson-Shore, 7300 West Joy Road, Dexter, MI 48130

We operate a distinctive and ethical publishing philosophy in
all areas of our business, from our global network of authors to
production and worldwide distribution.

Contents

Also by Tony McKenna

Angels and Demons: A Radical Anthology of Political Lives
ISBN-10: 1789040205

The Dying Light (a novel)
ISBN-10: 1910705888

The Dictator, the Revolution, the Machine: A Political Account of Joseph Stalin
ISBN-10: 1845198263

Art, Literature and Culture from a Marxist Perspective
ISBN-10: 1137526602

For Matthew and Oliver Mauro

Acknowledgements

I am grateful to the publishers of the following works for permission to reuse copyrighted material from them as the basis for the chapters indicated:

"The Suicide Forest: A Marxist Analysis of the High Suicide Rate in Japan". *Rethinking Marxism*, March 2015 (Taylor & Francis: Abingdon)

"John Molyneux and the Question of Art". *Critique: Journal of Socialist Theory*, May 2013 (Taylor & Francis: Abingdon)

Part I

Artful History

Chapter One

The Syrian Revolution

It began with children. And it began in March 2011 in a small farming town in Syria's arid south. A group of boys had scrawled graffiti across a wall whose words read: "The people / want / to topple the regime!" The children in question, between the ages of 10 and 15, had picked up this slogan from watching television, before hastily daubing it onto stone in a moment of childlike derring-do and wonder. They had been inspired by the scenes of crowds of hundreds of thousands, flocking the streets during the Arab Spring which was breaking out across North Africa and parts of Arabia at the time. The young are most susceptible to the winds of change, perhaps because – for them – the panorama of the future is still so open, and its possibilities can seem invigorating and endless. The images of those protestors exploding out from cities in Tunisia, Morocco, Egypt, Yemen and Algeria must have seemed to the young boys as fantastic harbingers of the exciting and ever-changing world they were on the cusp of stepping into. Perhaps, by their small act of clandestine rebellion, they felt as though they too were embarking on their own great adventure.

Those who would disabuse them of this notion were not children. They were grown men. And they were neither credulous nor hopeful. Rather they were the hired thugs who operate on the part of a state apparatus which seeks only to perpetuate itself in and through the monotonous application of dull, unthinking cruelty. Those men, hardened by years of state service, were well used to carrying out their inhuman work in gloomy interrogation rooms, and it was in such rooms that they made themselves known to the children. By beating them. By burning them. By pulling their fingernails out. It is worth noting

3

that such "interviews" were carried out in the cells of the local Political Security branch and conducted under the control of one General Atef Najeeb – who just so happened to be a cousin of the regime's president – Bashar alAssad. The Assad regime had always been cruel, of course, even in the time of his father, Hafez al-Assad.[1] But at its outset in 1963, the Ba'athist state's stability had been guaranteed by more than just force. The surreptitious, behind the scenes terror orchestrated by an increasingly well-honed secret police was complemented by large investments in social works. In its early phase, as Shamel Azmeh points out, the regime was bound to projects of industrialisation and land reform which gave it a more trenchant basis in the countryside, especially after Syria began to more vociferously exploit its reserves of oil in 1968:

> During the 1970s in particular, Assad expanded the state-led developmental model in Syria. This included large investment in state-owned enterprises; large public infrastructure projects such as dams, roads, and energy projects; investments in agriculture; a large expansion in spending on health and education; and a large electrification program in rural areas. It also included the gradual expansion of a large subsidies system that covered basic food products, energy, agricultural inputs, fertilizers, and machinery. These changes ushered in a rapid expansion in agricultural production.[2]

As the Marxist writer Louis Proyect points out, reforms which "helped to create jobs in the public sector, provide health services, guarantee free education, and ensure that working people had access to cheap energy and food"[3] were complemented by the development of a Stalinist-like state, with a muscular security service, where "political parties, trade unions, student associations and women's groups were depoliticised by attaching them to the Ba'athist machine".[4] Indeed Syria under

4

Assad the elder was heavily funded by its gargantuan neighbour to the north, who saw in it a useful proxy for imperial power and a gateway to the Mediterranean via a base the USSR had installed at the Syrian port of Tartus in 1971. But in the decades that followed several processes would intersect and work to undermine the gains which the Syrian population, particularly the rural poor, had seen. The collapse of the USSR in 1991 meant not just the loss of funds which came from the "largesse" of the "communist" government, but also removed from the economic arena a significant market for the export of Syrian goods – and agricultural goods in particular. From 1996-2004 there was a decline in oil production from 590,000 bbl/d to 460,000 bbl/d[5] – partly as a result of fields which had been discovered in the 1960s and had reached maturity with their yields tapering off at slower rates. In addition, between 1970 and 2011, the population of Syria was to expand from 6.1 million to 22 million, creating an almost unsustainable pressure on a labour market which was already in the throes of contraction.

Although Bashar alAssad had been handed the legacy of the Pan-Arab Nationalism of his father's regime, and although he decked himself out in the colours and the rhetoric of populist anti-colonialism, when push came to shove the dictator proved to be an eminently pragmatic individual. In the context of a global neoliberalism, where governments across the board were enacting the most pronounced forms of deregulation and overseeing the carving up of state industries by private capital, the Assad government responded to the heightening contradictions in the Syrian economy by following suit – by showing the ability to march to the tempo of foreign investment while evincing a willingness to cut subsidies for workers and farmers. A period of neoliberal reform was opened up – which the dictator euphemistically described as a "social market economy" – and it saw public employment capped, trade liberalised and medical care privatised. Such fiscal solutions provided, as they

nearly always do, a temporary boon – wealthy neighbours like Saudi Arabia and Qatar flooded the economy with billions in investment, directed specifically toward the lucrative real estate and tourist trade which, in turn, saw a boost to financial services, leisure activities and communications.

But, as always, such measures provided only the type of palliative which would temporarily ward off the deeper, underlying contradictions which were gestating in the economy at an elemental level. Governmental investment poured into the rich suburban areas where a new elite enjoyed state funded improvements to roads, the creation of more traffic tunnels, the beautification of streets adorned with multi-colour lighting systems and lined by elegant, carefully tended trees. Streets across which cruised the latest luxury sports cars, indeed as Shamel Azmeh notes, "the liberalization of imports led, between 2003 and 2007, to a 122 per cent increase in the number of private cars in Syria".[6] But no such impetus was provided to the development of public transport and the number of buses didn't increase. And while the most salubrious areas in cities like Damascus seemed to be booming, their elite denizens snapped appearing at twilight, champagne-sparkling soirees in all the latest glossy magazines – in the arid north-eastern provinces of Raqqa, Hassaka and Deir ez-Zor (collectively known as the Jezira) the people were implicated in the type of struggle for existence which might have come straight from the pages of Steinbeck. The neoliberal reforms projected out from the urban heartlands and the seat of power were shrivelling the already meagre earnings of the small farmer and rural worker like rays from the beating, relentless desert sun, and when – in 2007 – a drought set in, the situation in the countryside began to attain critical mass. Constituting more than a third of Syria's overall territory, the Jezira produced the majority of Syria's wheat, and when the drought and the subsequent crop failure arrived, it posed an existential threat – partly because the neoliberal measures had

destroyed the capacity of the farms to adequately respond to the danger. As Proyect points out, the wells which could have provided the remedy to the rain shortage were often in a state of disrepair or more simply they were just unaffordable: "Not only were agricultural supports removed by the dictatorship; fuel was no longer subsidised. The price for a gallon of gasoline rose by 350 per cent. This meant that motor pumps, so essential to drawing water from underground wells, became difficult to afford".[7] Myrian Ababsa describes the consequences in the grimmest of terms:

> The drought put an end to decades of development in the fields of health and education in the Jezira, and the sanitary situation became dramatic. In 2009, 42 percent of Raqqa governorate suffered from anemia owing to a shortage of dairy products, vegetables, and fruit. Malnutrition among pregnant women and children under five doubled between 2007 and 2009. To complicate matters, vegetable and fruit growers in dry northern Syria used polluted river water to irrigate their crops, causing outbreaks of food poisoning among consumers, according to environmental and medical experts. Experts pointed out that the problem stemmed from sewage and chemicals allowed to reach rivers in rural areas near Aleppo, Latakia, and Raqqa...Between 160 and 220 villages were abandoned in Hassaka governorate. The wells dried up and the population could not afford to bring water from private tankers at a cost of 2,000 SYP per month (about 30 euros).[8]

The way in which Syria more and more came to rely on oil imports rather than exports, the collapse of the USSR along with the subsidies it provided and its foreign markets, the turn to neoliberalism on the part of Assad and the further impoverishment of agriculture, the emergence of a bloated

financial sector and a new middle class premised on an industry of luxury consumer goods and services – all these processes and developments seemed to converge at the point when the drought kicked in creating a situation in the countryside of the most desperate suffering and upheaval, a situation which at once spilled over into the larger towns, as the multitudes of rural poor affected great and terrible migrations in a last ditch attempt to ensure survival. These huddled, displaced masses swelled cities like Homs, cities which are situated in the agricultural heartlands, cities which were already poor and overburdened, and could not but buckle under the sudden influx of the economic refugees. As the levels of poverty skyrocketed, it was the suburbs on the fringes of cities like Aleppo or Damascus, where the migrants who had arrived with next to nothing were now eking out a subsistence level existence based in the informal economy as odd jobs men or street vendors – it was these elements who would become the motivating force in the political and social unrest which was beginning to mount. And it was against this backdrop that those children scrawled across a crumbling wall the prophetic message: "The people / want / to topple the regime!" It was a message which would resonate with a power they could have scarcely imagined.

On Friday 18 March 2011, after midday prayer, the parents of those children, alongside a smattering of supporters, took part in a peaceful march which culminated in a gathering outside the governor's house in their town of Dara'a. The protest carried a rather simple demand – to see the missing children returned to their families. The security forces also responded in the simplest of ways. By turning their guns on the protestors. And when ambulances arrived to ferry the injured to hospital, the military men barred their entrance, and the wounded and the bleeding were instead taken to a local Mosque where basic medical care was hastily improvised on an ad hoc basis. Perhaps every revolution has its genesis in just such a moment; a moment

of casual, callous cruelty on the part of an ossified regime – a regime for whom torture and murder have become as much a part of the regulation of civic life as the issuing of parking tickets. In downtown Dara'a it was simply business as usual, conducted with high-powered automatic weaponry and a soldier's snarl. And yet, the news of the shootings spread like wildfire. In Damascus a 200-strong crowd took to the streets, and now the demands were more and more uttered in general terms – "God, Syria and freedom only," the protestors chanted. The need for justice was greeted with more violence, with police batons, but by now a further protest of some 2000 people had broken out in Homs, and a couple of days later everything came full circle when in Dara'a once more, the funerals of two protestors who had been killed the days previous were attended by thronging crowds of 20,000.[9] The protestors' demands were growing ever more strident, demanding the release of political prisoners who had been incarcerated by the regime in the decades past. Once again the cry for freedom was met with a hail of bullets, but the revolution, it seemed, was swifter than steel, and within days the conflagration had engulfed the southern towns of Inkhil, Nawa, Al-Sanamayn and Jasim, revolutionary fire had spread across the rural areas which surrounded Damascus and was rippling up the Mediterranean coast reaching areas as far afield as the historic city of Banias at the foot of Mount Hermon. At the same time the struggle had graduated in its intensity – in Dara'a people burnt the local Ba'ath Party headquarters to the ground and they also decimated a branch of the SyriaTel phone company – a company owned by possibly the richest businessman in Syria, Rami Makhlouf – yet another cousin of the ghastly, bristling, moustachioed ghoul who was ensconced at the head of the country like a canker.

The Assad regime, murderous and top-heavy, resonating malice, dimly began to apprehend the nature of the movement which was developing against it. Alongside the most draconian

application of state violence, the regime now made some hasty concessions to the protestors, offering to release several students who had been detained in previous protests.[10] The governor in Dara'a – Faisal Kulthum – who had been a focal point of the initial protests, was removed from his position.[11] At the same time, however, the government used the mass media to slander the protestors, to present the revolution as the chaos orchestrated by subversive international interests (the Israelis and the Palestinians were both implicated in the role of foreign infiltrators). Such variegated tactics on the part of the Assad regime had a classically Stalinist flavour, designed to inculcate confusion by offering a glimmer of compromise which would then act as a cover for another bout of the most sustained and brutal violence, before supplementing that with a strategy of misdirection in which the hidden hand of a sinister foreign conspiracy was alluded to. All with the unified aim of undermining the cohesion of the developing revolutionary moment, but now Assad would deploy what was possibly the most Stalinist move in his repertoire yet. One of the tactics the old Soviet dictator would resort to – when faced with mass unrest in the labour camps – would be to bus in a multitude of common criminals in the expectation that these would turn on the politicos and the energy of heightening resistance directed toward the authorities would be swiftly dispersed. It was an incredibly effective gambit, it must be said. Assad would do something similar, only instead of unleashing a group of common criminals, he chose to empty the jails of various Islamic radicals, effectively using them as a toxin whose spores could be wafted toward the burgeoning revolutionary movement from the outside, a form of ideological pathogen which would set in and at once start to eat into the resistance like a corrosive, flesh eating disease.

A former member of Syria's military intelligence relates how many such releases were enacted, especially during the 4-month

period which led up to October 2011. In this time, those who were released from facilities such as the Saidnaya prison would become some of the major players in the Islamic extremist groups which would go on to be locked into a life and death struggle with the revolutionaries on the ground. As the journalist Phil Sands points out, men like "Zahran Aloush, commander of the Jaish Al Islam; Abdul Rahman Suweis of the Liwa al Haq; Hassan Aboud of Ahrar Al-Sham; and Ahmad Aisa Al Sheikh, commander of Suqour Al-Sham, were all held in regime jails prior to the uprising".[12] This has to be assimilated into any historical narrative of the process of revolution and counter revolution as it developed in Syria. The majority of accounts promoted by those on the left in particular tend to present the Syrian Civil War in terms of a somewhat progressive secular state locked in combat with the darkest strains of Islamic medievalism. But while it is true that the Assad regime has battled against elements of Islamic fundamentalism at different times and to varying degrees, it is also true that such groups have provided one of the central buffers in insulating the regime from the revolution more broadly. Rabid fundamentalist groups have been consciously cultivated by Assad for this very purpose time and time again, and that is why the release of many of their leading lights by the Assad government in 2011 has to be seen in light of a developing trend and ongoing political strategy. To see in the Syrian Civil War only a simple and undifferentiated opposition between a species of Arab secularism and religious fundamentalism is to cleave to an anti-dialectical vision in which the perverse but symbiotic relationship between the Assad regime and certain fundamentalist groups goes entirely overlooked.

In the period of time when Assad was emptying the jails to provide these carcinogenic fundamentalist groups with impetus, the danger the revolution posed to his regime had become a mortal one. At the end of July 2011, the Free Syrian Army was formed, an entity which would provide the militarised core of

the revolutionary movement, and whose numbers were made up primarily of defectors from the Syrian national army (SAA). In times past, the SAA had been used by Assad senior to quell local rebellions by the most bloodthirsty means. For instance – the series of clashes which had been taking place between the Ba'athist state and Sunni Islamist fighters, and which broke out sporadically in decades before, reached a bloody dénouement in 1982 when Hafez al-Assad ordered military forces to besiege the town of Hama where a Sunni uprising was in motion. The massacre was prolonged, lasting almost a month; sustained shelling and tank incursions were complemented by the torture and mass executions of those who were suspected of being rebel sympathisers. The Syrian Human Rights Committee estimated that the massacre claimed over 25,000 lives, denouncing it as "genocide and a crime against humanity".[13] But in enacting its terrible crime, the state remained in a somewhat paradoxical position, for it was attempting to liquidate a Sunni uprising against an Alawite Shi'i administration by means of an army corps whose members were themselves, in a great majority, Sunnis. It was for this reason that the structure of the Syrian Army had been cultivated by Hafez al-Assad in a very particular way. The regular army forces, who were by and large Sunnis, were attached to highly specialised leaderships which had often been carved out of the material of the regime itself, who were extended members of the Alawite clan which now monopolised the state machine and whose loyalty to the Assads was welded by blood. In addition, such military units were reinforced by *Shabiha* paramilitaries – once the racketeers who ran the smuggling roots of the costal Alawite heartlands – they were cemented to the regime by a combination of ethnic identity and unrestrained power, especially once the ruling caste had helped convert them from thuggish criminal opportunists into a deadly militia force which could rob, rape and murder at will, and with governmental impunity.

The Syrian army had been effectively restructured in and through the activity of a Shi'i dictatorship as a honed response to the social composition of its membership, specifically the Sunni majority who reflected a larger Sunni bias in the population more broadly.[14] The refashioned army had proved to be an effective tool against Sunni rebellions, of which Hama provided the most notable example, but it is worth remembering that the uprising in 1982 which had taken place under the auspices of the Muslim Brotherhood had failed fundamentally to link to any greater pockets of resistance in the Syrian territories more broadly. In 2011, the situation was radically different. Here the revolution had broken out across the board. Sam Charles Hamad lucidly diagnoses the situation when he writes that such "a popular revolution" embroiled the regime in "a 'counter-insurgency' strategy that requires ethnic cleansing of Sunnis and the mass killing of civilians".[15] Such a crackdown would more and more promote the broiling resentments of the Sunni soldiers who found themselves having to turn their guns on their repressed brethren, and this translated into the type of pressure which would rapidly and inevitably cause the military machine to strain and fragment. Throughout 2011 and 2012 Assad's army was inflicted by desertions and defections and, as Hamad points out, this led to the quite startling situation in which Assad himself was compelled to demobilise two-thirds[16] of his own armed forces. Not only was the regime being wracked by the hammer blows of the revolution, its basis in the army was evaporating week by week, hour by hour. It was in this context that the Free Syrian Army was established at the end of July in 2011[17] with its spokesperson Riad Mousa al-Asaad, a former colonel in the Syrian Air Force, describing its agenda thus: "We announce the formation of the Free Syrian Army to work hand-in-hand with the people to achieve freedom and dignity to bring this regime down, protect the revolution and the country's resources, and stand in the face of the irresponsible military machine that

protects the regime."[18]

Given the breadth and depth of the revolution, and given the rapid disintegration of the Syrian army – how was the survival of the Assad regime even conceivable? One factor was the way it was able to detach and neutralise potential avenues of support for the rebels. Such was the case with the Democratic Federation of Northern Syria or Rojava with its large Kurdish population. This region is run on a largely autonomous basis in terms of three self-governing "cantons" which operate through a grassroots system of communes and councils. Under normal circumstances, it would have provided a natural ally to the Syrian rebels. The Kurds had fought against Assad and his repressions of them in the past; indeed in 2011, "the Syrian independence flag – which replaced the Ba'ath flag – flew side-by-side with the Kurdish flag in opposition-held territory throughout the country".[19] Many Kurdish activists had helped besieged Arab rebels by providing food, medical supplies and even housing in the early stages of the revolution. However, in a particularly shrewd move, Assad for the first time granted Rojava autonomy from the Syrian state in 2012 with the hope of preventing Arab-Kurdish solidarity. He did this in a behind the scenes agreement with the KPD and the PKK parties, organisations which increasingly operate on an authoritarian basis abstracted from the grassroots movements in Rojava. Assad offered another influential party, the PYD, the chance to consolidate political control over areas of Kurdish Syria, and in return this organisation rejected the cause of the Syrian rebels and even sent forces to fight against them.[20] On the other side of the mirror, some forces within the Syrian Revolution, like the Muslim Brotherhood, refused to acknowledge the Kurdish right to self-determination and relations between the two groups have become increasingly fractious.

In addition, Assad has sought to fashion a weaponised sectarianism by arming vigilante groups within Syria – in minority quarters in Damascus and other big cities – by

cultivating a series of "popular committees" in Alawi and Shi'i, Christian and Druze communities. These were eventually brought together in a unified body known as the National Defences Forces. Such an initiative was launched to fill the void left by the collapsing SAA, but it was conceivable only as a result of funding flooding in from an Iranian state which was hungry to ensure the survival of the Alawite government in Damascus as a proxy for its own power and a bulwark of Shi'i hegemony in the region more broadly. In fact *The Economist* argued that, by February 2012, Iran had already provided the Assad government with 9 billion dollars of financial assistance[21] which was essential in solidifying the militias which would eventually coalesce in the National Defence Forces; for now soldiers – often from the lumpen sections of the poorer layers – were being offered significantly more money to enlist. Equally important was the fact that the NDF shock troops were being trained in guerrilla warfare by Iran's Revolutionary Guards, alongside the expertise which was being provided by Lebanon's Hezbollah who were also delivering military instruction at facilities dotted around Syria. Suffice to say Iran also provided a steady cache of the most up-to-date, high-powered weaponry. Hezbollah, which had been deploying its own troops in Syria since 2011, openly declared its military intervention on the side of the regime when it launched an assault on the rebel held Qusayr in 2013, a siege which lasted some 3 weeks and saw the battle-hardened, armed to the teeth Lebanese militia outgun the home grown Sunni fighters on the ground, while planes from Assad's air force screeched through the sky, strafing the rebels with fire from above. Since its liberation in mid-2012, Qusayr had become one of the beacons of the Syrian Revolution, and the Assad regime had not felt confident enough to retake the city – until it was fully emboldened by its Iranian and Lebanese allies and the sheer military superiority which they projected. But when the reconquest did take place, Mark Boothroyd rather

poignantly reminds us of just what was lost: "The opposition [had] established a local council and organised the provision of public services, reopened schools and governed for the people. It was an example of the possibility of creating a free, democratic Syria."[22]

A contrast is inevitably invited. The contrast between the Syrian state regime, saturated by foreign finance, fortified by the latest and most sophisticated weaponry from abroad, bolstered by legions of seasoned international fighters – and, on the other side, the rebels themselves; civilian volunteers or army deserters who were more often than not improvising their resistance from scratch, using weaponry which had been pilfered from the SAA or smuggled across the border, and whose quality was often inadequate or out-of-date. Much has been made of Western imperial support for the rebels in the early years of the revolution – this has, in fact, been an ideological lynchpin of first the Iranian and then the Russian military interventions as they took the part of the Assad government. Such interventions were often framed in the spirit of anti-colonial rhetoric in which Iran and Russia purported to come to the aid of a beleaguered state very much at the mercy of a rapacious, Western imperialism which was seeking to carve the country up, shawarma style, according to the appetites of the US government and the IMF. Such accounts glossed over Assad's own neoliberal adventures, but it was certainly true that, in the early stages, rebels against the regime were given some backing by the West. What is absolutely vital, however, is that the quantity and quality of such assistance was on an entirely different scale to that which was being offered to Assad by his plethora of international backers. Western powers did not intervene in a direct military capacity until the middle of 2014 and when they did so then, their bombs were targeted at ISIS rather than the military installations of the Assad regime. As Boothroyd points out, "By mid-2013 the Free Syrian Army had received only $12 million of a promised $60

million of aid from the US."[23] On top of this, the flow of money and arms from the West to the rebels was tentative and sporadic. In 2013 a commander of the Islamist group Soquor al-Sham said of the international support they were receiving: "The outside countries give us weapons and bullets little by little...They open and they close the way to the bullets like water."[24]

Why were the Western powers so lacklustre in the support they offered up? Assad, like Gadhafi before him, had shown a certain ability to compromise with Western interests when they coincided with his own. But at the same time he had remained something of a volatile and unknown quantity, a dictator who was less than pliable and determined to forge alliances with groups like Hezbollah and Hamas who have remained anathema to Washington from day one. More critically, however, the US was less than persuaded by the forces which were developing against Assad. Naturally, they were against the rabid strains of Islamic fundamentalism represented by ISIS and certain Al Qaeda affiliates. But they were also nervy about more secular and democratic trends, often turning their back on the fight for survival such people were engaged in, either by ignoring them or – in words uttered by the then president Barack Obama – blithely dismissing them as "former farmers or teachers or pharmacists".[25] Behind the suggestion that the more secular inclined strands of the resistance were incapable of forming an effective fighting force lurks the more invisible suspicion housed by imperial power toward the development of any popular movement which emboldens the poor. It was the kind of suspicion the US administration had evinced to the social movements which had developed throughout the Arab Spring – consider, for example, the US administration's initial support for the Egyptian dictator Hosni Mubarak even as people gathered in their thousands to risk their lives in protest against his regime. His was, of course, a bloody dictatorship which was closely allied with American imperial interests and had been heavily

funded by the US for decades, so when Mubarak was faced by the spectre of a popular uprising, US president Barack Obama at once sent his lobbyist Frank Wiser to Egypt[26] in order to advise the old murderer on how to save the decadent, crumbling charnel house his regime had become. It was only when the upswell from the masses achieved such force and momentum that it was clear Mubarak's position was unattainable – it was only then that Obama appeared on the TV stations and the radio waves around the world to laud the values of democracy in sombre, reverent tones and to explain that Mubarak really should have the decency to bow to the will of the people and abdicate his role. In Yemen too the US supported the old regime and only under duress adopted a policy of orderly transition which was designed to preserve the regime minus the dictator.

The rebels in Syria received a drip-drip programme of foreign aid from their Western "sponsors", a programme which was often curtailed, sometimes running dry in the very moments when the revolutionary thrust seemed to be gaining purchase and the need for bullets was most pressing. The triumvirate of the US, Britain and the old imperial masters of Syria – France, were profoundly ambivalent toward the popular power which was developing from below; Assad's backers, on the other hand, showed no such reticence. Beyond this, the spores which Assad had helped cultivate were now beginning to bear their poisonous fruit, Daesh was on the rise in Syria. Daesh – a strain of Wahhabi fundamentalism which first appeared as an independent splinter group from Al Qaeda (Al Qaeda in Iraq) – emerged in the context of the US invasion of Iraq where a defeated, defunct Sunni state had been dismantled and then reconstructed on the basis of a top-heavy Shi'i sectarianism infused with American capital from the private companies that, vulture like, swooped into the country in the aftermath. The combination of enhanced Shi'i power and American capital whose interests were carried by the reverberations of scud missiles and semi-automatics was

a necessary one in as much as it fractured the possibility of any unified national resistance to the American invasion in and through the cultivation of an entrenched sectarianism – but in creating such a divide, the newly-formed subaltern government was locked into a perpetual process of repression against the belittled and fragmented layers of the old administration and the Sunni elements which underlay it. Sunni villages were monitored and contained by a series of checkpoints fortified with nests of machine guns. Sunni activists, religious and community leaders, bureaucrats of the old regime were arrested *en masse* and transported to newly created desert facilities where they would be held indefinitely.

It was here in the baking heat of the desert sands that Frankenstein's monster was called into being. Daesh, conjured up like a spectre, a haunting desert mirage, before the forces of imperialism – in combination with their brutal sectarian inflection. Daesh metastasised against a backdrop of international conflict and local ethnic oppression – its programme geared to overcome not only the Sunni-Shi'a divide in Iraq by obliterating the latter, but to dissolve the parameters of the nation state by raising Sunni hegemony across the countries in the Middle East and eventually the world in and through a clarion call to the most horrific violence and the creation of a universal caliphate dripping viscera and gore. But the growing power of Daesh in Syria was advantageous for the Assad regime and perhaps even saved it. The sheer horror of the atrocities Daesh would perpetrate helped provide an ideological justification for the regime's almost genocidal onslaught against its own population, depicting the repression as a necessary product of the "fact" that Daesh had infiltrated local populations so thoroughly that relentless, large-scale aerial bombings were the only recourse. That local Sunni populations were being blitzed with such interminable and methodological violence naturally provided a fertile recruiting ground for an extremist group which, in the

words of Hamad, quite "literally thrives on sectarian slaughter and war".[27] Beyond this, the rise of Daesh helped stymy what little Western support was reaching the rebels in the first place and became part and parcel of the ongoing process by which the resistance of the rebels and the sectarian violence of Daesh became elided into a single phenomenon on the part of the propaganda wing of the Assad regime, with the international mass media increasingly following suit.

But perhaps most importantly of all, Daesh's political programme of conquest and extermination was differentiated from its progenitor Al Qaeda and that group's direction under the leadership of Osama Bin Laden.[28] Daesh's strategy consisted, in the main, of targeting non-Sunni groups, particularly Shi'ites, attacking them in the hope of provoking a conflict which would create a rising tide of Sunni militancy. Al Qaeda, of course, also saw Shi'ites as "apostates" but nevertheless tended to regard killing sprees against them as counterproductive – at least before the more immediate and imperative aim of waging war against America and driving American troops from holy lands. For this reason (though to a limited degree), the militant strategy of Al Qaeda would sometimes permit a more generalised Islamic resistance which could cross the sectarian divide to be channelled into the struggle against US occupation. The specifics of Daesh's historical development – a rabid product of a particularly inflamed form of sectarian repression undergone by Iraqi Sunnis – had led to a death cult which, in practice, was rigid and ossified such that its high priests could not even tolerate alternative strains of Sunni Islam, let alone Shi'i; before the one true caliphate virtually every other brand of Islamism was, by definition, apostate. Though the Assad regime was loudly declaiming that Daesh was being funded by the Wahhabi Saudi state – part of its ongoing promulgation of a foreign conspiracy, any foreign conspiracy – in actual fact, however, Daesh had maintained a low-level but ongoing war against the

House of Saud, regarding that dynasty as craven pretenders, Shi'ite sympathisers and obfuscators of the true Islamic destiny. Daesh's hostility toward other Sunni groups was not confined to Saudi Arabia. As Hamad points out, the "largest single massacre carried out by Daesh anywhere in the world was not of Shi'i, Yazidis or Christians but rather as many as 900 of the Sunni ash-Shuaytat tribe in Deir ez-Zor in Syria. Men, women and children were shot, blown up, crucified and beheaded simply because they would not give up their lands to Daesh and acquiesce to their tyrannical rule."[29]

The absolute, unswerving sectarianism which drove Daesh's demented political project was always going to spill over into the most unadulterated violence against other pockets of Sunni resistance within Syria itself. And it throws into relief the truly tragic situation of the Syrian revolutionaries – for not only were they given little material support against a heavily-militarised dictatorship but soon the struggle had opened up on two fronts. Daesh killed rebel commanders on a frequent basis, all the better to seize and monopolise the territories the latter controlled. But as Boothroyd points out, Daesh also attacked the revolution's means of communication: "Daesh was suspected of several attacks on the Kafranbel media centre and the attempted assassination of its director, Raed Fares. Kafranbel's weekly demonstrations and creative English language banners have attempted to keep alive the spirit of the revolution, and were a regular target for repression by ISIL and al-Nusra."[30] Things finally came to a head in late 2013 when Daesh tortured to death the popular Ahrar al-Sham commander Dr Hussein Al Suleiman. Prior to this, rebel forces were desperately trying to negotiate some form of truce with Daesh so they might concentrate their fire on the Assad regime itself, but when the mutilated body of Al Suleiman turned up, scarred and missing an ear, the incident acted as a flashpoint for a broader set of grievances. In the town of Kafranbel, which had so recently been scourged by the

violence of Daesh, an ominous mood was beginning to develop. A leading activist from the town, Muhammad Khatib, described the situation in the following terms: "Daesh tried to impose their ideology on the Kafranbel people. They kidnapped activists and destroyed the media centre. They banned smoking, demanded Islamic attire for all the girls. They tried to ban jeans and casual clothes, and asked men to grow beards. The people were fed up in less than a month."[31]

All at once the powder caught and the flame burst forth. Protests erupted across Syria as thousands upon thousands took to the streets, while rebel groups launched themselves with white hot fury at the outposts of the mirthless, murderous fanatics who had so high-handedly declared Syria to be one more piece in the creation of their chimera – that illusory vision of a global caliphate whose colours have run wet with blood. But even the demented promise of their bloodthirsty Utopia was not sufficient to fortify the black-cloaked, sword wielding, head-chopping fanatics of Daesh against this massive eruption of popular power, which swept across them in an almighty wave. As Boothroyd points out, "[i]n the space of six weeks the rebels had driven Daesh out of Latakia, Idlib, Hama, Aleppo and Raqqa province. They hung on in Deir al-Zour Province, near the border with Iraq, but their presence in most of Syria was smashed. As Daesh retreated from Syria they retaliated by slaughtering many of the civil society and democratic activists they had imprisoned in their dungeons."[32] The rout was conducted by the Free Syrian Army and coalitions of various Islamic groups working in tandem, and the pressure against Daesh proved so potent that even Jabhat al-Nusra was conscripted into the onslaught very probably in order to avoid being obliterated by the rebel forces itself. This was one of the most significant chapters of heroism written in any revolution, but beyond that, it sheds light on the nature and the dynamic of what had been transpiring in Syria. It gave the lie to the notion that the rebels operated in terms of a single bloc

of religious fundamentalists with an ISIS type agenda. It is true that the majority of the rebels had and continue to have some type of Islamic affiliation, especially considering the backbone of the revolution was forged from mass migrations of rural poor sweeping into the vortex of urban life in the great cities. It was virtually inevitable that these elements would draw on their rural, predominantly religious traditions as a means of guiding their resistance and militancy. But within groups fighting under an Islamic ideology there were, in fact, a multitude of differing political tendencies and tones. Ahrar al-Sham, for instance, who had been prominent in the struggle against Daesh, operate according to a hard-line Salafism which seeks the establishment of an Islamic state tightly governed by the Sharia, but they also fight alongside more democratic forces such as Faylaq Al-Sham (The Sham Legion) as when together they liberated the city of Idlib from the regime and its Hezbollah sponsors back in March 2015.

The eviction of Daesh from Syria by the rebels – in a heroic action conducted in the most perilous of conditions – received scant attention in the world's media. Paradoxically, however, the tragic sequel to these events has been covered in full. We all know the story. Daesh spilled back into Iraq in waves where they proceeded to launch an offensive against the historic city of Mosul. The Iraqi army – at this point little more than a corrupted group of mercenaries marching to the tune of American dollars – was greeted by the spectre of legions of legions of true believers emerging from the desert's shimmering heat; almost at once they collapsed and fled. Large sections of the city's Sunni population, having been subject to the brutal sectarian violence of the Maliki regime, greeted the black clad marauders in the fashion of a liberating army; Daesh were, in a matter of weeks, fortified by thousands of new recruits, by the high-tech weaponry the national army had abandoned in its wake, and by the resources of a whole city which was now open to plunder.

23

Exponentially more powerful; regrouped and energised, Daesh swept back into Syria like an excoriating desert wind. As Boothroyd recounts, "[t]hey captured much of Deir al-Zour province and Raqqa and advanced almost all the way to Aleppo before they were halted. They declared their Islamic State with Raqqa as its capital on June 30."[33] The cost to the revolution was devastating. At a single stroke it had lost almost half of Syria to Daesh. As rebel strongholds, many of these cities and towns had been hubs of revolutionary activity, in the process of creating fledgling forms of social and democratic organisations in the void which had opened up post-Assad. So, for instance, in the city of Manbij, a revolutionary council of some 600 members was also complemented by the creation of Syria's first free trade union[34] designed to service the needs of the flour mill workers who produce a sizeable amount of Syria's flour. When Daesh retook control of the city, the newly unionised workers, along with a host of shop workers and community level activists, took part in a protest which culminated in a general strike where an estimated 80 per cent of businesses were shut down.[35] The protests were, of course, crushed with Daesh's customary brutality. Some months later an uprising occurred in villages and towns across the Deir al-Zour province which succeeded in expelling Daesh; only the triumph was short-lived and Daesh reinforcements from Iraq resulted in a repression which saw the mass execution cited earlier, and which involved "as many as 900 of the Sunni ash-Shuaytat tribe"[36] being murdered in cold blood.

There are no doubts that the years of struggle in a situation which was so heavily weighted against them have taken their toll on the rebels. While entities like Daesh and Jabhat al-Nusra could rely on high levels of funding from international terrorist networks more broadly, the rebels had no such recourse. Boothroyd argues that such financial weakness sometimes crossed over into the processes of civil reconstruction: "Some

took kickbacks from state employees in return for allowing them to sit at home, undermining public services and local government in rebel held towns. Assets like oil fields, factories and power plants were seized by groups and income from them used to pay for the armed struggle."[37] This could lead to infighting as various factions fought to preserve their vested interests and it was made more difficult for local councils to maintain democratic control over the military groups on the frontlines. The situation was conducive to the emergence of warlordism as some armed groups resorted to robbery, or imposing arbitrary checkpoints on newly created borders in order to levy taxes on travelling and trading. As Boothroyd also points out, such petty corruptions seemed to contrast unfavourably with the extreme fundamentalists whose stark, austere ethos was brutally enforced in and through the creation of Sharia courts; hence "Islamic rebels gained a reputation as being less corrupt than nationalist or secular armed groups."[38] Perhaps as a consequence of a rising warlordism, the constant bombardment of local rebel governments and populations and the sheer loss of infrastructure and life – in 2013 some armed rebel groups engaged in the first bout of sectarian massacres in combination with the forces of the most extreme fundamentalism like Daesh and Jabhat al-Nusra. The Syrian Network for Human Rights documented the killing of 132 civilians including 18 children in the Latakia suburbs massacre of 4 August 2013 which took place in an area populated mainly by Alawites. Similarly, in June of that same year the SNHR documented the murder of 14 civilians including three children in Hatla village which was also predominantly Shi'itein its ethnic composition, while 44 civilians were killed in the Sadd City massacre in October 2013, some of whom were Christians.[39]

Before 2013 crimes against humanity had been the particular province of the Assad regime. But after years of brutalisation, after 2 years of massacres at the hands of the regime – borne by rebels and civilians alike – certain elements within the revolution

degenerated to the point of barbarism. That there have been atrocities on both sides cannot be denied. But as distasteful as it might seem to play the numbers game in the context of life and death – in order to get some idea of the general trends of the ebb and flow of the conflict it is necessary to cite the statistics which reveal the level of casualties in the cold hard light of day. In a report, carried out by the United Nations, it is estimated that in 2015 the rebel opposition was responsible for the deaths of 1072 civilians. Daesh had a higher body count which stood at 1366 for that same year.[40] But when it comes to the Assad regime the numbers at once spike. In 2015 regime forces were estimated to have killed 12,044 civilians. This pattern was also indicative of a broader trend. From 11 March 2011 to 1 March 2016 the regime was responsible for 183,827 civilian deaths which accounts for a catastrophic 94.7 per cent of all civilian deaths while in comparison – in the same period – Daesh were responsible for an estimated 2196 civilian deaths which made up 1.1 per cent of the total.[41] The higher death toll is, of course, a product of the military superiority of a regime which has been fortified first by Iranian then Russian military ground troops and air power. But this must be understood in light of the fact that the social basis of the regime's power within the civilian population of Syria itself has largely evaporated. The Iranian and – from 2015 onward – the Russian interventions have, despite the propaganda, served a purpose beyond the fight against Daesh. In bombing rebel held territories – where often no Daesh presence was to be discerned – the military bombardment was able to consistently disrupt the means by which the rebels were able to build civil and state infrastructure and thus coalesce their resistance into more permanent forms of alternative government. In other words Assad's regime is being propped up by virtually genocidal means projected by external foreign powers. Without the backing of its Russian and Iranian paymasters, that regime would collapse within a week. What little support the Assad

regime has is demarked across ethnic but also class lines. Alawite business people, alongside Sunni and Christian elements, form a cross section of the urban capitalist class which is bound to the regime, often grudgingly, by an organic sense of revulsion before a revolution which has, in the main, mobilised the rural and urban poor and tends to present itself in terms of a more traditional religious framework. It was precisely the latter, argues Michael Karadjis, who were the ones to be "left out of the bourgeois 'secular' Ba'ath project, especially after 2000".[42] The religious hue of the rebel opposition thrown into relief by the secular agenda of the brutal regime merely overlays a more fundamental opposition which has opened up along class lines over a significantly longer period. And yet, even the core which remains loyal to the regime is showing some signs of wear and tear, particularly among its Alawite elements. Alawite soldiers have absorbed a disproportionate amount of losses in terms of defending the regime, partly because, as one former Alawite combatant notes, in "battles with Sunni armed groups, the government doesn't trust their Sunni soldiers not to defect...So the Alawites are sent forward."[43] The majority of Alawites are poor, suffered under the period of Assad's neoliberal reforms – and though they are allied to the government on the basis of ethnic identity, "it is an alliance tinged with hatred", for the ongoing way in which the regime is using the poorer Alawites as cannon fodder is setting the basis for "a quiet rebellion among many in the sect".[44]

The horrific depth and scope of its violence, then, is a consequence of the fact that the regime itself now has little organic basis in the society it seeks to pacify, and so it can only preserve its power by the application of the most excessive, external force alone. It has become a ghastly, sclerotic entity which exists in a type of limbo state; it is neither dead nor alive, for it has long ceased to be oxidised and animated by the lives and activities of broader sections and swathes of the Syrian population, but is

more and more held in place by the mechanical application of an external and alien power; it is, for all intents and purposes, a zombified state which – having been artificially revivified by international forces – now holds the population in a kind of ossified death grip. But although the rebels have everything against them – although they are faced by an awesome array of international military power, although they have been compelled into fighting a war on two fronts against overwhelming odds and with terribly depleted and underfunded resources – nevertheless the one thing the rebels don't suffer from is a lack of manpower. And despite the deterioration of the revolution as a result of the sectarian abuses inflicted upon it by both the Assad regime and ISIS, nevertheless the struggle for more democratic forms of state and civil society has sustained. Initiatives like those of the Syrian anarchist Omar Aziz who theorised the need for "the collaboration between the revolution and the daily lives of humans" by means of the creation of "the local council".[45] Such councils would hold the legal responsibilities of housing displaced people, providing loved ones with access to organised databases on the whereabouts of incarcerated family members and friends, and offering some kind of financial aid for people attempting to build their lives again. But they would also form a space for "collective expression", one which would "initiate activities of the social revolution at a district level and unify supporting frameworks"[46]. In other words, political and economic activity was to be combined at the grassroots level creating a network of democratic organisations. Aziz died for such a vision; incarcerated by the regime in 2012, he perished from a heart attack in prison the following year. But, as of late 2016, there were over 400 local councils[47] in the areas of Syria which have been liberated by the rebels. And alongside such councils there exist "a plethora of other civil society organisations; women's centres, radio stations, journalists' unions and many others".[48]

And even when Daesh had devastated rebel territory

throughout 2014, and had created the basis by which the Assad regime could go on the offensive once more, even when the struggle of the rebels was at its lowest ebb – Assad's victories at this time were sporadic, limited to key areas and unable to affect a breakthrough by which the vast majority of territory could be reclaimed. Despite all his overwhelming military advantage, Assad lacked what the rebels continue to have – that is, significant popular support. Hamad argues that this was nowhere clearer than in the case of Aleppo in early 2015 when "the regime, backed up by the foreign invasion forces of the Iranian Syria Revolutionary Guards, Hezbollah, the sectarian head-drillers of Asayib Ahl al-Haq and various mercenary forces, not only failed to capture the jewel in the revolution's crown, but provoked a successful rebel counter-offensive".[49] On the occasions when the regime does actually enjoy a rare infusion of popular support, this comes about when rebels unite with it temporarily against ISIS in those places where the sheer barbarism of the latter has served to override everything else. Of course, Assad may eventually claw back all Syrian territory because of his incredible military advantage, he may even be able to subdue the revolution itself but he will never be able to truly pacify a population where the resistance of the masses across the spectrum is only held in check by the application of external foreign power. For once the sound of Russian bombs begins to fade, the drumbeat of the revolution will start to beat again.

The issue of the Syrian Revolution offers up the single most important challenge to the radical and revolutionary left in many decades – it has provided a test for Marxist thinkers and activists which we have not known the like of since Soviet tanks rolled in to crush the worker and student councils which emerged in the context of the Hungarian Revolution in 1956. And there is a level of parity between these two events – the Syrian and the Hungarian Revolutions – and the way in which the radical left

has responded to both. The 1956 revolution provoked a fissure in the radical left, with many of the old communist parties of Europe cleaving to the party line and supporting the forces of the USSR. The irony that the Soviet Union was actually murdering the forms of popular, working-class democracy (the soviets) it had been named after was lost on much of the higher levels of the party bureaucracy who received both funding and direction from Moscow. But towing the Stalinist line was about more than just material gain and position. The Stalinist bureaucracy had arisen out of the ashes of the proletarian revolution in Russia – and reached its ghastly fruition in a period of revolutionary retreat more broadly. Revolutionary outbreaks of the working class in Germany, Hungary, Italy and China had all been crushed (sometimes with the active collusion of the Stalinist state) and in the wake of this there lingered a pervasive sense of despair.

The palliative was provided, somewhat perversely, by the existence of the Stalinist state itself. Though it had murdered much of the original Bolshevik vanguard, though it treated the Russian working class with the utmost brutality – it nevertheless decked itself out in the colours and idiom of the proletarian revolution. It presented itself to the world not as a bureaucratic aberration whose power was premised on the wreckage of the workers' democracy, but as a lonely and fateful entity carrying forth the proletarian flame at a time of the most abiding darkness. In the aftermath of the Second World War such a sense of things was heightened. The successful establishment of a genuine workers' democracy was not forthcoming, and in its absence many communist radicals cleaved to the image of the non-capitalist USSR as the next best thing, as a challenge to Western hegemony, and the true carrier of the communist tradition. Even Trotsky – who had maintained a lonely and noble opposition to Stalinism for which he would pay with his life – had developed in the theoretical realm a notion which would support such a perspective. He argued that – as Stalinism abolished capitalist

social relations in countries by invading them and placing Stalinist bureaucracies at their helm – what the USSR was in fact doing was forming new workers' states albeit in a "degenerated" guise.

If one had to give a brief explanation of Stalinism's ideological pull then, one could do worse than say it is first and foremost a council of despair – the conviction that socialism could be imposed by an external power from above in a period of time when the living, breathing possibility of a revolutionary awakening from below was felt to be either negligible or non-existent. Of course, this was a delusion which worked against the grain of the most fundamental dictum of all Marxist thought – "the emancipation of the working classes must be conquered by the working classes". But what was perhaps even more problematic was that the left – large sections of which had spent many years orientating themselves toward Stalinism as a form of pseudo-salvation from above – was also a left increasingly unequipped to attend to revolutionary upheavals when and where they did break out from below. So when the USSR suppressed the Hungarian Revolution, the Communist Party of Great Britain, along with a large swathe of Marxist and communist activists, applauded Moscow feeling in themselves that the true revolutionary path was being traversed. At the same time, however, from this rump – ossified by tradition – a key element began to break away. There were mass resignations and expulsions. Those Trotskyist groups, usually miniscule, maintained their noble opposition to Stalinism and decried the events of Hungary. More broadly, a "new left" began to cohere, one which tended to operate in terms of a more humanistic, anti-Stalinist vision of Marxism. Many such figures gathered around the journal *New Left Review*. In the 1960s as these elements began to develop new theoretical perspectives it must have seemed like a kind of spring time on the left, an airing out of all the dusty, accumulated dogma of ages, the chance to breathe in a new,

fresher air.

Decades later, it is notable, with regards to Syria, how depressingly monotone the current left seems to sound. Almost across the board, its leading figures seem united in the conviction that, though the Assad regime itself is not an unqualifiedly good thing, it nevertheless represents the most progressive force on the ground and is preferable to that which it fights against. Slavoj Žižek, for instance, argues that the opposition shows "no signs of a broad emancipatory-democratic coalition, just a complex network of religious and ethnic alliances",[50] that any secular resistance has been "more or less drowned in the mess of fundamentalist Islamist groups".[51] Tariq Ali draws the inevitable conclusion from such a perspective – "If you want to fight ISIS, you should be going in and fighting alongside Russia and alongside Assad."[52] Ali is a serious Marxist thinker – part and parcel of that new left of the sixties which emerged very much in opposition to Stalinism and its emissaries in the European communist parties. In addition, Ali has also been an excellent chronicler of the development of Islamophobia in the context of the ongoing Western military interventions in the Middle East over the course of the last decade and a half. And yet, one can't help but feel the logic which underpins his analysis of Syria has both Stalinist and Islamophobic connotations – albeit that he remains oblivious to them. It has Islamophobic connotations in as much as it helps blur the shades of differentiation within the opposition into a single tone of uniform extremism – all those who fight under the banner of Islam are understood as ISIS-style combatants or their ilk. And once one has established this – has understood that the forces from below are irredeemably incapable of rising toward more progressive forms of social organisation and social struggle – then the door is open to a Stalinist-like logic, an inevitable and fatalistic last resort; for the despair which comes from faithlessness in popular power is neatly amended by the masochistic desire for an external force

32

to step into the breach and impose some form of order from above. Enter stage left – Assad and his Iranian and Russian cronies.

How is it possible that so many on the left have misread the situation so catastrophically? Part of it comes from the fact that the more secular and democratic forms of popular power in Syria tend to be obliterated in the moments they are being materialised in the forms of civic institutions – primarily by the bombs of Assad's air force and Russian and Iranian planes. Secondly, the elements which throw up these aborted developments are also woefully underreported at the expense of extremist elements. So, for instance, when regime forces retook the city of Aleppo amid reports from the UN Secretary General Ban Ki-moon[53] of atrocities against civilians by Assad's forces, the communist daily, the *Morning Star*, shamefully reported the repression as the "liberation of Aleppo",[54] as a victory for progress over and against the dark forces of Islamic extremism. What they failed to report on was the UN estimate released a month before which suggested that of a possible 8000 rebel fighters only a maximum of 900 were members of the al-Nusra Front.[55] Thirdly, there are occasions on which moderate forces certainly do unite with entities like al-Nusra. So, for instance, in 2015 rebels liberated the city of Idlib from the SAA and Hezbollah, freeing the prisoners who had accumulated in the regime's dungeons – but they were assisted in the endeavour by elements affiliated to the al-Nusra Front. Naturally these elements are horrendous, and would – at some point along the line – seek to obliterate entirely the more moderate rebels in an attempt to impose their brand of brutally authoritarian Salafism, but the moderates have to make these kind of cagey compromises, and with a prickling sense of unease – precisely because they themselves are so underfunded, are locked into a war on two fronts against both Assad and Daesh – both entities who are significantly more moneyed and militarily girded than

themselves. To avoid opening up yet another conflict – until it becomes absolutely necessary – is surely a prerogative born from the need for survival.

Finally, the broader global dynamics of the civil war speak to a specific intersection of contending imperialisms. Western power would ideally like to find an opening where it can sponsor a rebel element which would be wholly beholden to its interests – like the Maliki regime in Iraq – but such a possibility hasn't come to fruition. For that reason, it has been prepared to fund some rebel strands weakly and intermittently, and to look on the Assad/Iranian/Lebanese/Russian alliance with a great deal of trepidation. That there are, in essence, a competing set of imperial interests at work on the global stage is lost on many of the leftist thinkers who see in the Assad and Russian bloc a progressive form of anti-imperialism working against US incursions in the region. Now this is partly down to recent history in Iraq – and the series of disastrous invasions the US, Britain and their allies have conducted there in the pursuit of their own imperial interests. But it is also part and parcel of the Stalinist legacy – when, during and after the Second World War, Stalin carried out a series of brutal invasions and annexations of satellite countries. Many, on the communist left in particular, saw these invasions as being part and parcel of the last bastion of resistance to the imperial power projected out by the US and the heartlands of global capitalism – and so they failed to recognise that Stalin's military endeavours represented a form of rapacious imperialism in their own right. In the case of Syria, this image of Russia as in some way anti-imperialist has been overlaid by the false and undialectical opposition of a secular regime vs a virulent fundamentalism. But in the last analysis we, as Marxists, must always return to the class roots of the phenomenon. For, as Proyect questions with both acuity and pathos: "If we line up on the wrong side of the barricades in a struggle between the rural poor

and oligarchs in Syria, how can we possibly begin to provide a class struggle leadership in the USA, Britain or any other advanced capitalist country?"[56]

Chapter Two

La Cosa Nostra – The Historical Evolution of the Sicilian Mafia

The Norman conquest of Sicily was a gradual, blood-soaked, sluggish affair. Before it, the Saracens, the Arabs of North Africa – whose coastline looked out across the small Mediterranean island – created a flourishing emirate with the bejewelled capital of Bal'harm (Palermo) as its centrepiece, replete with pleasure palaces and mosques, baths and improved irrigation systems, walled suburbs that were cleaved by highways and punctuated by wide piazzas. The Saracens by and large co-existed peacefully with the populations they had conquered and subdued; Catholics, Orthodox Christians, Jews and Muslims broke bread in the same restaurants, drank from the same fountains, and rested side-by-side, slumbering in the same cemeteries. Palermo was then one of the greatest cities in Europe, a bastion of culture and glittering cosmopolitanism.

To some extent this spirit lingered still, even after the decades of reconquest which the Norman Christian armies affected. Under the kingdom of Sicily of Roger II, people of a variety of religious persuasions and ethnicities continued to live in relative harmony – native Sicilians, Lombards, Byzantine Greeks, Jews, Arabs and Normans – and while the political character of the state had changed, Muslims maintained their presence in industry and production and Muslim artisans and craftsman continued to receive kudos for their much sought after service. In the twelfth century the Muslims began to lose this political and cultural sense of independence; they were faced with voluntary departure or complete subjugation to Christian rule; in light of this many left, and many others converted, and the remaining rump of Sicilian Muslims now became almost wholly dependent

on the bonhomie of the royal power of the times. Inevitably, with the spread of the crusades across Europe, such bonhomie was rarely forthcoming, and in the 1160s a "pogrom" style series of persecutions was launched. The annihilation of Islam in Sicily was completed less than a century later.

The repressive politics, the narrowing down of culture, achieved its most profound expression when Isabella and Ferdinand merged the provinces of Castile and Aragon, creating a unified Spanish state which would become the fulcrum of a world empire. Sicily, one of the many components of this empire, was to be ruled from Spain via imperial governors and viceroys – an arrangement which presupposed an increased concentration of political and economic power among a handful of local barons. While Spain's international markets became a valuable focus for exports, and in the sixteenth and seventeenth centuries allowed Sicily's sales of wheat and silk to spike, nevertheless the stark and intensified "feudalisation" of the territory meant that the profits from the wheat and other crops augmented the wealth of the rural lords and were channelled into their luxury estates and fineries, and did little to stimulate urban industries. As a consequence, the cities which had been great in the Arab period rapidly depopulated as large numbers flowed away from the towns and into the countryside.

Spanish rule in Sicily endured for centuries. It was diluted somewhat when control of Spain (and control of the two Sicilian kingdoms) passed to the Bourbon dynasty under the French prince Philip of Anjou. It was interrupted briefly by the Napoleonic conquest. But in the nineteenth century the Spanish branch of the Bourbon dynasty had control over what was then known as "the Kingdom of the Two Sicilies" which extended over much of the Mezzogiorno more broadly. The Bourbon state was a hopelessly decadent one; a fossil, a historical relic ossifying under the glare of modernity and the impulse to national independence which was rippling across the region more generally. The French

Revolution had provided a powerful impetus to the nationalist movement within "Italy"; the *Cabonari*, a loose network of secret revolutionary organisations, developed at the start of the nineteenth century and in 1820 a revolutionary wave had swept across the Kingdom of the Two Sicilies which forced the Bourbon monarch King Ferdinand II to promise various reforms including a constitutional monarchy. The revolution was crushed, and the *Cabonari* dispersed, but the incentive to independence continued to intensify throughout the following decades, complemented by a series of other historical processes. In the countryside, the old feudal landowners were being displaced by the rise of a new agricultural bourgeoisie, who used their money and means to lease the sweltering, stagnant tracts of land – which had been subsumed under the vast estates of the old *latifundia* system – to a larger number of tenant farmers whose competition now provided new development to productive technique.

From within the interstices of the old feudal world, a rural capitalism began to take shape and acquire its definition at a rapid rate, and such a development also necessitated a modern state with a more efficient apparatus; one which could successfully regulate the exchange and purchase of land through a sophisticated legal code – a legal code which had the efficiency and the muscle to make sure new forms of property were respected. For instance, in the rolling empty ranges of the Sicilian ranches, cattle were susceptible to rustlers, while the costal orchids – ripe and blooming with a bounty of oranges and lemons – were equally vulnerable. But the old state was a foreign imposition; decaying and rusty, it lacked the material means to provide the necessary and extensive security and it was without the ideological capacity to provide a modern and updated legal infrastructure to encompass the new property relations which were developing in the countryside. In response to these challenges, the increasingly defunct foreign monarchy leased out the administration of justice to private interests; it introduced

a scheme of "Armed Companies", a series of individual units, which were funded by local landowners, and which were responsible for deriving justice by seeking compensation for those who had been robbed. In practice, this meant using strongmen and thugs to rob elsewhere; rather than ensure the rule of law such a system promoted a rapidly spiralling cycle of lawlessness – gangs of armed men marauding the countryside attempting to relieve their rivals of booty.

Almost every section of Sicilian society was united against the Bourbon regime. The rural capitalists resented it because the state proved incapable of modernisation and imperial taxes produced a drain on their resources. The peasants resented it because the Bourbon state was parasitical, corrupt and incapable of offering them any kind of succour in light of the exploitation they endured from the classes above – incapable of preserving their access to the rapidly diminishing land of the commons in the context of a burgeoning and rapacious rural capitalism. The urban merchants and artisans disdained it because it enforced the feudal trade tariffs of old and was incapable of securing a free and vibrant market. Out of all of this, organically grew the basis for a cohesive and unified national movement which worked against foreign oppression and would at the same time more rapidly ensure the high-speed development of rural capitalism from within the context of a modern state. In 1848 the Sicilians rose in tempo with the series of revolutionary waves washing across Europe and for a short time established an independent Sicily. As the counterrevolution gathered momentum, this experiment was defeated and the Bourbons were able to cling to the country again, but in 1860, when Garibaldi led his expedition of the 1000 into Sicily as part of the broader process of *Risorgimento*, the Sicilian population flocked to his cause. In 1861 Sicily officially became part of the new nationalised state: the Kingdom of Italy.

The Mafia grew out of the way in which the processes of a developing rural capitalism linked up with a broader,

burgeoning national movement in the Sicilian context. By the time of the mid-nineteenth century, the historian Eric Hobsbawm estimates that the Sicilian rural bourgeoisie owned land [which] "still amounted to only 10 per cent of the cultivated area"[57] in the region. Their influence was growing, their economic power was allowing them to buy out the old feudal lords, gradually replacing them as a ruling class by subletting their property to peasant tenants at a profit, but this growing economic power was not, as yet, bolstered by an equivalent political and material force; as we have seen, the Bourbon state was weak and ineffective when it came to regulating the day-to-day affairs of the Sicilian countryside, and the new bourgeoisie were vulnerable to their rivals, to peasant rebellions and widespread banditry. The Mafia was a form of organisation which was drawn, by and large, from a layer of diffuse and disparate social elements: outlaws, members of the "Armed Companies", harvest labourers who lacked work in the winters, tough displaced peasants, the rootless urban rabble who could provide muscle for cash, and so on. This organisation was mobilised by the rural bourgeoisie, as a way of creating an alternative form of social power which – in the absence of an effective state – would help prosecute its own class interests by securing its land and providing the muscle by which it might expand its economic gains. Thus, alongside the lower layer which provided the body of its physical power, the head Mafia figures were often members of the rural bourgeoisie itself – the rural landlord who directed his Mafia retinues – and such combinations, in their totality, provided a political and structural alternative to feudal, foreign oppression; thus when the movement toward nationhood and independence was aroused across Italy more broadly, Mafia forms in Sicily would naturally form a corresponding and significant part of it.

It should be added that although, primarily, the Mafia served the historical function of helping bring the rural bourgeoisie to its fruition as an independent and comprehensive ruling power,

its remit extended beyond this. Because the Mafia had a diverse social composition – because it contained in itself men who were tied to the bottom as much as to the top – it also provided some element of security to poorer peasants or exploited mineworkers, often making sure that the terms of their contracts were respected by the powerful interests which their labour served. The progressive tendency was, of course, much less to the fore, and was often neglected in favour of the mission of consecrating the power of the rural bourgeoisie which was, the majority of the time, in flagrant contradiction to the economic interests of the peasantry – seeking, as it did, to intensify exploitation and to consume all remaining common lands as part of its political project. And yet the Mafia provided some type of "legal" framework which did ensure that the peasant, land labourer, miner or fruit picker couldn't simply be "robbed blind" by the exploiting classes, for many members of the Mafia were to some degree rooted in the oppressed classes; for all of this, the Mafia, to a lesser or greater extent, successfully refracted the interests, hopes or aspirations of a broad set of social groups within Sicily, and it was for this reason that the Mafia became a powerful conduit through which the struggle for independence was directed. Its conscious political allegiances were from the outset stamped by this fact; its political links tended to be of the far left, the Garibaldian Radicals being the main Italian opposition party of the time.

But how did the Mafia regulate the relations which opened up between the landlords and the peasantry? How were they able to accomplish this effectively? Hobsbawm argues that Mafia notions of honour and obligation should not be understood in the context of feudal traditions of old but in light of the rapacious agricultural capitalism whose proponents were more and more engaged in a fierce scrabble for accumulation and land. He writes:

A Mafioso...recognized no obligation except those of the code of honour or *omerta* (manliness)...the sort of code of behaviour which always tends to develop in societies without effective public order, or in societies in which citizens regard the authorities as wholly or partly hostile...One should resist the temptation to link this code with feudalism, aristocratic virtues or the like. Its most complete and abiding rule was among the *souteneurs* and minor hodlums of the Palermo slums, whose condition approximated most closely to lawlessness, or rather to a Hobbesian state in which the relations between individuals or small groups are like those between sovereign powers.[58]

I think that Hobsbawm's analysis here paves the way to a significant error. He argues that the Mafioso code represents something contrary to feudal "values" because it is more modern – "Hobbesian" – in its intent, and on a certain level this makes sense, given that the creation of the Mafia was part and parcel of the struggle of a modern bourgeoisie to establish itself in the countryside. At the same time he misses the paradoxical and uneven nature of the historical process itself. In becoming a prism for the broader national movement, in seeking to mould the peasantry in line with new property forms, the Mafia had to achieve hegemonic victories alongside physical ones. They had to win a section of the peasantry over to their cultural values as well as compel it through forceful means. Hobsbawm's suggestion that Mafia-like codes of behaviour develop in societies where the state has lost its own capacity to generate a moral authority over and above simple physical repression is astute. But the point is, the Mafia moral code would have had to fill the "moral" void so to speak, and it is hard to see how they could have done this if they had simply offered the peasantry a vision of social justice which boiled down to a crude Hobbesian/ Spencerian survival-of-the-fittest narrative.

In actual fact, the moral life of the peasantry had been structured by feudal values for centuries, even though they resented the Spanish monarchy itself as an alien and foreign imposition. Those feudal traditions by which common lands could be roamed by both master and serf; and the sense – however fanciful it was – that the most powerful had a moral duty to protect and care for those who fell within the orbits of their estates, was one which had existed from the time of the Roman Republic when the poorer peasants offered labour services to powerful landed interests, labour services which were subsumed under the cultural relation of *patroni* and *clienti*. These social forms and values asserted a powerful sway on the way in which the vast number of peasants comprehended life on the plains and the fields; and although the Mafia is a modern phenomenon –a nineteenth-century phenomenon – when one casts an eye across its rituals and ceremonies, even in the modern day, one can't help but detect the potent whiff of antiquity. The mumbling Godfather in some darkened backroom softly coaxing a blood oath from the trembling lips of some desperate, powerless plebeian; the practice of holding a secret ceremony before pricking the finger of a man who is about to be "made"; these rituals which are still retained today date back to the nineteenth century – in fact the pricking of the finger was something first observed in 1877.[59] In my view they grew out of the need to demonstrate to the peasantry that Mafia life was very much rooted in the ancient traditions of the countryside, traditions which were feudal in origin, or which went back even further still.

So perhaps we can further our definition of the Mafia; it helped facilitate a developing rural capitalism which was inexorably linked to a burgeoning national movement; while at the same time it achieved this by mobilising large sections of the peasantry in and through a cultural ideology which was cloaked in the values of the feudal world of yore. It is this rather

erratic combination of the old and the new which best describes the political and social character of the Mafia in its early period. In 1861, the *Risorgimento* reached fruition and Italy formally declared nationhood. The radical movement from the south led by Garibaldi, and supported by the Mafia, was to some extent, co-opted by the Northern Piedmont state as the restructuring of Italy was carried out. As Martin Clark points out: "It was Piedmontization all around."[60] The promises which Garibaldi had won from Cavour, Italy's first Prime Minister, were erased after the latter's unexpected death in 1861, and as a consequence political power became ever more concentrated in the north, before eventually being consecrated in the new capital of Rome itself. It was from here that all national and regional officials were appointed, and the Piedmontese tax officers, rates and system of administration were now imposed on the country as a whole. This effectively set the basis for a geo-political fissure which extends into our own time; the Mezzogiorno, including Sicily, was represented as an anarchic, superstitious rural wasteland which had to be "civilised" by the modern and secular national state; hence a project of repression was called into being which saw the southern region become something like the equivalent of a colony within the framework of the national project as a whole.

This resulted in a glut of cheap exports being sucked from the south in order to fund a project of industrialisation and modernisation in the north, which, in turn, left the south badly underdeveloped especially in the urban regions which suffered from a severely backward infrastructure, while the region as a whole was subject to a further intensification of an already desperate and widespread poverty. Because the impetus to production was very much centred on agriculture, and because the new rural capitalist class had thrown off the yoke of feudal restrictions which had once tethered it, such a class no longer had any use for the radicalism of the Garibaldian type; it mattered

little to it that the urban areas were underdeveloped, that the south could not fund its own project of industrialisation. None of these things reined in the forms of their own accumulation; the selling of their produce to the richer north or the privileges and perks these rural capitalists gained from entering into a strong political and economic alliance with the ruling power in Rome, albeit at the expense of regional autonomy. They essentially became a subaltern class which now functioned to administrate the population of Sicily in accordance with the whims of their political paymasters back in Rome.

How did this affect the Mafia? The Mafia, as we have seen, was bound up with the projects of both rural capitalism and nationhood; once the rural capitalists had aligned with the centralised power of the nation state following independence, the Mafia now became a critical join in the mechanisms of this relationship – and, therefore, an essential part of the process by which the north was able to prosecute a political and economic hegemony over the south, including Sicily. Again this goes back to the fact that the Mafia had a strong plebeian streak in its composition, had a strong rootedness in local populations, even if its members conformed to a philosophy of authority which had certain Nietzschean overtones; the spectacle of the land labourer, bandit or small farmer who had arisen from the plebeian masses but nevertheless sensed in themselves a spirit of power and independence which was destined to elevate them above the mere "herd". Such characters were able to speak the language of the masses – in a way that those from the higher echelons of the ruling class could not – even as they were exploiting them. With the new political state also came a new political form – that of a liberal democracy. The first general election occurred in 1861 which brought the largely right-wing candidate Cavour to power, but the election itself was far from representative, as only males were allowed to vote – furthermore only those who were literate, over 25 and had some level of property. Despite

this, the left-wing current in the country as a whole remained a powerful force within the population, and often liberal or right-wing ministers were compelled to enact some level of radical policies in order to mollify it – such as the nationalisation of railways which occurred under Prime Minister Marco Minghetti in the 1870s. In Sicily the fevered and radical atmosphere was especially acute, indeed throughout the Mezzogiorno peasant rebellions broke out frequently in this early period as the disillusionment and dashed hopes of the *Risorgimento* set in.

Not only were the majority of the Sicilian peasants unable to vote, the small landowners who were antagonistic to the politics in Rome often found their votes either swayed or coerced by Mafia elements, who were redefining their own role in orientation to those political parties in Rome who would line their pockets in order to procure the Mafia as a means by which electoral influence in the south could be won. Again, because the Mafia had roots in the population, because they drew upon a demonstrable radical tradition which came out of their support for Garibaldi's army – they were not only able to coerce voters on the smaller property scale but also to persuade them. In Sicily, for this reason, the preferred candidates of the Mafia were almost always elected. In 1880, and in the nation as a whole, a widespread apathy toward the right-wing administration led to the election of the party of the Historical Left under the new Prime Minister Agostino Depretis. The Historical Left Party had originated, in part, from the radical political tendency which Garibaldi had led, though the Historical Left Party had broken with much of its revolutionary politics, in spirit if not in name – with Depretis advocating a nationalistic millitantism and the imperial expansion of Italy in Africa. This marked a critical juncture; now that the revolutionary spirit of the Garibaldian project had been assimilated into the state machine the political degeneration of what remained of the Mafia's last vestiges of progressivism was inevitable; once a "left" popular party was in

power, unifying capitalism, then the Mafia could begin to fully move to the right. The banner of Garibaldianism became the same thing for both the Historical Left Party and the Sicilian Mafia; it became the radical ideology by which the full unfettering of Italian capitalism, in conjunction with the exploitation of the rural south by the industrial north, could be achieved.

There was one other factor which saw the Mafia transformed from an embryonic state within a state, a parallel system of "justice" on the land which helped facilitate a progressive national movement against a decaying feudal kingship to a more naked system of domination by which the central nation state enshrined its power over the periphery. And that was the rise of the trade unions and the political forms of organisation which developed within the peasantry and the workers toward the end of the nineteenth century. In the revolution of 1820 the urban artisans had already formed in organisations known as "ronde", but once nationalisation had been achieved, a new and more modern form of political militancy began to take shape. From the start of the 1890s a popular movement, the *Fasci Siciliani*, developed a federation of hundreds of local associations which were manned by land labourers, small farmers, sharecroppers, artisans, intellectuals across Sicily, and very swiftly the movement came to number in the hundreds of thousands. In terms of a coherent politics, the movement's ideology remained nebulous, with leaders of a socialist and anarchist bent mingling with leaders of the more reformist type; while at the same time the strong peasant mood which formed the pulsing undercurrent of the movement was a heady mix of radical social justice in the vein of Garibaldi, Mazzini or Marx along with the holy fervour of ancient and venerable religious tradition and an almost supine, childlike faith in the benevolence and power of the king. And yet, despite these clashing, contrasting colours, the actual pragmatic demands of the movement were written out in indelible black and white: lower land rents and taxes, wage

increases and the redistribution of the land. The *Fasci Siciliani* was an incredibly significant popular movement, not simply because of its numbers and its radical demands, but because it managed to forge the political link between the town and the countryside which saw the lower classes as a totality begin to push back, with a great and resonating power, against the new form of Italian chauvinism which the northern state had imposed on the south in collusion with the agrarian capitalists and the big city business magnates within Sicily itself.

It was also hugely significant for the evolution of the Mafia. For decades the Mafia's wheels had been greased by the political establishment in Rome, but in prosecuting Rome's political project, the Mafia were able to achieve some level of hegemonic control over the lower classes because they had, in the not-too-distant past, provided a conduit for the fight against national and regional oppression, forging links with the Garibaldian army which spearheaded the resistance of the south. In becoming a true and comprehensive form of political organisation which had arisen from the upswell of the poor and dispossessed, the *Fasci Siciliani* usurped the lingering political energy and faith the lower classes invested the Mafia with. The breaking of this connection quite naturally meant the extinguishing of any progressive impetus to the politics and ideological direction of the Mafia as a social organisation. More than this, the peasants and workers had come together in a popular movement which decisively transcended the boundaries between the rural and the urban spheres. In the past, the Mafia had a large degree of control over the way in which the city related to the countryside in as much as, along with its role on the land, it was also strong in the urban peripheries of cities like Palermo where businesses thrived which absorbed the agricultural product and prepared it for export.[61] The Mafia could run such businesses because they had control over the agricultural product given their ability to enforce terms on local peasants.

They began to effectively control the flow of goods between the countryside and the town and so it would be incorrect to describe them as a purely rural phenomenon. But the new movement, the *Fasci Siciliani*, which established a form of political organisation which connected rural workers with the urban masses, also threatened to undermine the Mafia's control of those routes and bring to light the secretive, coercive practices by which they could monopolise the peasant product in the name of their own export companies on the city's outskirts. For all of this the Mafia had plenty of reasons to hate the *Fasci Siciliani*. Its response to the movement was integral to forming the character of the Mafia in the next period. The Mafia, which had for decades helped Rome to shape the political consensus in the Sicilian countryside, had now graduated into a broader, more explicit and more vicious form of repression levelled against a burgeoning nationwide radical movement; it became an extra auxiliary arm of the state mobilised against the new forms of worker and peasant political self-determination – utterly committed to the crushing of them. It became a force which was able to operate underneath the radar, and achieve the more rapacious and repressive inklings of a state which itself was bound by modes of legality; in essence the Mafia became a supplementary terrorist force which was directed at the left with a wink-wink, nod-nod from central government. In the words of Umberto Santino, "The *Fasci* movement was bloodily repressed by the joint action of the Institutions and the Mafia."[62] That its political character was indelibly marked by this is certain; if one considers the Mafia as an organised crime syndicate in modern day America, one is aware that a high level of its finance comes from big business who appreciate its "extra-judicial" ability to quell and smash the unions; indeed the current President of the United States, and his father before him, made use of Mafia figures in precisely these terms. By securing deals involving the purchasing of concrete from Mafia men like Anthony "Fat Tony"

Salerno, boss of the Genovese crime family, or Paul "Big Paulie" Castellano, boss of the Gambino crime family, Donald Trump was also able to procure the kind of muscle which would see many of his construction jobs pushed through with quick, brutal efficiency by applying the type of pressure which could secure "union peace" and a cheap and pliable workforce.[63]

But to return to the early twentieth century, something else solidified the Mafia's role as political enforcer. In 1912, as a result of the political pressure of the developing left-wing movements and Catholic pressure groups and organisations, the Italian state granted full suffrage to all adult males over the age of 30. The establishment and the academic consensus of the time seemed to suggest that the reform itself would destabilise the political system in favour of the most extremist trends: "The prevailing opinion is that the reform will damage the constitutional liberal party and benefit the extreme parties. It is widely believed that – with some exceptions – the beneficiaries will be the extreme parties in the urban areas and the conservative and reactionary parties in the rural areas".[64] The extreme left would claim the cities for itself then, while the far right would take control of the countryside. For the political mainstream in Rome the masses could not be entrusted with their own destinies, were incapable of voting in a "reasonable" and moderate fashion; even the luminaries of leftist reformism, such as the Italian statesman and eventual Prime Minister Ivanoe Bonomi, would argue that "the franchise in itself is an instrument, and without a force that knows how to use it, it can damage precisely those that demand it".[65] Now that the masses had the franchise, the necessity to oversee their voting patterns, especially in the more rebellious and turbulent areas like Sicily, became an even greater priority. In this connection, of course, the ability the Mafia had to influence local populations – either through fear or favour – plus their capacity to neutralise the growing power of socialist or trade union movements through violence, became

ever more prized by their political paymasters back in Rome. Subsequently, it was "well documented by newspapers of the time that the election of 1913 happened in a climate of unusual violence and intimidation"[66] in which Mafia and local enforcers used brute force "to ensure that poor voters stayed at home and did not exercise their right to vote, which would explain the lower turnout rates in swing districts".[67] In the Mafia districts such violence was particularly pronounced, indeed there was consistently recorded "a significant increase in homicides in Mafia regions relative to non-Mafia regions before elections".[68] For all of this: "Enfranchisement did not increase the number of seats won by the left and did not cause a displacement of traditional and aristocratic elites from their parliamentary seats."[69] The Mafia had been moulded into a lethal political force infused with the wealth of the Roman political establishment, almost entirely given over to prosecuting their political hegemony at the local levels of electoral politics. Whatever remained of radicalism in this clean, efficient and murderous arm of the Roman political bureaucracy had been extinguished. But now the Mafia was about to meet with a political form which was even more deadly than itself.

In 1922 Mussolini enacted his fateful march on Rome. In the years which followed, the fascists waged a relentless and effective war against the Mafia, stamping out their strongholds and obliterating their power. At first glance, this might seem incongruous. After all, one would imagine that the fascists and the Mafia had much in common and would have formed an organic partnership. Both were a product of modernity, were highly pro-capitalist in orientation, and yet both endeavoured to present their political projects in the guise of a more venerable, quasi-feudal ideology which prized blood and honour – a potent and nostalgic commitment to a fantasised notion of a fatherland, the rank subordination of women to men, the raising up of the traditional family structures into an authoritarian style fetish,

the notion of an ancient manly code, and the Nietzschean idea that violence and conquest was the means by which the heroic individual raised themselves above the grey, monotone masses in order to manifest a singular and creative destiny. Both institutions, the Mafia and the fascists, were adept at establishing a strong "legal" presence in the political realm while at the same time working behind the scenes using every possible angle of violence and illegality to strengthen their base. Both had refined and sharpened their powers in the violent and bloody struggle which had been opened up against the workers' unions and movements. And yet, there was one insuperable difference. The Mafia had, however long ago, come out of the left political tradition of Garibaldianism which was anathema to the fascists. In the twenties, therefore, the Mafia was still very much connected to backing the type of non-fascist liberal party which had for decades been filling its coffers to subdue local populations in the pursuit of votes. Rotten and corrupt, the Mafia's economic and political power was nevertheless fused with a decaying and bankrupt liberal democracy. It is true that in the first couple of years Mussolini paid lip service to the idea of liberal democracy while the fascists sought to consolidate their power, but the façade soon began to slip as Mussolini unleashed a period of free-market policies consolidated by an authoritarianism which absorbed the unions into the state and gradually dismantled the democratic institutions. In the words of the *Duce*: "Capitalism may have needed democracy in the nineteenth century: today, it can do without it...Life turns to the individual...Gray and anonymous democratic egalitarianism, which had banished all colour, and levelled down all personality, is about to pass away...now that it has been demonstrated that the masses cannot be the protagonist of history, only its instruments."[0] Because the Mafia's political role – although authoritarian, individualistic and violent – was nevertheless fused with the democratic apparatus more broadly, fascism was impelled to suppress the

Mafia as part and parcel of its own overarching project. In 1925 Mussolini appointed Cesare Mori the prefect of Palermo, and in this position the *Duce's* underling was quick to earn the epiphet of "Iron Prefect" (*Prefetto di Ferro*), a result of the speed and ferocity of the campaign he launched against the Mafia. Mori mobilised a small army; within months hundreds of Mafioso had been arrested, families were taken hostage, livestock was slaughtered and beatings and torture were commonplace. Many Mafioso were executed without trial. Of course, these tactics mirrored the tactics of the Mafia more broadly. In so doing, Mori was successful in breaking the hold of the Mafia on the local populations, the larger Sicilian families were broken up, and although the Mafia's influence wasn't wholly eradicated, it was now the case that ordinary citizens could approach the legal and political institutions of the state without these overtures being mediated by Mafioso who would often take a cut in the proceedings. But why wasn't the Mafia able to better resist the fascist offensive?

The 1980 film *The Long Good Friday* involves the fictional story of a London gangland boss, played by Bob Hoskins, who crosses paths with the IRA. Attempting to avert the conflict which will ensue, one of his underlings advises him not to engage the politicos, because it is simply not a winnable fight: "You can't wipe them out...Kill 10, 20, bring out the tank and the flame-throwers...They pour back. It's like an army of ants."[71] The moment is genuinely chilling; the sense of those innumerable, anonymous shadowy figures, lurking behind the scenes, driven by demented, implacable purpose, and yet the scene – and the film more broadly – conveys something more than just a violent, dramatic menace. It hints at a truth which the Bob Hoskins character simply cannot fathom; he may be savvy and ruthless, and murderous and powerful, but he is not driven by any other purpose than the acquisition and expansion of his own criminal fiefdom. The force which is now arrayed against him is united

by a broader political purpose, and that is why the Hoskins character is ultimately doomed. I think something similar could be said of the Mafia's struggle with fascism. Although the fascists and the Mafia used similar tactics, held similar values, nevertheless there was a fragmented, privatised, purely entrepreneurial element to Mafia acquisition which had long since been divorced from any broader purpose. The Mafia was, for this reason, an inherently unstable structure. Those heads of families which had grown large and powerful had a vested interest in "legitimising" their offspring; that is to say, where possible they sent their sons and daughters to the best finishing schools and universities in order to propel them into the stratum of the respectable upper classes, to allow them to become lawyers, doctors, merchants and so on. A space was created, the older generation of Mafioso lingered, but the newer generation was increasingly filled by outsiders, the more impoverished and hungry – those who were not connected to the old bosses by direct bloodlines; inevitably gang wars brewed between the two as the new element sought to seize its slice of the pie. There was no unifying ideology, no political purpose, which could act as a form of social cement which would allow the Mafia to overcome such fragmentation, to resist the fascists as a single, organised force. Indeed the fascists were able to exploit the divisions and warring interests within the Mafia, by sponsoring those discontented elements which had lost out in the power struggles, those seeking revenge. By 1928 over 11,000 suspected Mafioso had been arrested,[72] and this, of course, also gave the fascists an important alibi as they sought to quell rebellious peasants and political dissenters whom they could have arrested over supposed "Mafia" connections. As Salvatore Lupo says, in what is perhaps the most detailed systematic study of the period, Mori was able to exploit "accusations of Mafia association whether they were true or false — in both cases for exclusively political reasons — to destroy all political groups in Sicily that the regime

considered to be undesirable, irrespective of whether they did or did not support the National Fascist Party".[73]

In any event, the Mafia themselves were laid low by the fascist contagion, even if the illness wasn't a fatal one. The rank and file of the Mafia had been battered and eroded, but the fascists did not systematically target the very top-level men, they did not imprison the most wealthy land magnates, for they did not wish to deconstruct fundamentally the *latifundia* system of property which had passed into the hands of the rural bourgeoisie. In the 1930s, as Lupo notes, "old and new generations of Mafiosi were once again able to take control of the great estates".[74] While much of the Mafia's content had been reduced, its essential form remained intact. For this reason, by the time of the Second World War, the Allies, and in particular America, were able to draw upon a more sporadic and scattered set of Mafia groups in the fight against fascism and the reconstruction of the country in the aftermath. The Americans negotiated with Mafia elements as a way to distribute resources and obtain funds on the black market during the war effort. The Sicilian Mafia had had a presence in the US since the turn of the century, but under fascist persecution in Sicily this presence was exponentially strengthened as many more Mafiosi fled from the motherland to America. The connection between Italian-American gangsters and the Mafia rump back in Sicily has often been exaggerated, especially in terms of the significance of the role of the Mafia in helping American troops defeat the fascists. In this capacity the Mafia's influence was certainly negligible, despite the rather romanticised claims to the contrary. However, what was more significant was the role Mafia types played in the aftermath of the war. Once the fascists had been driven out, once Sicily had been occupied by the Allies, the US found it useful to install Italian-Americans at every level in the new Sicilian administration, and "among the emigrants who had returned to Sicily and were employed in the new administration at various levels were many

who 'had been raised by the American Mafia'".[75] Alongside this, many indigenous Mafia were able to present their anti-communist politics as a form of bold political dissidence and were able to occupy a good number of the mayoral positions which the fascists had left vacant. Mafioso such as Calogero Vizzini, for instance, who was made mayor of Villalba, as well as being made an Honorary Colonel of the US Army. Truly, a *made* man.

In the aftermath of the war, therefore, the Sicilian Mafia began to acquire new strength and new definition. A new wave of peasant mobilisations broke out, the question of land once more became fused with the notion of some type of nationalistic rebirth. Under peasant political pressure, the old shape of the large landed estates began to deteriorate; in 1946 the Segni law allowed peasants in cooperatives to take over "uncultivated or poorly cultivated lands".[76] As the old *latifundi* broke apart, the middling layer of Mafia enforcers was revived, again with the complicity of the new state, as a means to control both the anarchy which had broken out after the collapse of the fascist administration and, more significantly, the peasant movements from below which were reconfiguring the rural landscape. At the same time as they re-established themselves as terroristic enforcers working against leftist currents, the Mafia were also able to get back into the vote procuring business (though not to the extent they once had) by using their recently acquired roles in the new political administration to establish connections with the Christian Democrats, helping the party expand and filling their own pockets in the process. But the character of the Mafia was changing too. Their role as the traditional guardians of the *latifundia* was passing out of being; their link with Italian-American gangsters which had been fortified during the war period was now extremely useful in facilitating a network of trade, especially in narcotics, which saw the Mafia become an organisation with a more urban centre of gravity.

And so the Mafia came to resemble what it is today; it attained its modern character. In Sicily, the decimation of towns and cities which had taken place in war time was now succeeded by a boom in construction as the need for new homes was subsidised by state planning and money. In the early 1960s, 80 per cent of all building permits were doled out to just five people, none of whom were employed by any large construction firm and all of whom were thought to have strong Mafia links.[77] A big protection industry grew up around construction; companies were strong-armed into paying Mafioso money on a basis which was little more than extortion by menaces. Many buildings were illegally constructed in order to save time and money, and again the Mafia's links with government proved effective in the creation of these. In the 1970s cigarette smuggling became a particularly lucrative enterprise for *La Cosa Nostra*. At the same time, as Mafia economic power and influence began to grow strong again, sporadic, internecine conflicts erupted as different families waged war for the spoils. Shootouts and bombings became commonplace.

The violence reached a crescendo with the formation of a coalition of Mafia families — the *Corleonesi* — led by Luciano Leggio who was the boss of the Corleone clan. He was attempting to gain a monopoly over the narcotics trade, but was eventually imprisoned in the 1970s. However, he was able to command the *Corleonesi* from his prison walls, through an intermediary, and as they prosecuted their struggle for power, they also waged a campaign of assassination against journalists, politicians and police who stood against them. For this reason in the 1980s the state organised a widespread campaign against *La Cosa Nostra* led by the magistrates Giovanni Falcone and Paolo Borsellino – and this culminated in a key boss, Tommaso Buscetta, turning informant and hundreds of Mafioso being put on trial. In response the Mafia targeted and murdered judges, anti-Mafia lawyers and anti-Mafia businessmen, while conducting a terror campaign on

the mainland attacking tourist spots and even Catholic priests after the Vatican condemned them. Such rabid, sustained violence was ultimately self-refuting. It graduated the internal culture of violence and authoritarianism to such proportions that families of collaborators were also being executed, thus generating a wider circle of people who had grievances with the Mafia and were prepared to resort to police protection or recompense. It was creating fissuring cracks within the network of the Mafia organisation itself. In addition, the attacks on tourist hotspots and civilians more broadly produced a furious response on the part of the general population which very quickly cohered into a larger sense of grievance and protest. A new set of Mafia leaders, such as Bernardo Provenzano, put an end to the mass murder of informants' families and state officials and thus was able to initiate a period of relative calm known as the *Pax Mafiosa*.

Now *La Cosa Nostra* is a significantly weaker organisation than it was in its heyday. The organisation still remains a blight on the national landscape, of course. Persuasive allegations of its corrupt links with politicians in the modern period have been rampant. Most notoriously, rumours of its connections with the now defunct Berlusconi regime have long since festered, bolstered by the premature release by the state of 119 Mafioso.[78] The Sicilian Mafia continue their lucrative and brutal money laundering, fraud and drug trafficking operations. Their protection rackets are still in full swing. They continue to resort to the intermittent brutalisation and terrorisation of political enemies like the journalists who seek to expose their activities; so, for example, most recently, in 2018, a plot was uncovered to kill the investigative journalist Paolo Borrometi.[79] And yet, the power of the organisation has been significantly eroded, not only by the state's anti-Mafia initiatives, or the ever increasing antipathy of the broader population, but by new strains of criminal enterprise which have moved in on their turf. By the turn of the millennium, for instance, *La Cosa Nostra* had had to

cede most of the illegal drug trade to the "Ndrangheta" crime organisation from Calabria. And in 2006, that same organisation, the "Ndrangheta", was estimated to control 80 per cent of the cocaine imported to Europe.[80] The Sicilian Mafia's ability to coordinate its own operations has been much weakened. Imprisoned bosses are subject to strong controls on their contact with people on the outside; under the article 41-bis prison regime, their ability to run their families was greatly reduced.

Perhaps that's why recent reports suggest *La Cosa Nostra* is abandoning its base in the urban heartlands and attempting to build itself anew in the rural areas from which it sprang more than a century and a half ago.

Almost coming full circle, *La Cosa Nostra* have returned to their rural origins, in an attempt to re-establish their waning power. More and more farmers are reporting what at first seemed to be a sinister anomaly; large numbers of unfamiliar cattle suddenly wandering onto their land, destroying the crops. At first farmers believed that it was just a random, unfortunate event, but soon their own cattle started dying or their dogs were poisoned. Inevitably they would receive a knock at the door; a sinister gentleman offering to take the land off their hands at a vastly diminished price. These farmers were being made the victim of a practice called "Illegal grazing",[81] one of the oldest forms of Mafia intimidation in the region. But once upon a time the Sicilian Mafia had combined their mode of exploitation and power creation with an authentic rootedness in local populations, and even some level of progressive political commitment to the lower layers manifested in and through the struggle against foreign oppression. Now, however, they are the foreign oppressors, and force, rather than ideology, is all they have. Theirs seems like a doomed project, destined to disappear into the senseless parasitism of the run-of-the-mill criminal brutality and banality which inflicts all desperately poor societies. Such parasitism can be measured in more general

terms. Although desperately poor itself, in light of the multiple drownings of thousands of refugees, Sicily has welcomed immigrants into the country in their thousands. Perhaps this represents the best political traditions of a place whose history and cultural character has been so vividly demarked by an ever-renewed flow of people: Greeks, Carthaginians, Romans, Moors, Normans, Spaniards and French. But *La Cosa Nostra* responded to the immigrants with their own venerable tradition: that of preying on the weak. The Mafia traffic them, use them as drug mules, force them into prostitution[82] and absorb state funding designed for immigrant provisions into phoney services the criminals set up – said to be geared toward immigrant welfare.

Chapter Three

The Suicide Forest: A Marxist Analysis of the High Suicide Rate in Japan

At the base of Mount Fuji lies a forest which has all the gothic beauty of a medieval fairy tale. The trees there tend to be gnarly and twisted; their branches interlock, like witches' fingers, stretching in a tightly-knit canopy which blocks out both light and sound. Walking along the floor of the forest is a beautiful but eerie experience; you move in a perpetual twilight, a place which is forever on the verge of night. Every now and then, the shadows are interrupted by a flicker of colour; here and there a thin, bright ribbon trails and shimmies from one tree to the next. Follow one of these, and it might simply peter away in the stillness...but then again, it could lead you further and deeper still, toward something else entirely. To one of the forms which are so regularly found in this place; a body hung slack and dangling from one of the skeletal branches above.

For you are in Aokigahara – and Aokigahara is a place where people come to end their lives. It is estimated that 100 people die here each year. The ribbons are a precaution; if the person who is contemplating suicide changes their mind at the last moment, he or she will be able to find their way back to the world of the living once more. Ribbons are required because compasses simply don't function in this place. Something about the iron concentration in the ground interferes with them – though inevitably, such naturalistic explanation has been superseded by all types of supernatural ones; the forest is so spooky and still, it is hard not to infer the ghostly presence of all the souls that have perished here.

Of course, it is not only Aokigahara which has become synonymous with suicide. Suicide looms large in the national

reputation more generally, from the Samurai warrior to the Kamikaze pilot. Today, Japan has one of the highest suicide rates of any country, tripling that of the UK, and doubling that of the US. But the reasons as to why this might be remain as enigmatic and elusive as the shadows which flicker and dance in the "Suicide Forest" itself.

Some sociologists put it down to the specific character of Japanese religion. Unlike Christianity, Judaism and Islam, neither Buddhism nor Shinto places any explicit divine prohibition on the act of suicide. In Shinto, death provides the vehicle by which a person transitions into unity with nature once more – regardless of the manner in which it is achieved; while Buddha himself was recorded as having shown express sympathy with two suicides in his lifetime. Subsequently, the notion of suicide as sin which undergirds the Abrahamic faiths is more or less absent in both Buddhism and Shinto. But while this might be a significant factor, it nevertheless falls short of a comprehensive explanation. As the writer Christopher Beam has noted astutely,[83] China has a somewhat similar religious make-up, and yet the suicide rate there is significantly lower.

Howard W French writing for the *New York Times* suggests the high rates are due to the stigmatization[84] which surrounds mental health issues in Japan. Unlike the US, where the market is flooded with anti-depressants and mental health issues are regarded in the same forensic light as physical disease, French contends that the Japanese are inclined to view mental disorders in moral terms; the sufferer is more likely to be seen as simply ethically abhorrent or morally weak. Once more, though such "cultural" attitudes may play a role, they should not be read as decisive, especially given Japan had a similarly high suicide rate in the 1950s when such drugs were not widely available in any country, and where prejudices toward mental health were prevalent across the spectrum.

In one of the definitive books on the issue – *Suicide* – Émile

Durkheim tried to penetrate the ephemera of culture and discover the more fundamental tendencies which underwrite suicidal behaviour in society. Durkheim would go on and pinpoint two central variables which most fundamentally impact the patterns and type of suicidal behaviour a given society exhibits: these are "integration" and "regulation". Regulation refers to the degree to which individuals are subject to broader modes of social and moral control; modes which form a series of checks and balances on the myriad of feelings and impulses the individual life is in thrall to. In *Suicide*, Durkheim proffers the institution of marriage as an example of social regulation – "it completely regulates the life of passion...by forcing the man to attach himself forever to the same woman".[85] Without such regulation, a man falls prey to a certain listlessness, for he is no longer bound by a more universal sense of duty and hence "aspires to everything and is satisfied with nothing".[86] This, in turn, can lead to the form of suicide which Durkheim calls "anomic". However, excessive regulation, in which the broader mechanisms of social control come to smother and crush more individual passions, ambitions and sensibilities, can also prove perilous, for they can set the stage for the type of suicide which Durkheim describes as "fatalistic".

Integration refers to the degree to which individuals have a sense of attachment to particular social groups, and the manner in which they are ideologically committed to broader social purposes and ideals. Again, excessive integration runs the risk of smothering and annulling a sense of individuality – of creating "insufficient individuation" such that more universal and communal purposes tend to preponderate absolutely. In this context, the form of suicide which results is described by Durkheim as "altruistic". Here we might consider the example of the Kamikaze pilot. Durkheim himself suggested that this form of suicide (altruistic) was at work in modern armies where the soldier was "drilled to set little value on his person"[87] for the

"principle of action"[88] remained something outside himself. At the same time a lack of integration with broader social groups generates a situation in which "the less he depends on them, the more he consequently depends only on himself and recognises no other rules of conduct than what are founded on his private interests".[89] The lack of integration which is yielded by such "excessive individualism" sets the basis for the form of suicide which Durkheim describes as "egoistic".

According to Durkheim, then, pre-modern societies were often vulnerable to both excessive integration and excessive regulation. Integration was provided by the tightly-knit familial structures organised in terms of blood lineages and clan allegiances, and the way in which such families formed "denser" units which meant that "some social units are always in contact, whereas if there are few their relations can only be intermittent and there will be moments when the common life is suspended".[90] Such integration can become excessive and lead to forms of altruistic suicide – with Durkheim himself citing the practice of *Sati* or widow burning in India as an example; "[t]his barbarous practice is so engrained in Hindu customs that the efforts of the English are futile against it".[91] Likewise pre-modern societies are often categorised by an "excessive physical or moral despotism"[92] which operates via the "inflexible nature of a rule against which there is no appeal".[93] Or to say the same – they are under the sway of an excessive level of regulation. Here Durkheim offers us the example of the high suicide rate of slaves who are exposed to just such a form of despotism.

But when it comes to modern societies – or to say the same – capitalist societies (though Durkheim doesn't use this specific term) a very different paradigm is in effect. In modern societies, with their vast and complex divisions of labour, the individual is increasingly abstracted from the body politic – "it is too far removed from the individual to affect him uninterruptedly and with sufficient force. Whatever connection there is between our

daily tasks and the whole of public life, it is too indirect for us to feel it keenly and constantly."[94] Alongside this lack of integration, Durkheim also notes a concomitant lack of regulation, for while "the state...has itself excessively expanded", at the same time "society, weak and disturbed, lets too many persons escape too completely from its influence".[95] This combination of both a lack of integration and a lack of regulation means that the form of suicide most common to modern existence is that of the "egoistic" type.

How accurate is Durkheim's assessment of modern societies as those which fall prey to both a lack of integration and regulation? It is certainly true that the more static pre-capitalist economies tend to generate profound forms of social cohesion; economies where a tightly-knit progression is affected through a single social space – the movement from apprentice, to journeyman to master – which is characteristic of the feudal guild, for instance. Such a movement, which is actualised gradually and inexorably over many years, is naturally supplemented by an ethos and set of work practices which have had the chance to settle and ossify into tradition, thereby providing a more powerful impetus to "integration". At the same time one's sense of duty toward the guild master was "regulated" by a coherent moral code filtered through a rigid hierarchy from the top down. But in an economy whose life's blood is provided by the relentless and free-flowing movement of labour power, the possibility for such integration is constantly undermined by the dynamic of the process at the metabolic level. In a capitalist economy, traditions and moral codes less and less determine the relations between employers and employees, consumers and producers etc., for such relations are in a perpetual state of fluctuation which is largely – though often indirectly – determined by the forces of market competition more broadly. Generalised commodity production mediated through the anarchic flux of the market does corrode and break down forms of social cohesion often before they

even have the chance to set; Durkheim's characterisation of the modern economy as one which suffers from a deficit of both integration and regulation successfully identifies this.[96]

However, applying the logic of Durkheim's own concepts, there is an aspect to the modern (capitalist) economy which the author of *Suicide* failed to address. Although Durkheim is right to suggest that a modern economy suffers from a deficit of integration and regulation, one might add that the same economy can also suffer from an excess of regulation in the same moment. On the one hand capitalism tends to exhibit a far lower level of "integration" and "regulation" due to the fact that the individual is set against all others *qua* individual in and through the furore of market competition – but at the same time a level of "regulation" *is* required. Capitalism requires profound and systematic state regulation; an apparatus which is capable of tracking and regulating the movement and flow of free labour by way of its tax and legal status, and this involves regulation both in terms of physical/legal means but also in terms of an overriding moral ethos. Think about how effectively benefit claimants and the unemployed at the bottom of the chain are demonised as "scroungers" and "parasites". Regulation is also required – not only in order to better facilitate capital investment and capital reproduction through the extraction of value from labour power – but to make sure that individual capitals don't tear the system apart in and through the frenzy of competition, or denude the social system of its productive impetus by developing monopoly powers which stifle competition.

One might conclude, therefore, that according to the Durkheimien model, capitalism tends to exhibit a far lower level of "integration" – due to the fact that the individual is set against all others in and through market competition – while simultaneously a higher level of "regulation" is required by the state. The corollary, quite naturally, is that a socio-economic system of the feudal type is far more susceptible to both

moments – "integration" and "regulation"; its economic actors more receptive to the ethos of accumulated traditions such that codes of honour, for example, exert a heavier compulsion on a given individual.

If we then link these sociological insights with an explicitly historical theory – that of Leon Trotsky's theorisation of "uneven and combined development", it becomes possible to elucidate Japan's peculiarities in regard to the suicide theme.

Marx had previously written how "[t]he industrially more developed country shows the less developed only the image of its own future".[97] This was part and parcel of the way Marx was able – by drawing on extensive empirical and historical research – to crystallise the inner necessity of the development of capitalism as a logical unfolding posited along the lines of a given nation in the abstract. But Trotsky correctly pointed out that the same perspective is unsustainable when we refer not only to the logical development of a pure capitalism in the framework of a single country – but also to the empirical character of the world economy as a whole – particularly in light of the early twentieth century when capitalist globalisation had become a pervasive fact of life. The purely logical progression is inevitably subject to interruption, discord and reformation as individual countries oppose an uneven level of development in relation to others enmeshed in the totality; furthermore such specific and uneven instances of development tend to react upon and combine with one another generating radically unexpected formations and results. The great Russian revolutionary felt compelled to observe:

The theory of the repetition of historic cycles – Vico and his more recent followers – rests upon an observation of the orbits of old pre-capitalist cultures, and in part upon the first experiments of capitalist development...Capitalism means, however, an overcoming of those conditions. It

prepares and in a certain sense realises the universality and permanence of man's development. By this a repetition of the forms of development by different nations is ruled out. Although compelled to follow after the advanced countries, a backward country does not take things in the same order. The privilege of historic backwardness – and such a privilege exists – permits, or rather compels, the adoption of whatever is ready in advance of any specified date, skipping a whole series of intermediate stages. Savages throw away their bows and arrows for rifles all at once, without travelling the road which lay between those two weapons in the past. The European colonists in America did not begin history all over again from the beginning. The fact that Germany and the United States have now economically outstripped England was made possible by the very backwardness of their capitalist development.[98]

Japan's mature historical development provides stark confirmation of Trotsky's method. For Japan, in particular, indulged "the privilege of historic backwardness" in as much as in the latter part of the nineteenth century it experienced a revolution from above in order to secure capitalist property relations and development. The Meiji Restoration of 1868 yielded the creation of a modern nation state; it opened up national borders more fully to world trade, introduced a universal system of taxation, abolished local tariffs and so on. But at the same time the revolution itself was carried out by ancient feudal dynasties and to cap it off they reinstated the power of an emperor who was to be venerated as a god on earth. The anachronistic nature of Japan's bourgeois revolution can only be understood with regard to the country's more general backwardness in the context of the world economy as a whole. Elements within the feudal-land owning class became aware of the necessity to abolish the Shogunate partly as a result

of China's abject humiliation by Great Britain's industrial strength in the two Opium Wars; they understood, therefore, that an enforced top-down modernisation was required if they themselves were to survive as anything more than an auxiliary class tethered to European imperial interests. The nudging of US imperialism in the manner of Commodore Perry and his "gun-boat" diplomacy in the early fifties no doubt helped solidify such comprehension.

As a result of the Meiji Restoration the latest forms of capitalist innovation and technology were grafted onto an infrastructure via foreign investment, which in turn provided the impulse for an economic super-acceleration which saw Japan emerge as a major industrial and military power by the close of the century. Japan's very economic backwardness, therefore, provided the soil and "virgin" conditions in which contemporary capitalist forms could more effectively and rapidly take root.[99] For this, the Russian Marxist O.V Pletner observed that the Meiji Restoration should be understood as bourgeois in terms of its consequences rather than the class specifics of its central protagonists: "It may be called 'bourgeois' only from the viewpoint of its results, which does not mean at all that the bourgeoisie played the most important role at that time."[100] Pletner draws attention to the fact that the class of feudal landlords which had overthrown the Shogunate started the rapid development of capitalism on the new economic basis but they were, nevertheless, feudal lords. The Meiji Restoration , subject to the tendency of uneven and combined development, was an event which facilitated bourgeois property relations in and through the political ascendency of an ancient feudal class; it provides, in this respect at least, a counterpoint to the "classic" bourgeois revolutions of the French and English variety – for such revolutions were premised on the shattering of the feudal aristocracy along with the concomitant destruction of post-feudal absolutism.

All of which means that the character of Japanese capitalism

assumed a very particular and peculiar form. Although it helped extirpate feudal property relations and thus fundamentally transform the character of production along capitalist lines, the feudal class was left intact in a way its European predecessors hadn't been, and consequently its political culture remained more coherent and self-assured. Although many of its older cultural practices were dismantled for the modern context – for instance the right of Samurai to wear swords – nevertheless there was an intimate and unbroken cultural thread which ran between the old feudal guilds (Za) and the development of capitalist corporations – precisely because the lack of a developed bourgeoisie meant that the feudal class in combination with the state had to provide the drive toward industrialisation and generate the ideological practices which mediated it. The founder of Mitsubishi, for example, was of Samurai origin and began his career in the fief of Tosa. When the Meiji Restoration resulted in the dissolutions of such feudal domains and clan rule (1873), Iwasaki Yatarō was able to transfer materials from the Tosa clan's ship-building operations and funnel them into his own independent commercial company which would later be dubbed "Mitsubishi", and whose rapid expansion into other commercial arenas reflected keenly the capitalist ethos of the new epoch.

So whereas the aforementioned European revolutions presupposed a clearer demarcation and separation of old world forms and the new, Japanese historical development seemed to imply their fusion. Such a fusion of the archaic and modern inevitably left an imprint on the forms of labour practice,[101] the trace elements of which can be discerned right up to the present day. In Japan the remnants of a guild mentality in which extra-economic ties and loyalty to your patrons (bosses) have been fostered in a way which was largely absent from the more atomised and impersonal consumer economies of the Western world. The social life of the employees, for instance, is to a

greater extent orientated around the company itself; company outings, sports events and rituals like the singing of company songs were designed to allow the bonds between employees and employers to cohere in and through "shafu" or "company spirit". Equally coextensive with more traditional forms of labour practice was the notion of the "job for life" whereby Japanese companies tended to recruit at a specific time each year, and employees would start low down in the chain of a given company before spending their career working their way up – in contradistinction to the generic capitalist model; one in which companies hire all year round, where labour's flexibility and flux remained its defining characteristics, and where one might expect to hold several or many positions in the course of a lifetime. In addition, Japanese workers are encouraged to pursue romantic relationships with colleagues, with companies offering financial incentives to those who get married and those who have children – all, one assumes, to forge a collective and cohesive attitude around labour practices.

Thus one can utilise the Trotskyist theory of uneven and combined development to demonstrate the historical necessity by which Japan became one of the most advanced industrial capitalist economies while still containing within itself a certain quasi-feudal hang-over which was crystallised in and through its forms of labour practice. If we now use such a framework as the basis with which to apply the Durkheimien sociological categories of "integration" and "regulation", we are able to go some way to solving the enigma of Japan's high suicide rates. The historic peculiarity of Japanese capitalism means that its citizens are not only subject to the excessive regulation and lack of integration which is part and parcel of the generic capitalist model – i.e. the laws, morals and bureaucratic forms which regulate and constrain individual economic actors alongside the anomie which is provoked by market instability and isolation. In addition to these, in the Japanese example, we

can also locate a moment of excessive integration generated by notions of "shafu" – which themselves provide the ghostly echo of the feudal past from within the capitalist present. A Japanese businessman is more likely to commit suicide due to the taxes and economic obligations which crush the efficacy of many businesses and also the anarchic, destructive instability of market competition and its consequences; but in addition to all this, in the event of bankruptcy, he is more likely to feel the potent sense of failure which comes from the inward awareness of "shafu" – of "company spirit" – and the feeling that he has in some way betrayed it.

Something similar might be said of the workforce more broadly. *The Economist* records how in 2007 the Japanese workforce, along with US workers, clocked up more hours than any other First World country. But this was deceptive because the comparison of the Japanese figure – 1780 hours, with the American figure – 1800 hours, didn't allow for the massive level of unpaid overtime Japanese workers supply. The same article notes that other studies show "one in three men aged 30 to 40 works over 60 hours a week. Half say they get no overtime. Factory workers arrive early and stay late, without pay. Training at weekends may be uncompensated."[102] And again Durkheimien sociology provides the key theoretical tools with which to comprehend the anomaly of the high levels of unpaid overtime the Japanese workforce "voluntarily" commits to. On the one hand, these higher levels express "regulation". In periods of economic decline, and periods of economic crisis in particular, competition between workers reaches a fever pitch – or to put it in the nonsense refrain of the business jargon – people are more likely "to give 110 per cent" in order to save their jobs and to avoid the social stigma of unemployment. At the same time the particularity of Japanese historical development means that those same workers are also subject to excessive integration; i.e. a higher proportion of them will expend a

greater degree of uncompensated labour power – because of a sense of identification with – if not the employer directly – than the group ethos which the parent company has so meticulously cultivated.

In practice this has led to a large number of deaths which result from the exhaustion and deprivation of long working hours; indeed the Japanese have coined a specific word to describe it – "Karoshi" – which literally translates as "death from overwork". The concept itself seems to have gained real purchase in Japanese cultural life, from the spate of law-suits which have been opened up by the bereaved families of those extinguished prematurely by crushing work schedules, to the more macabre event of "Karoshi" computer gaming – where the goal is to work your on-screen digital avatar toward a fantasy expiration. The phenomenon of "Karoshi" is intimately related to that of suicide. Government figures suggest that out of 2207 work-related suicides in 2007, the underlying motivation for 672 of them was overwork,[103] while an article for RTT news suggests that in 2008 health problems including work-related depression accounted for 47 per cent of suicides in Japan.[104]

It is, of course, possible to exaggerate the presence of "integration" vis-à-vis Japanese capitalism. Some recent studies suggest that notions of any type of "collective" mentality have been repeatedly over-emphasised. The Economist, for instance, suggests that – even at Japan's economic peaks – any expectation of a "job for life" was far from certain, and in reality, such job security typically lasted for a little over 30 years and was only ever enjoyed by about a third of the population. In the last analysis, Japanese companies are beholden to the rhythm of boom and slump as much as their international counterparts, and the depth of economic crisis which Japan endured in the early 90s and again recently, more and more throws into relief the limitations of "shafu". For although "shafu" has provided an important ideological bulwark in shoring up Japanese

labour relations and has experienced periodic revivals, it has been progressively eroded by the crises which, in turn, have seen a rise in part-time contracts[105] that have meant workers are subject to a far lesser degree of job security than once was, and are increasingly subject to unemployment and mass lay-offs.

Naturally it is the young who have borne the brunt of these changes. As a result there appears to be something of a generational split; with younger people better inured against notions of "shafu" and more likely to regard the work ethic of their parents as a shambolic delusion which feeds into the predatory practices of labour exploitation. And such a shift inevitably impacts on the forms of suicidal behaviour. If older generations were to a greater degree enthralled to notions of "shafu" which provide an excess of "integration", the younger one is increasingly characterised by its absence. Anthropologist Chikako Ozawa-de Silva, writing about internet suicide pacts in Japan (where people arrange online to meet up and commit suicide together in a group), argues that these new forms of suicidal behaviour should be understood in terms of the Japanese concept – "ikigai" – which roughly translates as "purpose".[106] With the destabilisation of the economy, and the loss of the ideological networks which had more profoundly integrated previous generations with their labour practices, younger people more and more experience the loss of "purpose" which is the product of an increasingly uncertain future.

The more modern modes of suicide are, therefore, an expression of profound alienation. If anything, the act of killing oneself in a group allows the alienated individual to experience a single, ultimate act of "purpose" through a level of social integration which the uncertainty and fragmentation of modern existence has denied them. Again, it seems that Durkheim had it right – if the excess of "integration" through "shafu" provides an impetus toward suicide, its lack can also provide a singular

drive toward self-immolation, and among the new generation in Japan today, it is the depth and intensity of isolation, of alienation, which more and more causes them to heed the Suicide Forest's siren calls.

Chapter Four

The Genesis of Islam: The Universal Rises in the Desert

The Hajj is the pilgrimage to Mecca many Muslims undertake and it happens at the end of the Luna year. If you are physically and financially capable of carrying out the journey, if your family can be supported in the interim – it is the duty of every adult Muslim to undertake this journey at least once in a lifetime. Consequently, in the 4 to 5 days during which the pilgrimage takes place, people from all over the world, of all ages, ethnicities and nationalities flow into the holy city to arrive at the Great Mosque – the Al–Masjid Al-Harām – a vast white edifice with several cornerstones and barbicans upon which a series of minarets flow upward toward the sky. When it gets dark, the lights from the walls and the towers bathe the building in a pallid silvery glow. Past its perimeters can be seen the modern buildings and skyscrapers of Mecca's business district pressed tightly together, and beyond this the outline of mountains – vast, indistinct shadows which seem to climb higher in the night.

The Great Mosque is open-topped, so one can see the hundreds and thousands, perhaps millions, of men and women as they flow through its various gateways and toward its centre. At the centre is the Ka'ba – a large stone cube which is draped in black silk. Some Arabic verses from the Quran have been embroidered into the material in gold thread, and the contrast between the gold and the more predominant black is a simple but powerful one. The stone cube is a singular presence, it is both beautiful and mysterious; its simple shape and its darkness denote something which is both timeless and opaque. The men and women from every walk of life are dressed in the same plain white fabric, so that they seem to merge as one, in a single

movement, flowing round the cube like a constellation of stars swirling around the dark regions of space. The pilgrims are required to circumambulate the Ka'ba seven times. As they do so, from loudspeakers are recited prayers in Arabic, and though these are not supposed to be musical they nevertheless resonate, melodic and mournful, in the still night-time air. There is something timeless about the ritual which strikes even the non-believer.

In a way the Ka'ba has always performed this function. The Ka'ba is older than Islam of course, though nobody knows exactly how old. The Quran suggests that it was built by Abraham and Isaac, while more secular sources such as Ptolemy cite a place in Arabia called Macoraba which grew up around an important religious sanctuary in about the third century BC. Some scholars regard this as a reference to the Ka'ba in what was early Mecca. The Ka'ba, as we encounter it now, is not the original – the shrine itself has been destroyed several times over and replaced by new stone, new cloth; in the time of Muhammad its idols were cleared out and destroyed – yet the question of authenticity goes beyond the age or type of material which embodies the physical structure of the monument. Instead the Ka'ba maintains a symbolic integrity, no matter how much its physical form is adjusted; in its robust simplicity, in its opaque darkness, it provides an archetype of eternity; an unchanging essence – both enigmatic and abiding – which human beings are drawn toward almost hypnotically, and which they choose to term God.

Or gods, as the case may be, because we do know that in its early days, the Ka'ba housed many hundreds of idols representing a cross spectrum of religious affinities throughout the region, and much in the way the pilgrims circle the Ka'ba in their processions – such religious identities and peoples were scattered around the outlying regions and desert plains which surrounded Mecca itself. There were deities like the moon god

Hubal, a Syrian divinity, who was worshipped by the powerful and sedentary tribe of the Quraysh who came to predominate in Mecca itself, or the god Abgal who arose in the Palmyrian desert regions to the north and was worshipped by the Bedouin as a god of camel drivers, alongside the jinns which inhabited the desolate shadowlands of the desert at night and which threatened the nomadic traders with their malevolent mischief. Panning out more broadly, there were the powerful empires which promoted various monotheisms, from the Orthodox Christianity which was projected out from the vast but decaying Byzantine Empire, to the Nestorian Christianity which held sway in parts of Persia, to the Zoroastrianism which had a presence from Iraq to the Persian Gulf, to the "Babylonian Rabbis" who had set up academies in areas of Iraq. These influences were streamed back into Arabia, so that by the time of the sixth century you had Arabianised Jews living in the settlement (Yathrib) which would later become Medina; there were the Christianised Arabs such as the Kahlani Qahtani tribes of Yemen alongside the communities of Chaldeans, Arameans and Armenians who had chosen to settle in the Middle East – all these elements mixed and comingled with the various pagan traditions which had shaped the region from time immemorial.

In a rather iconoclastic study Patricia Crone makes the provocative argument that Mecca in this early period was not a thriving trade metropolis – in the way in which scholars like Montgomery Watt have traditionally presented it – but was in fact something of a backwater, which is why, in the time before Islam, the existence of Mecca is noted only by local Arabic sources alone. There is no reference to it in the broader literature, "be it in the Greek, Latin, Syrian, Aramaic, Coptic, or other",[107] and Crone is able to conclude that Mecca was probably a far smaller entity which traded in only a couple of staple products. The issue here perhaps seems like a minor one, but it is vitally important. Crone uses such conclusions to pierce the idea that

the ideological and political contours of Islam were shaped as a result of the way in which the forms and structures of tribal societies were being rewritten in accordance with the demands of a more modern mercantilist economy; where more traditional distinctions of clan and honour were gradually being phased out before a market universalism.

But Reza Aslan, in an adroit and penetrating study, goes right to the heart of Crone's methodological weakness. Yes, he argues, it is fair to say that Mecca was not on the most significant trade route in pre-Islamic Arabia, for that route lay in the Hijaz to the east of the city, and other cities like Ta'if would have provided a more natural stopping point for merchants. But, argues Aslan, in reducing the question to an abstract economic one, Crone naturally overlooks the presence and the sheer gravitational pull of the Ka'ba itself. "The Ka'ba", he says, "was unique in that it claimed to be a universal shrine. Every god in pre-Islamic Arabia was said to reside in this single sanctuary, which meant regardless of their tribal beliefs, all peoples of the Arabian Peninsula felt a deep spiritual obligation not only to the Ka'ba, but also to the city that housed it and the tribe that preserved it."[108]

And what of that tribe? The Quraysh's power in Mecca dated back to the late fourth century AD, when an Arab named Qusayy was able to unite several feuding clans under his own rule, merging them in the single tribe. In the same moment he gained dominion over the Ka'ba itself, he gained access to the keys to the temple. Though he allowed the former religious rituals to continue untampered with, nevertheless Qusayy was the one to provide the pilgrims with their material needs – with food and water and religious banners – and he would preside over the various religious ceremonies in the manner of a king overseeing court. In fact, he rather audaciously gave himself the title of "King of Mecca", which was probably not too much of an exaggeration, for he who controlled the Ka'ba increasingly

came to control the city. In keeping with this, Qusayy was able to divide the city into sections; an outer and inner settlement which orbited the Ka'ba. The closer to the Ka'ba you were, the more salubrious your dwellings and the more social status you had.

Naturally Qusayy's own tribe, the Quraysh, came to monopolise the centre, and Aslan estimates it is likely Qusayy's own house was attached to the Ka'ba itself. Thus all the ceremonies and offerings were mediated by him, and in this way was he able to develop both a political-economic and religious authority over the denizens of the city, and the outsiders who were drawn to it. Under Qusayy, a more concerted attempt was made to collect idols from further afield, from the tribes who resided on the hills of Safah and Marwah, and to relocate them in Mecca. Henceforth if one wished to show one's religious appreciation of a local god, it was increasingly likely one would have to show some economic appreciation toward the Quraysh, and Qusayy in particular, who acted as the gatekeepers to the religious experience. Qusayy was able to charge tolls, and also sell goods and services to the often famished pilgrims, and these he would provide for by taxing the permanent residents of Mecca and keeping the profits for himself or divvying them up among the rest of his tribe.

The importance of what must have been, at the time, a radically innovative economic model cannot be overstated. Firstly the city itself was shrouded in a sacred aura. Because it became such a bastion of divinity, laws were introduced which banned weapons on the grounds that they were profane – but such a prohibition also had the more practical, secular effect of creating a space which was conducive to trade, for it was now that much more difficult to rob someone's produce. For this reason religious pilgrims would also be more inclined to take advantage of the city's markets in order to trade safely; and thus trade itself entered into a particularly symbiotic relationship with religion. The great religious pilgrimages gradually melded

into the great commercial fairs, and the Quraysh, as the religious guardians of the city, were also able to harvest taxes for their role in mediating and organising trade. But while this new form of social organisation had an effect in redefining the role of Mecca in the region, it also began to reshape the role of the Quraysh themselves. Hitherto they had been bound firmly to their rural origins and a more undifferentiated form of social organisation which – in the words of Karen Armstrong in her wonderful potted history of the subject – produced an "old tribal ethic [which] had been egalitarian".[109] This shouldn't allow the often quite brutal and rapacious nature of the old Arabian tribal world to go overlooked, however. It was very much a world of the blood feud, of the vendetta, a world in which the principle of "an eye for an eye" was inscribed in the most violent forms of social practice. Raids were regularly conducted, looting the booty of other tribes became a brutal form of wealth redistribution which often prevented any one group from becoming a monolithic power. Such raids were considered not so much criminal enterprises but cultural practices, deeply rooted, and sanctified by tradition. Within the blocs of warring nomadic desert tribes an egalitarian ethos surely did pervade, for as Aslan writes, "the only way to survive in a community in which movement was the norm and material accumulation impractical was to maintain a strong sense of tribal solidarity by evenly sharing all available resources".[110] For all of this, the nomads had traditionally been contemptuous of kings, been reluctant to concentrate absolute power in one individual, preferring councils of elders who would elect various tribal heads. The rise of the Quraysh, however, helped create a monopoly on trade and taxation, concentrate wealth in the hands of just a few elite families, and led to the development of a religious hegemony in and through their control of the Ka'ba and the religious idols it housed. Such changes broke down many of the ideals of tribal egalitarianism and an increasing number of impoverished and dispossessed

began to swell the outer regions of the city; their desperation causing them to borrow money from a swelling caste of parasitic loan sharks, and – unable to pay back the exorbitant interest – the debtor would often find themselves cast into slavery.

For all of this, when Muhammad first began to hear and feel the terrible power of the invisible presence which presented itself to him in 610 in a cave on Mount Hira; when he reluctantly felt himself, his body and mind, to be a receptacle of the divine impulse – the messages which came from God spoke very much to the social and historical role of the gatekeepers of Mecca, the Quraysh themselves. Muhammad was, of course, a member of the Quraysh tribe, and yet he had also been orphaned at a young age, so his situation was from the outset precarious both socially and economically. It was only his rescue by a benevolent uncle (Abu Talib) which allowed Muhammad to escape the fate of so many other of Mecca's orphans – that of destitution or slavery. But while Muhammad's uncle was a gifted theologian and respected tribal elder, the sub-section, the clan which Abu Talib was a member of – made up a much smaller entity within the indomitable Quraysh called the Banu Hashim, a clan which had little wealth or numbers. His uncle was the *Shaykh*, or religious leader, of the clan. It was a clan which had garnered a great deal of spiritual authority and was mired in rich religious traditions. So in his early years, Muhammad – by virtue of his origins and social position – was abstracted from the true seat of power, was an outsider to the political elite in Mecca, but was simultaneously situated in a venerable tribal lineage which was still alive to the religious values of the past.

For this reason, it was inevitable that, when God began to speak to Muhammad on the mountain, *His* words would revive key elements of the tribal egalitarianism of a rapidly vanishing world, and that these impulses, feelings and intuitions – which were part of Muhammad's own social-historical make-up – would eventually bring him into conflict with the power brokers

who dominated the religious and economic crucible of the city itself – the Quraysh elite. Some of the early verses which inform the Quran deal very explicitly with the contradiction between the tribal world of old and the glittering monolith of privilege and wealth the elite families of the Quraysh had formed in the commercial and political heart of the city. "Do not oppress the orphan", the Quran exhorts and in the same vein, "do not drive away the beggar" (93: 9-10). For those who have accumulated great swathes of wealth it has the most damming words of all: "Woe to every slanderer and backbiter, Who amasses wealth hording it to himself. Does he really think his wealth will make him immortal? By no means. He will be cast into...the fire kindled by God." (104: 1-6) These were no simple abstract moral judgements wafted across an unblemished realm of holy purity. These were political bombshells, containing an explosive depth charge, designed to undermine and shatter some of the most fundamental social categories of power and exploitation. At a time when slavery and debt bondage were rife, Muhammad was preaching about a day of judgement when those who do not "free the slave" (90: 13-20) are to be consumed in a heavenly, purifying blaze.

At the same time, while the new religion contained in itself the longing to revive more egalitarian principles, rooted in the free-flowing lives of tribal nomads, nevertheless early Islam broke with the religious form tribal society engendered in the most profound way. Typically speaking, the populations centred in and around Arabia had cultivated a massive, colourful proliferation of gods, deities and spirits to match the rainbow spectrum of a vast multitude of tribes – each one with its own particular mode of life, its own sacred geography and its own historical traditions. The uniqueness of the particular combination of supernatural entities to whom a tribe made obeisance was a complex cultural marker – a badge of unique creative identity woven into the social practices and idiosyncrasies of the life of

that particular tribe; polytheism was at the same time a religious, practical and cultural staple of life in pre-Islamic Arabia. And not, therefore, something easy to relinquish, for it meant the ripping away of your own identity at the most profound level. Even those groups which had taken on a monotheistic inflection were still at heart polytheistic. A creator god – Al-ilah – had for some centuries begun to take shape out of the primordial soup of animisms and object deities; Al-ilah – or "The God" – was originally a storm or sky god who increasingly began to lose the semblance of specificity, to shed the connection to a particular and naturally given object, and to be elevated above the other gods to a more transcendental and abstract realm thereby. Al-ilah was a powerful entity for sure, the most powerful of all in fact, but in its abstractness it was not something the members of the tribe felt they could supplicate easily – for it was no longer master and commander of any specific region of the natural world; perhaps more profoundly, its implacable omniscience already contained in its aspect something alien, an infinitude which was immune and indifferent to the transitory and fleeting physical needs of the finite human life. And so while the presence of Al-ilah increasingly began to spread across the desert sky like the darkness of night, nevertheless in the foreground the twinkling array of gods, sprites, spirits and other supernatural intermediaries were very much the go-to figures when tribal peoples wanted to shape the form of their destinies in the searing heat of the sweeping sands. It seems that even those groups who had adopted a notion of god from the Abrahamic religions of Judaism and Christianity – religions which expressly forbade the worship of other gods – nevertheless such groups like the Kahlani Qahtani tribes were elastic in their religious vision, and simply absorbed the monotheistic God into a polytheistic harmony.

This is important for two reasons. Firstly it shows us that Muhammad's "turn" to monotheism did not come out of a clear

blue sky; the monotheistic religions of Judaism and Christianity had been co-existing with pagan beliefs in the region for centuries, and "indigenous" belief itself had reached the point where a single, more transcendental god was beginning to issue out of the polytheist morass. But the significance of Muhammad's achievement lies in the sheer difficulty of the task; he was able to raise a monotheistic vision which drove the other gods from the temple – the Prophet himself would personally rid the Ka'ba of all competing idols. How and why was he able to do this especially given the intimate and binding power the region's polytheisms asserted on its subjects? Part of the answer lies in the aforementioned power of his radically egalitarian programme, a challenge to the increasing divide between wealth and poverty which had opened up in the region, especially in Mecca. Among other things Muhammad introduced divorce rights for women, allowed them to inherit property and he raised a prohibition on usury; but these radical proscriptions – although they had their roots in tribal egalitarianism – were not addressed to any particular tribe. Muhammad was not, for instance, trying to simply reform the Quraysh so that he could stand at their head. Rather the proclamations were directed toward the slave who had been abstracted from his tribe by the brutal processes of debt accumulation and bondage, the marketer who found themselves on the cusp of destitution as a result of heavy city taxes, the women in villages and small towns who had found themselves the property and playthings of their husbands, the small time merchants whose rickety, ancient caravans carried their wares and their lives, providing a fragile carapace against raiders and bandits – a last thin perimeter against the whispering promise of destitution and death carried by the excoriating desert winds.

For this reason Muhammad's "new" religion had to transcend tribal particularism – and therefore overcome the form that carried it, i.e. polytheism. The old tribal world was being gradually eroded by commercial centres like Mecca, by

the perpetual and ongoing wars of tribe against tribe, by the increase in the breadth and intensity of trade throughout the region – and out of these processes was being created a buttress of people who had once been bound by the security of localised tribal identity and belonging – but were now fashioned into a larger, more amorphous mass; the key to their true identity was no longer guaranteed by tribal bloodlines but rather by the fact that they had been flung into the ranks of the marginalised and impoverished. A vast group of steadily swelling people, from every corner of life – from sedentary societies to nomadic ones, from slaves to freemen, from men to women, adults to children – all bound to one another by the fact of their exclusion. A different kind of tribe then; a universal tribe of the dispossessed. Such a group required a more universal ideology, because its own universalist dimensions had been sculpted at the level of socio-historic being.

For this reason, Muhammad's great genius lies in the fact that he was able to fuse the egalitarian elements of an older tribalism with an all-encompassing monotheism, thus creating a radical and practical social programme which mobilised vast numbers of the dispossessed and the poor in accordance with the character of their own "universal" formation at the level of social being. In this sense Muhammad was the quintessential revolutionary leader; that is to say he sensed and felt on an organic basis the genesis and growth of a new social power, and was able to develop an ideology which in some way mediated it. In this respect the Prophet's ability was as much aesthetic as it was political, for the ideology he created was a semi-conscious and profoundly intuitive response to the unfolding trajectory of a new social layer which had been formed out of the fragments of the shattered tribal world. The great revolutionary becomes the nodal point by which a more progressive historical development is expressed and condensed into a more conscious ideological form which people can lay their hands upon, and change the world

thereby. Because his programme was implicitly universalist, because Muhammad wasn't able to appeal to any specific tribal deity and its history in order to justify his religious claims, Islam emerged bound to a different type of dynamic. Toward the other great monotheisms in particular he showed great benevolence and respect, demanding that their beliefs be respected and that they be treated as *ahl-al-kitab* – or *people of the Book*. But this was more than mere equanimity toward other faiths. Muhammad would argue that the God which had presented itself to him in the cave was in fact the same God who had revealed himself to Abraham and Moses in the Judaic tradition, and was the same God whom Jesus[111] communed with in the descriptions provided by the Gospels. In fact, in the early days, the first followers of Islam prayed not toward Mecca, but toward Jerusalem. Had he encountered the Hindu concept of *Brahma* or the Buddhist concept of *Nirvana* – the infinite, ineffable and ultimate power which underlies all reality – Muhammad might well have recognised in these things a different religious interpretation of what he himself came to refer to as *Allah*. In the Quran, Ishmael, the son of Abraham and his servant Hagar, is considered to be the true heir (as opposed to Isaac) and in the Islamic tradition Ishmael makes a journey to Mecca, along with his father, there to found the Ka'ba. The myth should not be scrutinised literally as to whether this specific journey was undertaken at this time by these figures – for, of course, it wasn't. But it has more of an allegorical and philosophical power; for by providing the knot which connects Islam to the other Abrahamic religions, the story elaborates a religious vision in which some infinite power is immanent in the world, and that various civilisations and societies across the ages have encountered that power through the prism of their own cultural milieus; that great religions – from past to present – are the imprints divinity leaves in its wake as it marches across the world. There is a real historical flavour to this, the idea that history is nothing other than the

progressive unfolding of an absolute power, and it must have been particularly alluring to the desert folk who had always subsisted on the shadowy hinterlands between the great empires of Persia and Byzantium, who had hitherto felt themselves as a small and fragmented presence buffeted and blown by greater forces like dust scattered by a hot desert wind. The people of the Arabian Peninsula had mingled with the Christians and the Jews freely, and even converted to their religions, just as easily as some Christians and Jews integrated pagan practices into their own theological programmes; nevertheless, there were Arabs who felt a sense of inferiority, for the God of the monotheists had never sought to reveal itself to them – they had none of their own prophets in such a tradition to stand alongside figures like Joseph or Moses. With the revelations of Muhammad, however, many of these same people felt themselves – in religious terms – to be part of a group whose time had finally come, and surely this provided a great sense of pride and impetus to the already dynamic mobilisations Muhammad was beginning to command.

Generally speaking, the argument about the origins of Islam has fissured into two increasingly pronounced antipodes: there are those, following Montgomery Watt, who argue that the rise of trade and a more universal and encompassing moneyed economy disrupted and dissolved the tribal forms of yore, and that Islam evolved in the ideological arena as a theological expression of this. And there are those who, *a la Patricia Crone*, argue that trade was not a significant factor in the evolution of Islam at all – rather Islam was still fully rooted in the social forms of tribal life, but what made it unique was that it provided the carapace, the ideological cover, for a form of tribal imperialism – the point at which one tribe was able to take power and submit all the others to itself. The reality, however, is fully dialectical; both these positions hold powerful truths, for such a duality was one which had been grafted onto the political persona of the Prophet himself. Muhammad himself was raised by a tribal

leader, Abu Talib, and was therefore deeply immersed in tribal life, was pious and sincere, and was known to be an upright, serious and moral young man. At the same time he made his living through trade, he was a skilful merchant who, in the words of Aslan, knew how "to strike a lucrative deal".[112] But what did striking "a lucrative deal" in this context presuppose? It meant that Muhammad's life was attached to the life of the "caravan" – the long procession of merchants who would carry their wares in makeshift vehicles across the desert expanses, passing through towns and villages, bartering with other nomads along the way, setting up camps under the stars. It meant that Muhammad himself was brought into the orbit of vast conglomerations of different peoples, not only the tribes and towns within the Arabian Peninsula, with all their different cultural tones and social forms, but also his commercial travels carried him as far north as Syria. Muhammad would have been required to understand and navigate the belief systems of a vast myriad of different peoples, polytheism, paganism, Hanifism, Manicheanism, animism – in and through the processes of barter and exchange. Indeed, although Muhammad was orphaned, and scraped out a rather meagre existence during the early part of his career, nevertheless his success as a merchant – known both for his honesty and forthrightness, and his ability to seal the deal – eventually resulted in the kind of financial boost which would see him – if not propelled into the ranks of the Quraysh elite – nevertheless financially well off such that he was even able to procure his own slave. He married the older and savvy business woman Khadija who was someone the Prophet cherished and would take advice from until the day she died. His marriage to her also helped acquaint Muhammad intimately with the political mechanisms and motivations of the Meccan elite. Even though his own wealth had grown, even though he was now in a position where he had taken another for a slave – Muhammad remained, by virtue of his own past as an orphan and an impoverished clan

member, radically welded to forms of egalitarianism and social justice which came out of the tribal collective consciousness. In other words Muhammad himself was a living antinomy; he contained within himself the universalising element of a society which was increasingly structured according to the prerogatives of supply and demand, where people were more and more brought together by anonymous market forces rather than the intimate and idiosyncratic bonds of familial bloodlines – but at the same time he carried the spirit and ethos of the tribal life which was more and more passing from the scene.[113] When Muhammad became successful as a merchant, when he was able to procure his own slave, when he began to enjoy the perks and privileges of a commercial elite which had been converted into a sedentary and increasingly rapacious vehicle for exploitation, Muhammad's present was brought into violent contradiction with his past and the older, more venerable world he had stepped out of. Such a contradiction was aggravated to the point at which it presented as an acute spiritual and psychological crisis – and this crisis reached its apex, burst asunder, when Muhammad entered the cave and felt the full force of God's presence. One needs only reference the descriptions Muhammad provided of the epiphany to understand that this was no mere saccharine and gentle religious revelation, but rather a tempestuous and world-shattering spiritual event –a violent psychic convulsion – which was as much violation as it was elevation. Reflecting on the experiences he had as the Quran was revealed to him, Muhammad commented: "Never once did I receive a revelation without feeling that my soul was being torn away from me."[114] The revelations which unfolded over the next 22 years following 610, and which form the body of the Quran, can, in some sense, be regarded as the attempt to resolve the contradiction which had been grafted onto the Prophet himself between the parochial tribal upbringing he had known and the vast universalism of an emergent world; the Quran was the attempt to cohere and

coalesce a universal community by mobilising the social and political values of tribal particularism – in and through a radical and beautiful religious synthesis which arose from the unconscious recesses of the Prophet's conflicted psyche.

Once God had begun to speak to Muhammad, the contradiction was in some way alleviated; Muhammad would set his slave free, and he would begin to preach his radically egalitarian vision systematically in Mecca. In his religious prospectus there was "no God but God". Allah, as Muhammad described him, was clearly a contraction of the high god of the ancients – Al-ilah. The God of the Prophet was fully transcendental and impersonal, but unlike Al-ilah it was a god which was possessed of a mysterious benevolence "the most merciful" (55:1), "the most generous" (96:3). And yet, you couldn't appeal to Allah through the typical tribal routes; one did not perform animal sacrifices in acts of propitiation or appeal. One found favour with Allah, not so much through one's individual acts of worship which were related to the social needs and physical requirements of one's existence as a herdsman or farmer – instead one pleased God most profoundly in and through one's role as a communal being, upholding values of justice, charity and egalitarianism – no longer at the level of the single tribe – but at the level of the broader *ummah* or community. The Day of Judgement exists for precisely this purpose; it is the divine reckoning by which someone's fidelity to the *ummah*, its community ideal, its principles of justice, are to be measured. One might argue that the creation of Islam marked a shift – to some degree – whereby the religious principle ceased to be refracted outward toward the natural world and the pantheon of gods which inhabited its objects, and was instead turned inward, directed toward the single object – the social object – the community, and its principles of organisation which were rendered sacred thereby. Islam inevitably assumed a monotheistic form, then, in order that it could allow communal values with a tribal origin to attain an

explicitly religious character; something which would provide the ideological mandate to raise and fortify a community of believers in and through a social model which transcended tribal lines.

So a political project of social restructuring which grew out of the shattered remnants of the tribal world, the dispossessed and impoverished masses, naturally grew into a religious vision of a monotheism which helped usher into being a universal community of believers united by a sense of radical egalitarianism. The social contradiction between entrenched wealth and the displaced and impoverished masses had reached its most concentrated expression in the city of Mecca itself. So it was this city which would become the crucible of the religious and political struggle Muhammad was trying to facilitate; here was the seat of Quraysh power. Again the religious and the political were profoundly intertwined; it was not simply that Muhammad was to target Mecca, but more specifically, he wished to target the Ka'ba itself. The Quraysh were able to maintain power at the pleasure of the Ka'ba, for their control of its religious idols allowed them to become the religious and economic intermediaries between the various tribes, peoples and their gods. Muhammad's monotheism – which explicitly demanded the destruction of the idols because of their polytheistic nature – grew out of more than simple religious acrimony. In destroying the idols, he was also endeavouring to destroy the political power of the Quraysh, and to show, in a more radically egalitarian fashion, that the true believer needs not a class of intermediaries which stand before himself and God, but is able to access the divine directly, in and through the set of pious and righteous actions he performs in his life as a communal being – the things he does in order to sustain a healthy and just community.

By 616, Muhammad's preaching in Mecca had earned him followers, some 70 families had converted to the new religion.

Mecca, however, had always been a hotbed of itinerant preachers from exotic and far flung horizons, declaiming their new and strange religious wares in the market squares under the beating heat, while the power-that-be tended to regard such fly-by-night characters as exotic oddities or amusing charlatans. But Muhammad's message arrived with a particular sting in its tale and, as Armstrong points out, it was not just the monotheism and the idea of breaking with the religion of the ancestors which the elite found particularly galling. After all, such things had been preached before. Rather the Meccan elite "were particularly incensed by the Quran's description of the Last Judgement... they were especially concerned that in the Quran this Judaeo-Christian belief struck at the heart of their cut-throat capitalism. On the Last Day, Arabs were warned that the wealth and power of their tribe would not help them; each individual would be tried on his or her own merits: why had they not taken care of the poor? Why had they accumulated fortunes instead of sharing money?" And if the Prophet received his instructions beamed into his head directly from God, why on earth would such a man accept the guidance – or submit to the ideological hegemony of – the Quraysh elite? The situation soon became polarised. Although there was a prohibition on violence in the heart of Mecca, nevertheless the Quraysh had other ways of repressing the burgeoning politico-religious movement. In the tradition of power-elites both before and since, they imposed an economic embargo on the Muslims, forbidding members of the Quraysh from trading with them, and also prohibiting intermarriage – thereby stifling the ability of Muslim families to forge new alliances and gain new resources. Naturally the new religion's message resonated with slaves, but those slaves who converted to Islam were often tortured – strapped to ropes and left to burn under the full glare of the afternoon sun. In addition, Muhammad's patron Abu Talib died, and thus the safety net which was provided by the allegiance and protection of the

Banu Hashim at once evaporated. It was one of those moments when history really seemed to be perched on a knife edge, where everything was stacked against a small band of progressives; a black ravening maw had opened up, threatening to swallow their meagre forces, consigning them to oblivion thereafter.

There was, however, one glimmer of salvation. Some 250 miles north of Mecca there was a region in which several tribes had settled, giving up the lives of nomads, and trying to forge a sedentary existence based on farming. Much of the land was rich and fertile, scattered with palm orchards and oases, yielding the product which was most prized and key to the wealth of the early settlers – dates. The populace of the settlement – which was called *Yathrib* – was organised along tribal lines in the conventional manner, in clans, but what was perhaps a little more unique is that the early Arab settlers had converted to Judaism, while the later Bedouin arrivals had maintained their pagan allegiances. Just like the ideology of Islam itself, the region was marked out by the presence of elements of tribal particularism against a backdrop of broader monotheism. Significantly, the clans themselves had been pulled into a tribal war perhaps because the region's resources were increasingly over farmed and competition for land had become more intense. At any rate, these people had begun to hear of Muhammad's reputation as something more than a stellar preacher, as a harbinger of a new spiritual and political awakening and so, desperate to end the conflict which was renting their community asunder, they appealed to the Prophet – an outside, objective force who had been touched by the divine – to mediate their dispute, to become the arbiter or *Hakam* who would bring peace to their lives once more.

For Muhammad and his followers this simply could not have come at a more critical point. What power and influence his group had accrued in Mecca had now collapsed under the brutal onslaught of Quraysh persecution, and, in desperation,

Muhammad had sent out a small band of his followers to seek tribal support in places as far afield as Abyssinia – all to no avail. Eventually the Quraysh graduated their campaign into an assassination attempt, a group of young knife-wielding nobles broke into Muhammad's hut but the Prophet had got wind of the attempt. He'd fled the city the night before, sheltering in a cave before beginning the long journey – *the Hijra* – which would eventually unite him with his brethren in Yathrib, those who had made the same peregrination through the barren wilderness in the weeks before. The majority of Muhammad's followers at this point were merchants and traders, and Yathrib was no city with bustling markets but rather a loose constellation of various agricultural tracts; economically speaking, the newcomers had nothing of value to offer. Except, of course, the political intercession of Muhammad himself. Over the next few years, Muhammad's role as mediator began to gain him more followers and more respect; his political influence grew, and eventually culminated in the creation of a constitution for the region. Yathrib was supplied with a set of non-aggression agreements which were legally binding, and which encompassed Muhammad himself and the recently arrived settlers, along with the Arab and Arabianised-Jewish clans – and these agreements provided the embryonic framework by which a single community could start to take form, gradually coalescing out of the tensions and polarisations of tribal particularism. Consequently, Yathrib was given a new name – it was called Medina, and this set of legislations became known as the Constitution of Medina. The Islamic calendar is dated from 622, from the Hijra, and one can see why, because Muhammad's flight from Mecca and his subsequent settlement in Yathrib/Medina were not just important in terms of the survival of his movement, but also represented its first practical test; by bringing the tribes together Muhammad was able to materialise the new religion's ideal – that of the *ummah* or universal community – in practice. The character

of early Islam was demarked almost entirely by this form of religious communalism; one of the first things Muhammad did on his arrival in Yathrib was to build a Mosque. But as Karen Armstrong notes, the character and social role of Muhammad's church represented a radical break with the Jewish or Christian equivalent:

> There was a courtyard, where Muslims met to discuss all the concerns of the ummah – social, political and military as well as religious…Unlike a Christian church which is separated from mundane activities and devoted only to worship, no activity was excluded from the Mosque. In the Quranic vision there is no dichotomy between the sacred and the profane, the religious and the political, sexuality and worship. The whole of life was potentially holy and had to be brought into the ambit of the divine. The aim was tawhid (making one), the integration of the whole of life in a unified community, which would give Muslims intimations of the Unity which is God.[115]

This notion of unity, of oneness, also had significant and problematic implications for Muhammad's own political role. Although he took the advice of his peers very seriously, and though he would often change his decisions in line with the qualms and criticisms of those around him, it nevertheless has to be acknowledged that Muhammad's power was almost absolute. Just as there was one God, so too would there be one leader – and so, much of the power which had devolved onto several elders in the old tribal paradigm was now fully concentrated in the figure of the Prophet. As Aslan says: "He was not only the Shaykh of his community, but also its Hakam, its Qu'id, and, as the only legitimate connection to the Divine, its Kahin. His authority as Prophet/Lawgiver was absolute."[116] From a purely practical perspective, this had certain advantages.

It was able to solidify the newly-founded *ummah* into a fighting force which was not riven by the tensions which underpinned tribal particularism. Islam became, in the words of Tariq Ali, "the cement [Muhammad] used to unite the Arab tribes"[117] and this unity flowed inevitably into a form of tight-knit military discipline where the *one* Prophet was able to disseminate the *one* religion of the *one* God. The confederation of tribes was strengthened in its unity and its unanimity by the strict observance of religious ritual each individual in the *ummah* was required to submit to. The combination of a single leader, a universalising ideology and an increasingly militarised and disciplined model of social organisation evolved swiftly out of the need to ensure the embryonic *ummah's* survival – and very quickly did it begin to pay dividends. In 624, for example, after a series of minor skirmishes, the Quraysh organised in a massive army and marched on Medina. The army they raised was estimated to be three times the size of the defensive forces Muhammad was able to muster, and yet the Muslim forces succeeded in repelling the Quraysh and killing several of their most important leaders. Muhammad's victory acted as an incredible propaganda boon, for the victory of a smaller, radically organised rabble of impoverished tradesmen, merchants, small farmers, artisans and ex-slaves over a far superior and prestigious force seemed divinely sanctioned, a David and Goliath spectacle in which the weapons of the humble had been fortified and guided by God. At once many more people flocked to the Muslim banner. As well, according to the nineteenth-century Islam scholar William Muir, the Muslims treated their prisoners of war in a far more benevolent fashion: "In pursuance of Mahomet's commands, the citizens of Medina, and such of the Refugees as possessed houses, received the prisoners, and treated them with much consideration...when, sometime afterwards, their friends came to ransom them, several of the prisoners who had been thus received declared themselves adherents of Islam."[118] The

bonhomie toward the captured men must surely have resulted from the way in which the Islamic vision was able to cross tribal lines, and see even its enemies as Arabs who were part of a chosen people.

For all of this, some 6 years later, Muhammad was able to march on Mecca with an army of 10,000. Many of the city's inhabitants welcomed the troops with open arms. The Quraysh surrendered. According to tribal law Muhammad was entitled to turn his vanquished foes into slaves, but instead he declared all of Mecca's inhabitants, including its slave population, to be free. Aslan reveals that "only six men and four women were put to death for various crimes"[119] by Muhammad's forces, and nobody was forced to convert to Islam as part of the armistice. Once these issues had been dealt with, Muhammad made his way to the Ka'ba where he would pass through the veil, take the idols from the interior, and smash them one by one. Only an image of Mary and Jesus was preserved. The shrine has been the spiritual bedrock of Islam ever since. But once the Prophet had helped shape a burgeoning social power according to the radical and systematic strictures of a new universal religion, once Muhammad had successfully united the tribes and taken control of Mecca, the question was inevitably posed: Where now? The answer was not one the Prophet himself would live to see, for he passed away a short 2 years later. But the key to it nevertheless lay in the type of community Muhammad had managed to forge. The *ummah* had a very particular character; it had evolved out of a radical movement which had pulled into its remit much of the city poor but also the merchant traders who were itinerant and mobile and whose lives were very much centred around the rhythms of the trading cycle. The creation of the *ummah* helped uncork the slumbering power of the mercantile classes, for it superseded tribal divisions and created a new social force which was at its core both urban and nomadic; it took advantage of the latent power of the city's huddled masses while at the same

time harnessing that to the wagon of those groups who were used to passing swiftly and efficiently across the most rugged and unsparing desert terrain in the pursuit of trade. These two elements, the urban and the nomadic, were fused in a religious apparatus which imposed the type of rigour and discipline that flowed from a belief in a higher power and a people whose time had come; at the crest of this movement was the Prophet himself – a prescient, poetic, political genius who had crafted from these remnants a social power of the most devastating and world historic implications. Now that the tribes had been subdued and "sublated" in the form of the universal community, it was virtually inevitable that the energies of the newly-founded Arabian power would turn outward, directed toward the peoples on the periphery; in other words the evolution of the *ummah* inexorably led to a new phase of world history in the region – a rapid, militaristic imperial expansion. The dynamism of the new social power combined with the fact that the great empires of the region – the Persians and the Byzantines – had grown decadent and fossilised, drained by decades of interminable war with one another. The new rapacious Arab power cut across their territories like a *saif* shredding a silk curtain. Within 20 years the foundations for an Arab empire had been set: by 1641 large regions of Syria had been wrested from Byzantine control, by 642 all of Egypt had been subsumed in a similar fashion, by 651 much of Persia and Mesopotamia was under Arab control and the once mighty Sassanid empire had been reduced to little more than a rump. The victories were ruthless and remarkable and served to sanctify the Arabs as a divinely appointed people, and thus many more tribes and peoples were pulled into the swirling vortex of the new religion.

And yet, the Arab expansion, although devastating and swift, was far from stable. Muhammad's stewardship of the early movement had endowed Islam with a leader of almost unprecedented authority, not simply for the fact that the various

roles of spiritual head, military general, political chief and bureaucratic-lawgiver had all devolved onto him; but because he had crafted the movement and had an exceptionally refined sense of the needs, aspirations and feelings of the masses of people who swelled its ranks. It was inevitable, therefore, that with Muhammad's demise, the question of how the mantle would be passed, who would step into the breach and assume the position of leader in the aftermath would, of necessity, prove to be a thorny one. Indeed the issue of the succession very nearly tore the early Islamic movement apart at the seams. By this point the wealthy and numerous Quraysh had been assimilated into the *ummah* and now they began to push their power base from within. They pressured and agitated to get Abu Bakr into the position of new leader against Muhammad's cousin and son-in-law Ali. There was probably some resistance on the part of the *ummah* or universal community to spiritual or political titles being inherited on a tribal basis through bloodlines, but more importantly the Quraysh wanted to limit the power of the Banu Hashim – Muhammad's own clan, and that is why they pushed for Abu Bakr over Ali. In the event Abu Bakr proved to be a wise and robust leader. He assumed the title of Caliph which endowed him with all the political power his predecessor had possessed; he only lacked the spiritual authority which came from being a prophet. He subdued rebel tribes who had reneged on their taxes after the death of Muhammad, and prevented the *ummah* from lapsing into tribal particularism once more. But he also repressed his rival, disinheriting Ali and Muhammad's daughter from the Prophet's property. No doubts the concentration of political power in his hands as *Caliph*, the legacy of the Prophet himself, made this easier for Abu Bakr. Abu Bakr's reign was short-lived, only a couple of years, and he was succeeded by another successful military leader who further culminated the imperial project, and then came the disastrous Uthman. Uthman too had been pushed by the remnants of the old Quraysh aristocracy, and

now as the head of a burgeoning empire he replaced many of the local emissaries of the Islamic power – the *amirs* – with members of his immediate family. Finally, he awarded himself the title "successor to God". Thus, the concentration of powers which the Caliph accrued to himself, alongside the empire building which the new state was engaged in, and the gravitational pull of the newly-founded universalist religion, yielded both a rapid expansion of the *ummah* and the creation of a new ruling caste centred around the unreconstructed power of the Caliph. Like this, the first dynasty, the Umayyad dynasty, was born. It was in some ways paradoxical, for it provided the organisational means, the central apparatus, by which the *ummah* could be bolstered and expanded, by which more peoples and tribes could be subsumed under the vision of a universal community which the Prophet had raised, and yet at the same time such a central power and the increasingly elite caste which facilitated it was profoundly at odds with the message of egalitarianism Muhammad's radical social message had sought to convey. The new Umayyad caste, rich, rapacious and increasingly inward looking and conservative, would have been abhorrent to the politics of the Prophet, and yet it was at least partially made possible by the fact that the Prophet himself had had concentrated in his hands great individual power – even if he used it in a more sparing and progressive fashion. The tension between the radical egalitarianism of the original Islamic movement and the Islamic states which emerged in the process of empire building was one which had the most fecund implications for theology, politics, philosophy and literature. So many of the sub-traditions – the political faction of the kharjites who rebelled against Uthman, but also later religious traditions like Shi'ism and Sufism – were extremely concerned with the issue of whether Muhammad's religious philosophy could be enacted in and through state building, or whether the *ummah* would find its true religious basis in a more apolitical fashion, through the observance of

communal rituals at a grassroots level beyond the frontiers of government, or in the case of Islamic mysticism – the retreat into the deeper recesses of one's own spiritual being. These rich and fecund traditions developed out of the tension which arose between state and social movement, egalitarianism and empire, and even the philosophical traditions which reached their highest fruition in the eleventh and twelfth centuries have their basis not only in Greek philosophy, but also in the need to mediate and harmonise this elemental contradiction which fissures through the heart of Islamic thought in its classical period.[120]

I think what must be said from the outset is that like early Christianity, early Islam is best understood as a radical social movement, a movement from below which contained both the poorer and middling layers at its core – small time merchants and the city's poverty-stricken and dispossessed. Like Christianity it was as well a movement of women and slaves. It was urban and yet it was also nomadic, possessed of both a strong streak of authoritarianism given the degree of power bestowed on the Prophet but at the same time it was often profoundly egalitarian in its ends. It freed slaves and though it didn't end the institution of slavery at a stroke, it nevertheless contained radical proscriptions for uplifting the rights of slaves and lessening their numbers. It abolished usury and therefore represented a sustained challenge to wealth and large-scale private property. It granted women divorce and property rights. In addition, and despite the common misrepresentation today, women in general were not required to wear the veil, and it seems that very few of them in this early period actually did. At the same time, however, though Muhammad reduced the number of wives a given man could take, nevertheless the institution of polygamy was preserved. And the Prophet's own wives were veiled. So although the movement was radical, it did not really resemble the struggles for women's liberation which open up in the modern period; it was not something which could

be described in terms of a proto-feminism.

In a way, though, this was inevitable. The development of the *ummah* partly relied on its ability to cross boundaries, and to forge connections with new tribes, to seek out new converts, and part of the way in which this was achieved was through patriarchal marriage arrangements which would, in turn, structure property relations at the level of individual families and clans. This is worth remembering when one hears the typical, unlettered portrayal of Muhammad as some "desert savage", lolling in his harem, surrounded by supine and subordinate women. In actual fact we know from the record that he lived with his first wife, an older woman named Khadija, monogamously for some 25 years. She seems to have been his senior in more than just age. Khadija, a business woman in her own right, had given Muhammad commissions and raised him out of poverty. Beyond this, she became the person whose advice he sought above all others, whose wisdom, savvy and compassion sustained him. The details of their relationship are genuinely touching and romantic, and it was only after her death that he took multiple wives, and these marriages were very much about forming political unions with significant Arab and Jewish clans.[121] For this reason there were ontological limits placed on the radical dimensions of Islamic egalitarianism by virtue of the forms and structures of socio-historical being itself.

For all of this we can say that early Islam was a social movement permeated by contradiction. The most common accounts of its historical genesis remain abstract precisely because they fail to penetrate the interplay of contraries. Patricia Crone argues that it was just another form of tribal imperialism, albeit *the form* of tribal imperialism, the form which was most successful and most far-reaching, and thus she overlooks the form of a more pronounced mercantile economy which had reached some level of fruition in Mecca in time with the religious pilgrimages which ebbed and flowed, eventually setting the basis for the economic

tensions between the petty traders of Muhammad's clan and the wealthy, monopolising power of the elite sections of the Quraysh. Out of such a development would also be fashioned the raw material of a class of dispossessed, of the slaves, debtors and the destitute more broadly who had been sucked out of the old tribal relations and securities, and whose social breadth and variety would provide a key impulse toward the universalism Muhammad's vision would encompass. On the other hand, Montgomery Watt, in seeing Islam rather baldly as an ideology which in essence expresses the eclipsing of a tribal network by a mercantile economy, overlooks the way in which Islam's radical universalism was exacted precisely by the demand to return to the tribal egalitarianism of yore. Early Islam fused the impulses of a more developed mercantile economy with the ideology and much of the social framework of the old tribal world; both moments were, in the Hegelian refrain, "sublated" in a more complete and harmonious unity, and this alone provided the key to the radical spirit of its religious doctrine.

Those moments also shed some light on the epoch which followed. Generally speaking Islamic imperialism tended to be tolerant of religious minorities, allowing them to coexist,[122] presuming they paid certain taxes, while forced conversions and religious persecutions were the exceptions rather than the rule. And though the imperial dynasties often constituted brutal fighting forces and exacted bloody take overs and ruthless repressions, nevertheless the level of "extra-economic" compulsion – i.e. the extraction of surplus product by the means of forcible theft or appropriation – was in general far lower on the part of Islamic forces in controlled or occupied territories than by say Western medieval powers in a similar period. When, for example, the Christian crusaders seized Jerusalem from the Fatimid Caliphate in 1099, the massacre which followed took the lives of an estimated 10,000 people, men, women and children, Jews and Muslims alike. When, in 1187, the great Kurdish leader

Saladin retook the city, there was no massacre. Some of the people were ransomed, many of them were allowed to leave of their own volition. Some were sold into slavery, though many of these were later freed as an act of mercy.

It was a far cry from the bloody mass murder the crusader troops had conducted almost a century before. Not that this in any way suggests Islamic imperialism in the medieval period wasn't rapacious, violent and homicidal on a vast scale, for of course it was. But just...less so. And part of that was to do with the social dynamic and the genesis of the Muhammadan movement. Because the lower sections of a mercantile class had provided a key impetus to the social movement, even when it was warped into a form of Islamic imperialism, that form was still marked by the early content. Islamic imperialism tended to combine rapacious and rapid conquest with the need to create open and stable markets which allowed the people in the subaltern territories fuller access to trade, the possibility of a livelihood which was conducive to their purchasing power as consumers. It was a far cry from the smash and grab imperialism of the crusaders, who tended to emphasise plunder and theft, and tended to repress, exile or stigmatise religious minorities rather than draw them in as a form of "cultural capital" which would help power the imperium; and, of course, Islam was generally favourable to the Jewish and Christian religions of the time, precisely because of its universality,[123] because the Prophet had exhorted that they be respected as "peoples of the book".

It is, of course, a far cry from the caricature of Islam which is promoted by Islamic State or ISIS today, with its rabid and degenerate murderousness directed at virtually everyone, including large numbers of Shi'i and Sunni Muslims. Indeed "fellow" Muslims form the biggest pool of their victims. Of course, the rise of Islamophobia, coextensive with an increased Western imperial intervention in the Middle East, has meant that the ISIS phenomenon has increasingly been portrayed as

an extreme version of the barbarism which lurks under the dark surface of a "generic" form of Islam, a barbarism which is endemic to the religion regardless of any social basis or the confluence of historical circumstance. For this reason alone it is worth returning to the roots, remembering the radical power of the forces from below which were crystallised in this, one of the last of the world's great religions.

Part II

Historical Art

Chapter Five

The Da Vinci Code and the Historical Trajectory of Christianity

The Da Vinci Code is a book which I have wanted to write about for a while. It is infamous, often considered to be one of the worst examples of prose writing and character creation in popular culture. And perhaps with good reason. Its author, Dan Brown, has a tendency toward blunt, bludgeoning simile which verges on parody. So, for example, when describing the dogged and moody police inspector of the piece, Captain Bezu Fache, the author says the following: "Captain Bezu Fache carried himself like an angry ox, with his wide shoulders thrown back and his chin tucked hard into his chest."[124] One might query the issue of whether oxen are particularly known for their anger but, in any event, the resort to the imagery of cartoon-like animals is almost redeemable, for there is something wonderfully innocent and childlike about it. One has the image of the author, holding his crayon tightly, grimacing in a puckered frown of innocent concentration, as he desperately tries to summon up that image which above all else would denote rage – before at last his features slacken in a blissful grin as he sees the snorting cartoon ox in his head and commits its image to words. All at once, however, everything goes awry, for – carried away by the success of the simile – the author immediately and unwisely adds "with his shoulders thrown back and his chin tucked hard into his chest". How is our poor, beleaguered ox going to accomplish this – is it even feasible that such a bovine creation would be able to throw its shoulders back and tuck its chin into its chest without performing some very un-ox-like movements? The mind, just like Mr Brown's metaphors, boggles.

The whole novel is peppered with incredibly grasping and

childlike comparisons of this type and it is difficult for critics, like yours truly, not to make some light fun of them. Perhaps too there is an element of *schadenfreude* involved here; Dan Brown's success has been astronomical – *The Da Vinci Code* has been translated into over 40 languages, sold millions and been made into a blockbuster Hollywood film starring Tom Hanks. For novelists in a slightly (ahem) lower sales bracket (again see the current writer) such achievements are supremely enviable, so perhaps it is natural that critics who haven't enjoyed the same level of success can balm their wounds with the knowledge of their own stylistic superiority. But the achievements of sales success point to a more obvious and interesting question: why? What is it about *The Da Vinci Code*, given its obvious flaws, which has made it so popular? Why, given the rather antique nature of its subject matter – ancient religious orders, dusty museums, cryptology and semiotics – has it proved to be so compelling?

I think part of the answer is to do with those very visible flaws. Every character in the novel is, to a greater or lesser degree, a cardboard cut-out, a vulgar stereotype. The hero, Robert Langdon, is a rugged, lantern-jawed Harvard Professor in his mid-forties; somewhere between Indiana Jones and Mr Darcy – he spends his days delivering charismatic lectures at various international conventions, and his nights stumbling through catacombs, deciphering ancient conspiracies and generally saving the world. He is aided in his endeavours by the requisite female foil; the inevitably younger, beautiful woman who happens to be a genius intellectual and has grown up weaned on the brilliance of Langdon's books. She is "sassy", however, so she gives as good as she gets, before the professor dutifully rescues her from danger. There is a supervillain – an evil genius who manipulates events from behind the scenes, plus a sinister, sadomasochistic monk of a murderous fundamentalist bent whose evil is – if one is still in danger of doubting it – marked out by the fact that he has glowing red eyes.

But while these characters are cheesy, highly enjoyable and paper-thin; their advantage lies with their sheer superficiality. Brown is able to present them as moral cyphers, either good or evil, and beyond this they have very little interiority; in *The Da Vinci Code* at least, they are not prey to any type of internal moral conflict or dilemma. Their goodness, their intellectuality and their ethical certainty is established in a few quick strokes of the authorial brush, and the advantage of this lies in the fact that it allows the emphasis of the novel to move away from character development and fall almost entirely on the development and movement of the plot. Because, aside from the throwaway thought here and there, there is no fundamental exploration of the inner moral universe, and so there is very little to interrupt the flow of events. The plot is split up into 106 short segments which are packed with events and revelations, and seem to flash by at a breakneck pace. Of course, this is simply the formal aspect of the issue: the book's formal structure allows for a dynamic, rapid-fire plot, but this has little bearing on the content; i.e. the question of whether the story is actually interesting and involving of itself – whether it harbours at its core some kind of more profound aesthetic truth.

But I would argue that it does. I think that the plot of *The Da Vinci Code* is both imaginative and profound, and that its execution exhibits the very highest level of acumen and expertise on the part of the author. The plot runs in its bare outlines as follows – it begins with the murder of a curator who works at the Louvre. Alongside his body are discovered a set of cryptic clues, which provide the rational for Robert Langdon's presence. These clues lead to other places, more clues. Along with Sophie Neveu, his beautiful sidekick who is also a police cryptographer and granddaughter of the slain curator, Langdon puts his expertise to work to decipher the mysteries behind the various clues, but in the endeavour ends up revealing more than just the answers to individual puzzles. Gradually, through the

puzzles and events, he begins to reveal a whole alternate history; a secret history which involves an invisible conflict which has sustained through the ages between the Catholic establishment and an alternative, underground religious tradition carried by an organisation called the Priory of Sion. The great, abiding secret which Langdon and Neveu are eventually able to decode is the secret which the Priory of Sion have formed their order so as to keep. The same truth which the Catholic establishment are required to suppress in order to preserve their ideological hegemony and their grip on power. The truth that Christ was not celibate; not only did he have sexual relations but he also begot a child with Mary Magdalene who was, in reality, his wife. More than this, Christ's bloodline has continued throughout history. The Priory of Sion have been tasked to keep the identity of his ancestors secret in order that they might be saved from persecution by a religious establishment which could only conceive of them as a mortal threat and would inevitably seek to wipe them out. The rehabilitation of Mary Magdalene in the Christian tradition would challenge the primacy of St Peter as a central Apostle and therefore undermine the power of the Papal legacy which had appropriated his name. As a consequence, the Opus Dei are conscripted in the role of the fundamentalist militants who are dedicated to destroying the Priory of Sion – the sinister ruby-eyed Albino monk Silas is one of their assassins.

The way in which Brown gradually unfolds the mystery using the various clues is, I think, ingenious in itself. He argues that although the luminaries of the Priory of Sion have, throughout the ages, been required to keep this great secret, they have nevertheless alluded to it obliquely, through some of their works which reveal a preoccupation with "the sacred feminine". So, for example, the eponymous artist of the novel, Leonardo, was one of the members of the Priory, and has concealed in some of his great paintings references to the Christ-Magdalene connection. In *The Last Supper*, for instance, we are asked to scrutinise the

figure of John the Apostle, the figure sat at the right hand side of Jesus himself. When we look closer, we see that the figure, with its light flowing locks, smooth, unblemished face, seems remarkably feminine, and this, the novel speculates, is a codified depiction of Magdalene herself. In addition, whereas traditionally Last Supper scenes would give prominence to the Holy Grail, the cup from which Christ sipped while he had the meal, in Leonardo's depiction the sacred vessel is notably absent. Why? The novel invites the reader to consider the words "Holy Grail". In old French, the expression for the chalice was Sangréal – itself a play on the words "Sang real" which, again in old French, meant royal blood (The Da Vinci Code's Mary Magdalene is descended from the bloodline of King David). The idea that the Holy Grail is somehow absent from Da Vinci's depiction is, then, something of a misnomer for the Grail was never a physical cup; rather Mary Magdalene herself is the Holy Grail or the "royal blood". But even the traditional image of a corporeal cup reveals something of the truth, for its voluptuous shape is itself symbolic of the "sacred feminine" and thus hints at the nature of the true Grail.

The Da Vinci Code is filled to the brim with such archaic cyphers and cryptic allusions, and despite the deficits in character and style, this is one of the reasons why the novel is able to attain a certain historical flavour. It gives one the feeling of stepping into a museum, of being around ancient dusty artefacts, of being in the presence of ghosts – only it is the type of museum where psychotic red-eyed Albino monks are liable to jump out at you from the shadows, and for my money, that's a fun museum indeed. Of course, even its strengths have been pilloried, with the author receiving a barrage of criticisms for the historical plot the novel outlines. There are criticisms which relate to originality – the 1982 book The Holy Blood and the Holy Grail included the hypothesis that the historical Jesus married Mary Magdalene and the union bore fruit in terms of a bloodline

which would eventually culminate in the Merovingian Dynasty, a precursor to the Holy Roman Empire of Charlemagne.

In addition, there is a core Christian element which has been galvanized by the novel into making a series of outraged criticisms, pointing out the lack of historical veracity – the Priory of Sion, for instance, was a fringe organisation founded as part of a hoax, and certainly had no relation to Opus Dei. To the first issue – that of originality – it might well be true that Brown lifted the idea of the Christ-Magdalene marriage from *The Holy Blood and the Holy Grail*, but what is important here is that the latter was an attempt at actual historiography, albeit of a highly suspect pseudo-type. *The Holy Blood and the Holy Grail* was trying to describe what took place between real historical actors, it was not trying for fiction. And this is significant, for many writers of fiction often draw upon the chronicles of "real-world" events for their inspiration. In *The Count of Monte Cristo*, for example, Alexandre Dumas drew the bare bones for his plotline from a second-hand account he read of a nineteenth-century shoemaker living in Nîmes who had been accused by three jealous friends of being a spy for England and was subsequently sentenced to a prison fortress for 7 years. Of course, although this provided the premise of Dumas' novel, it was Dumas himself who provided the characters and the details of the plot, its twists and turns, in ways which the original story simply couldn't have allowed for. The same is true with *The Da Vinci Code*; in extracting its "historical" premise from the notion of the marriage of Christ and his bloodline, Brown goes onto create a new set of characters and plot conflicts; that is to say, he creates a qualitatively new work.

To the second set of criticisms – those which target *The Da Vinci Code* for its historical inaccuracies – they should be rebutted in much the same fashion; *The Da Vinci Code is a work of fiction*.[125] As we have seen it borrows elements from actual history but has the licence to distort them by virtue of the fact that it is fantasy,

indeed its fictional power is premised on just such distortions. In the film *V for Vendetta* the protagonist, Evey Hammond, argues how "artists use lies to tell the truth, while politicians use them to cover the truth up". A pithy epigram but a profound one. The "lies" which the Christian critics and secular theologians have "exposed" in *The Da Vinci Code* are of precisely this order; that is, they exist in order that a more profound truth be brought out and culminated in a more sharply dramatic and fantastical form. If one goes back to early Christianity, when the religion itself resembled more of a social movement from below than a state institution from above – one comes to understand that the figure of Christ, for the early believers, represented something quite different from the religious presentation offered up today by both the Catholic authorities and the Orthodox forms of Christianity. If we go back to Mark's Gospel, which most analysts believe to be the earliest, the vision of Christ is in many ways fundamentally more ordinary than his later incarnations. There are no angels who trumpet his coming into the world. There is no reference to his childhood to suggest any mark of the divine. He is the Son of God, a fact revealed when the heavens above open to declare it during Jesus' baptism as an adult man, but here there is some controversy. The Son of God is an appellation which was used to describe those who were in a special relationship with God, those who had gained his blessing, and there were many such Jewish Messiahs – people representing the traditions Christ himself came out of – who were also the sons of God. If one is to take the other line, which is equally plausible, that the reference in Mark denotes a Christ who is literally God's child, one still has to acknowledge that Christ himself is not a divine being, not a manifestation of God, but still a man. A man who can perform certain miracles, who can exorcise demons – like many of the holy men who proceeded him – but a man nevertheless. There is no resurrection from the dead – at least not in the original form of the Gospel as we have it.

As the religious scholar Karen Armstrong notes, the "development of Christian belief in the Incarnation was a gradual, complex process. Jesus himself certainly never claimed to be God."[126] Quite. Such a process took place over centuries; the notion of the Trinity, for example, had been floated by second century scholars such as Origen and Tertullian, but it was only at the Council of Nicea in 325 AD that the church and state definitively recognised Christ the son as the living embodiment of God on earth. In the same period, there were many alternative and competing visions of Christianity, one of them – that of Arianism – was the very heresy which the Council of Nicea had been called into being to quash. The Christian presbyter Arius had argued that the Father alone was infinite and eternal, and though the son had been touched by his father's divinity, Christ himself was merely the most perfect of all the earthly creatures, and like them, was ultimately transient, subject to both a beginning and an end. In other words he was not identical with the essence of God.

One can see the fissure which opens up here as something which develops along keen political fault lines. Christianity had recently been co-opted as the official state religion of the Roman Empire – and in as much as the religion was coming to express the interests of a state elevated above its populations, it was perhaps inevitable the same state would have an interest in elevating the religious character of Christ above humanity per se. Arius, on the other hand, was of Berber descent, lived at the eastern fringes of the empire and did not occupy a powerful position in the church hierarchy, but was merely the head of a local congregation. As such it is almost certain he would have mixed with the ordinary people, and I suspect his religious vision was in some sense shaped by such a reality. He argued that we must see Christ as a fallible human being, for it is only as such that we can be moved by his example and inspired to follow it. Such a conception had more in common with the early descriptions of Christianity, and

vast swathes of people were attracted to its message. Of course, Arianism conflicted vividly and violently with the theology of state and empire, and following the Council of Nicea, Arian leaders were exiled and Constantine ordered all copies of the *Thalia* – the book in which Arius expressed his theology – to be burnt. The religious conflict raged on after Constantine's death, but by the late fourth century, under the joint reign of Gratian and Theodosius, Arianism had been effectively eliminated among the ruling elites in the east in and around Constantinople – the area where once it had flourished – and Roman subjects were required to profess loyalty to the Nicene Creed or face the consequences. At the same time, however, the religion found favour with the empire's outsiders. The Goths, Lombards and Vandals – the Germanic tribes who lived on the peripheries – all came to embrace a certain strain of Arianism, perhaps because their original pagan belief systems – whereby a multiplicity of gods were created in time and had more explicitly human characteristics – had more in common with Arianism than the Trinitarianism which had been established once and for all by decree in 381 AD and which put both God and Christ at a more distant remove from man.

Of course, Arianism wasn't the only heretical religious tendency at work at the time. Undercurrents of Gnosticism had provided their own radical interpretations of Judaism and Christianity, some going as far as to argue that Yahweh was an evil demiurge who had trapped humanity in an illusory world of matter which occluded the divine essence, and that Christ himself was an emanation of the true God sent to help liberate us from our material prison. Perhaps more significantly the word "Gnosticism" has its etymological origins in the ancient Greek *gnosis* or knowledge. The moniker is fitting for Gnosticism was based on the radical proposition that it was the knowledge of the divine element occluded by the material reality which would allow one to attain salvation; one came to grace not

with an absolute and blinding faith in the almighty or Christ himself, but by using one's knowledge and perceptions to figure out the great mystery of the world, to recognise the clues in the objects around us as ways to decipher the true reality which exists behind the veil of the material (exactly what, incidentally, Langdon and Neveu endeavour to do).

Early Christian sects were radical in other ways too. The early Christian movement, by virtue of its universalist ideology, helped unite many different elements – those strewn across a patchwork of exceptional ethnic and regional diversity but had nevertheless found their traditional social roles and local forms of organisation fragmenting under the pressure of imperial taxes, imperial wars and the vast project of social restructuring the Roman bureaucracy required. Many such people found themselves usurped from the land, from the possession of the small holding; dispossessed and subject to debt bondage, they were often sucked into the city rabble, destitution or slavery. In its universalist vision early Christianity raised such people up and in the moment of their most acute distress and abject destitution rendered them sacred. It was because it spoke to the dispossessed so eloquently that the early Christian movement was derided by the Roman establishment, most famously in the words of the Pagan critic Celsus who described the religion as one of "slaves, and women, and children". Of course, Celsus intended his words to be derogatory, but they do speak to the fact that early Christianity was a religion which appealed to the marginalised and the excluded, precisely because of its universalism. In the words of Galatians (3:28), "There is neither Jew nor Gentile, neither slave nor free, nor is there male and female, for you are all one in Christ Jesus." The Pauline rendition of Christianity, emphasising the universal moment, was bound to exert a strong pull on women in particular and in the early days of the religion, this was reflected in some of its tendencies and sects. The informal hierarchy allowed for women to occupy

significant roles and become significant figures; it is thought, for instance, that active leaders like Priscilla who were instrumental in founding Christian communities almost certainly held the title of "presbyter" and even in the second and third centuries radical Christian movements such as that of Montanism encouraged the practice of female bishops. But, as a result of prolonged historical processes and the absorption of Christianity into the Roman state – which helped structure the Roman family under strict patriarchal lines enshrined by law – the role of women in the religion became ever more marginalised. In the very period the divinity of Christ was being emphasised over and against his earthly nature, the first writ was issued which required the by now all male membership of the clergy to abstain from sexual intercourse with their wives (Council of Elvira, 306 AD). Such a sense of things was accentuated under the Catholicism which was promoted by the papacy after the decline and fall of the Western wing of the Roman Empire, and in the twelfth century the Second Lateran Council adopted a canon which would expel from office any of the clergy who had been found to be married. Not only had women been excluded from active roles in the Christian hierarchy, but also the very idea of the female had come to be seen as a form of contaminant – as something which could undermine the connection of the male cleric with the figure of a divine Christ which had itself been abstracted almost entirely from the human realm.

Of course, such a project was resisted by individuals and rebel sects with a range of ideological tones; the great scholastic philosopher Peter Abelard, for example, put forward the touching proposition that Christ had died on the cross as a way of evoking compassion in humanity and it is our compassion which saves us. In Abelard, therefore, it is love – that most human of things – which is truly divine. The proto-Protestant tendencies of Lollardy, which emerged in the fourteenth century, challenged the practice of clerical celibacy, while in the following century

the Hussite faction – the Taborites – made the attempt to more profoundly ground the divine in the earthly by arguing that the church itself was not the agglomeration of all the religious officials with a heavenly mandate, but rather the living, breathing community of the believers themselves. Such arguments attained great ideological momentum with the Reformation itself. Protestant clerics following the example of Martin Luther were permitted to marry, while Luther's translation of the Bible into German was considered heretical by the Roman Catholic Church precisely because it helped bypass the power and authority of the Roman Catholic priest who would traditionally translate passages from the Latin to the congregation. By making the book available in the popular language, Luther was, of course, allowing the mass of the population direct access to the ideas in the Bible unmediated by Catholic authority.

So, sometimes openly, sometimes from behind the scenes, a religious struggle was waged over centuries which involved those struggling to reform Christianity, to repossess it in a more popular and democratic guise; such a struggle was often channelled and refracted through a complex of sects and cults alongside larger mass movements which attained sweeping international scope. One might add that there was often a loose correspondence between the attempt to create a popular Christianity which was rooted in the lives of the masses and better expressed their social interests – with the ideological endeavour to restore the figure of Christ or the rituals which surround the celebration of Christ – to a less remote and more human conception. The Protestant tradition, for example, tended to downplay the miraculous nature of the Eucharist arguing that the bread and wine are not literally transubstantiated into the body and blood of Christ, suggesting instead that the religious ceremony which takes place is allegorical rather than miraculous. Alongside the endeavour to return Christ to a somewhat more earthly template, often went the attempt to

rehabilitate the role of women in the religion to some degree – or at least to see female sexuality as being something less of a taboo in as much as the concept of clerical celibacy itself was undone. Of course such themes only emerge in very loose outline, and many of the alternative sects were considerably reactionary on these issues too; the complexity and contradictory nature of this unfolding history is almost impossible to reduce to a wholly black and white conflict. Yet the role of women, the nature of the divinity of Christ, the ability of the masses to experience the truth of God without the intercession of an authoritarian church and state; these themes manifest in a variety of different epochs in and through a series of discrete religious movements. To return us to *The Da Vinci Code,* what is truly excellent about its plotline is that it provides an exercise in reductionism; it distils all the complexity – the separate epochs, numerous actors and multiple religious tendencies within a living history – into one single unbroken thread; a conflict which persists through the ages between two historical protagonists – the Roman Catholic Church and the Priory of Sion. By using the idea of Jesus Christ and Mary Magdalene forming a couple and having children, the plotline provides the rationale for the radical struggle the Priory of Sion are enacting; they seek to preserve a true "original" Christianity in which Christ himself was a far more human archetype – someone who was not elevated above humanity to an untouchable remove, but someone who had himself been married and had had children. The Priory of Sion, then, seeks to return Christ to a more earthly and democratic template while at the same time restoring the power of the feminine to the Christian tradition by rehabilitating the role of Magdalene. In other words, they seek to preserve the "true" roots of an early Christianity which has been suppressed and censored by the Roman Catholic Church as part of a sustained and conscious plan to dupe the world into accepting its own power basis. The nuance and complexity of a real historical development is, in

this vision, reduced to a conspiracy theory in which one of the actors – the Roman Catholic Church – seeks to destroy the truth and the Christ-Magdalene bloodline – while the other, in the form of the Priory, seeks to preserve and protect it.

But even though the vision is vulgar in historical terms – as a literary device it is wonderful because it preserves in abstraction a sense of an early Christianity which was far more democratic in its expression, and a later institutional Christianity which became an integral part of a more authoritarian state building project carried out through Roman times, the Middle Ages and the early modern period. In and through a conspiracy theory narrative, *The Da Vinci Code* reduces a complex historical truth to its most essential elements, and allows them to form part of an ongoing and complete unity of struggle between two polarised forces – the Catholic Church representing power from above, political corruption and falsehood – and the Priory of Sion, representing Christ as truth in its authentic, human guise. This has profound repercussions for the "heroic quest" Robert Langdon and Sophie Neveu embark upon; they are not investigating the myriad of historically specific cults, movements or popular reformations which have resisted the authority of church and state in multiple guises throughout the ages; rather all historical resistance toward Catholic theocracy is distilled into a single entity, the Priory of Sion, which holds "the truth" and thus the plotline of *The Da Vinci Code* is not in danger of fragmenting under the welter of actual historical detail and complexity the history of Christianity presupposes. In distorting the real religious history, in reducing it to an almost Manichean opposition between two trans-historical entities (The Catholic Church and the Priory of Sion), Brown is able to better reveal, in a literary and fantastical fashion, the opposition between a Christianity which is defined by a power above, and a Christianity which receives a popular impetus from the broader populations of believers – and this contains a real historical resonance and truth even in an abstract,

literary form.

And so Langdon's quest takes on a very specific character. It becomes about revealing the conspiracy of the Church by first discovering the existence of the Priory of Sion, and in discovering the *raison d'être* of the Priory of Sion, Langdon and Neveu are able to hit upon the "truth"; that is to say, they are able to discover the authentic human origins of Christianity uncontaminated by power. And it is because the history of Christianity more broadly is imagined in terms of a vast conspiracy theory which stretches through the ages that Brown is able to fully utilise the gnostic element in his literary vision. Langdon and Neveu follow the clues which the material reality offers up, in order to gradually uncover a deeper, more spiritual essence; in this case, the true legacy of Christianity and the power of the "sacred feminine". Neveu is particularly important in this connection; in the finale it is revealed that her grandfather Jacques Saunière, a Grandmaster of the Priory of Sion, was not only watching over and protecting the descendants of Christ, but on top of this his own granddaughter is part of that same bloodline: "Sophie's parents, and ancestors, for protection, had changed their family names...Their children represented the most direct surviving royal bloodline and were carefully guarded by the Priory."[127] Of course this is the "big reveal" of the book, and it certainly provides a more dramatic twist, but in a sense it is not Sophie Neveu's discovery of her holy origins which represent the truly "gnostic" revelation but rather the way in which she is able to come to terms with the memory of her murdered grandfather.

Earlier in the book it was revealed that Neveu was estranged from her grandfather many years before because, as a young student returning from university early, she had secretly observed her grandfather performing a religious ritual in the basement of his country estate, whereby the sex act was performed as "a pathway to God".[128] Her grandfather was in the centre of the room copulating with an unknown woman, while all

around the other participants in the ritual watched and chanted. The young Sophie Neveu is appalled and horrified by what she has seen, regards the sexual element inherent to the ritual as something dirty and perverted, and at once breaks off relations with her grandfather. But, all those years later – in the process of discovery, in the gnostic process of unravelling clues lodged in the here and now of the material world – both Neveu and Langdon are able to journey back into the past – to comprehend the true origins of Christianity, its roots in a more democratic humanism which celebrated both women and sexuality. Sophie Neveu suffers from the religious prejudices the Roman Catholic Church has sought to inculcate over centuries, and her reaction to her grandfather and the ritual he was participating in express that. However, with Langdon's guidance, the duo is able to access the more authentic truth which they locate in the historical past, and through this Neveu comes to see that her grandfather was both a brave and profoundly humane man; his beliefs and form of worship were in no way aberrant. She is reconciled with his memory at last, for she knows him to have been a good man, and this resolution – in its way more ordinary – is also more sacred and precious than the knowledge that she is descended from Christ. Because it is more human.

There is a wonderful scene in the film version of the book. Robert Langdon and Sophie Neveu are making their way toward Westminster Abbey in order to investigate the tomb of Sir Isaac Newton (who was in his own time also a Grandmaster of the Priory of Sion). As they walk up toward the main entrance of the abbey the things around them – taxis and buses, the objects of the modern twenty-first century world – begin to lose cohesion, fading to the point where they are the almost transparent, ghostly outlines of their former selves. Simultaneously, new objects are called into being; the faint image of crowds flocking toward the cathedral begins to grow stronger, to attain definition, and these people are draped in black cowls, moving in a sombre religious

procession. At the same time the high, white mortar buildings which surround the abbey in the modern day morph into smaller cottage-like buildings with slanted roofs and wooden beams very much in the Tudor style. Their chimneys billow smoke. The masses and masses of solemn dark figures flow into the great arched entrance of the abbey and in the background the haunting uplifting voices of a church choir can be heard echoing through the chambers. The device is very effective; it is telling us so clearly that what we encounter in the immediacy of the world around us – the impression of a stable, coherent and harmonious reality – is in fact something of a façade; that beneath the appearance the underlying and elemental currents of social struggle and polarisation which are inherited from previous epochs continue to be fought out; that the historical past is always on the verge of erupting into the present; that our history is our fate, and it is within the purview of our lives to walk in the company of ghosts.

The scene captures so perfectly the essence of the book; for the journey of discovery that Langdon and Nevue take involves precisely this: it involves the way in which the stability and immediacy of the present begins to unravel, revealing the underlying essence of man as something in flux, as both the producer and product of historical process, and it is only in the self-conscious awareness of our nature and development as historical beings that we are able to fully unfold our slumbering potentialities and unrealised freedoms. Neveu is ultimately freed from the trauma of her individual past, from her devastated reaction to the ritual she sees her grandfather performing, only by the mastering of that same past but at the level of humankind in its generality. It is by recognising and recovering the authentic Christian tradition – which in the novel becomes a stand in for the most progressive social struggles which have informed historical progress more broadly – it is her awareness and apprehension of the historical struggle which has been enacted on a species-wide

basis, often invisible and from behind the scenes, that allows her own individual reality to be thrown into relief, and she is able to see in her grandfather the kind and loving man he always was. *The Da Vinci Code* has enjoyed so much success because it is a labyrinthine, fast-paced, immersive and exhilarating novel full of creaking trap doors and cheesy splendour; but more than this, it contains within its aesthetic a profound truth about the reality of history and ourselves as historical beings – immersed in its flux, shaped by its rhythms, and yet often unaware of its elemental pulse and presence in the backdrop of our lives, until suddenly the stability of the present seems to fissure and crack, as history erupts once more, and new epochs, new adventures and new freedoms are born.

Chapter Six

The Wonderful Wizard of Oz and the Political Landscape of Nineteenth-Century America

I remember this story from childhood, and even today I can feel a bit of a tingle when I remember the type of magic it generated. It taps masterfully into the psyche of a young child, for we begin with Dorothy who is living with her Aunt Em and Uncle Henry. The landscape of the prairies where they live is harsh and grey to match the austere lives of farmers working the unyielding land, but though her aunt and uncle are gruff and stoical they love their little niece who provides them with a window of joy and colour the hardship of their lives has hitherto denied. Dorothy's existence is meagre but secure, and as all children should be, she is very much loved. Of course, this short prelude occurs before the day of upheaval, when the certainties in Dorothy's life are snatched away. A tornado arrives from the sky, and Dorothy – unable to make it to the cellar with her aunt and uncle – remains trapped in the house which is then scooped up by the whirling winds and whisked away. The child, along with the house, is deposited in the magical and topsy-turvy land of Oz, and thus her quest begins to find the wizard in the Emerald City and gain the means of returning home to her aunt and uncle. On the way, accompanied by her little dog, Toto, Dorothy meets and helps the Scarecrow, the Tin Woodman and the Cowardly Lion. Together they make their trip to the Emerald City, and having parlayed with the wizard, Dorothy and her odd, charming band of eccentrics journey to the West to battle the Wicked Witch. Finally, Dorothy clicks her heels three times with the magic shoes and she is returned to her family.

Now what makes this such a wonderful story for children is the

fact that the world is magical and colourful. Although darkness gathers on its periphery, the people who surround Dorothy are both friendly and benevolent, and while the child reader squeals with delight at their absurdities and their comic aspects, at the same time he or she feels reassured because the Scarecrow, Tin Woodman and Cowardly Lion are all archetypes of goodwill and bonhomie. In a way they are simultaneously children and adults. They are adults in as much as they are physically tall and clearly of a certain age, and each has an independent social function in the world they inhabit – each has some kind of job or independent role to play. The Tin Woodman is a land labourer, the Cowardly Lion a hunter, and so on. At the same time they are children, because each is possessed by a vulnerable innocence which they wear on their sleeves. Although the Lion is meant to be a hunter, he is also cowed and fearful. The Tin Woodman has rusted over and can no longer chop trees. The Scarecrow lacks brains and is imprisoned on his scaffold. It is their encounter with Dorothy which liberates each from his bondage. And all three of her companions – though they are the adults – come quite naturally to defer to Dorothy's kind, homely nature, her curiosity and her home-spun common sense. So while Dorothy is a child who is surrounded by benevolent "adult figures", in her interactions with her companions, Dorothy more and more takes on the role of the adult, and they – the children. In this way, the child reader is given a very exciting glimpse of the possibility of their own self-determination in a world which is at the same time scary and safe; I would say this is a paradox which makes Oz so alluring for the younger reader.

The characters of Dorothy's companions, and the landscape of Oz more broadly, have been subject to a keen level of scrutiny and analysis in the decades following the publication of the book in 1900. Perhaps the most notable and controversial analysis of the text was penned by Henry Littlefield in a piece for *American Quarterly* entitled *"The Wizard of Oz*: Parable on Populism". In

this article Littlefield attempts to map characters, places and elements in the world of Oz – to the categories which inform the late-nineteenth century political climate of the US. At this time the political scene was turbulent and in flux. The Western frontier had been pacified, the gold rushes which were so prolific during the 1860s had, by the turn of the century, largely abated, and yet these events were still within living memory and the pioneering spirit which they helped cultivate now pervaded both the political ethos of the US and its cultural mythology. At the same time, however, there was a darker seam which ran just beneath the surface of the national narrative: the Indian tribes who had been extirpated from their homelands in a "trail of tears", the indentured labourers who had helped construct for a pittance the great railroads in the most hideous of conditions, the workers of the north whose life energy was annihilated by the pistons and hissing steam of hulking industrial units which offered little in terms of labour protection, the small farmers on the unforgiving land whose gruelling struggle for existence was parched and scoured by drought and the great economic crisis of the 1870s which opened up like a ravening maw and threatened to swallow their meagre livelihoods whole. This darker underbelly of desperation, poverty and exploitation created the type of social unrest which demanded political expression, and in the formation of the Popular Party in the 1890s – it found it. The Popular or Populist Party, fuelled by a mood of rural unrest, was highly critical of the bankers and the railway barons and swiftly became the third most powerful party in the country and a major left-wing force in the politics of the time. The Populist Party had a strong "free-silver" tendency within it – that is, many of its members favoured the unlimited coinage of silver into money on demand, partly because this was seen as breaking the grip of an international elite of high financiers alongside the indigenous power of the railroad barons, factory owners and creditors of every type who derived economic benefit from loan repayments

in gold dollars.

This brings us to Littlefield's account of *The Wonderful Wizard of Oz*. The tornado drops the house in the centre of the land of the Munchkins, a beautiful fecund and verdant terrain, flooded with sun, and a vivid contrast to the desolating grey of the Kansas prairie. The Munchkins are a set of characters who are again both adults and children – "they seemed about as tall as Dorothy, who was a well-grown child for her age, although they were, so far as looks go, many years older".[129] But the house itself has landed on the Wicked Witch of the East flattening her and releasing the Munchkins from bondage. The death of evil in this region of Oz has in some way been accomplished by Dorothy's appearance but the latter retains the innocence of a child, for the kind-hearted Dorothy is very distressed by the accidental destruction of the malevolent witch. The childlike nature of the protagonist is perfectly preserved despite the ostensible violence which has been inflicted and the young reader continues to experience his or her own nature in the character of Dorothy. Later, Dorothy is consoled by the gentle witch of the north who takes the silver shoes from the evil witch's body and gives them to Dorothy. And it is these magic shoes, Littlefield argues, which become a metaphor for the "free-silver" tendency. Dorothy sets out with these shoes, walking on a golden road, but at this point in time she does not know their power, she does not know that should she click them together three times she can resolve all her problems at once; hence, according to Littlefield, "Dorothy becomes the innocent agent of Baum's ironic view of the silver issue...William Jennings Bryan never outlined the advantages of the silver standard more effectively."[130]

William Jennings Bryan was, of course, the populist Democratic candidate who made a famous rabble-rousing speech advocating the benefits of a return to the silver standard. But how much truth is there in Littlefield's suggestion that the "silver shoes" signpost such a policy in a fantastical literary guise? The

question is not easily resolvable in as much as Baum himself did not comment directly on the issue, and the "interpretation craze" which surrounded the novel really took off after the author's death. It is difficult to say for sure whether the author intended the silver shoes as a metaphor for the silver standard. And if Baum did intend the silver shoes to carry such a latent meaning, the meaning itself would still perhaps remain ambiguous. Was the author trying to say that the silver shoes, and vicariously, the silver standard, was capable of solving the fundamental problem of the age at a stroke? Or was he saying that the people who put their faith in the silver standard as an answer to the problems of the contemporary political climate were indulging in a naive and fantastical remedy wholly grounded in wish fulfilment?[131] In actual fact I don't think the resolution of such questions has much bearing on the interpretation of the text for the following reason: Whether the silver shoes mark a nod to the silver standard or not does not affect the essential element of the Oz world and Dorothy's narrative in any way. For instance, as the film version of the novel – The Wizard of Oz – would show in 1939, it was quite possible to portray the "silver shoes" as "ruby slippers" without altering the meaning or the subtext of the novel in the slightest bit.

Some of Littlefield's other political characterisations are closer to the mark. He talks about the Tin Woodman and the way that character, this simple labourer, has been "dehumanized...so that the faster and better he worked the more quickly he would become a machine".[132] Littlefield concludes that "[h]ere is a populist view of evil eastern influences on honest labour which could hardly be more pointed".[133] In this case I think Littlefield is correct, indeed perhaps he doesn't press his point far enough. The Tin Woodman represents more than just a "populist view" on "honest labour"; more specifically he provides a wonderful evocation in fantasy form of the themes of alienation and mechanisation. His work is alienating in the true Marxist sense

– that is, his labour becomes abstracted, transformed into an alien force which is set against himself: "the enchanted axe cut off my arms, one after the other; but, nothing daunted, I had them replaced with tin ones".[134] Moreover his transformation into tin causes his movements to become ever more rigid and mechanical until finally he rusts to the point of petrification. Now it was probably not the case that Baum consciously set out to create a character which exemplified the dehumanising and heartless effects of the mechanisation process the individual worker is subject to under industrial capitalism. But the question one should ask is simply this: Would Baum have been able to create the Tin Woodman if he had not been writing at a time when to the north industrialisation and the effects of automated metal eroding more traditional forms of labour practice had not manifested in all their dehumanising parameters? It seems highly improbable that the Tin Woodman could have been conjured into being without such a backdrop. So even if the archetype is not consciously employed as a literary device to reflect a particular political form, nevertheless, what makes the story creatively profound is its ability to channel broader historical themes in an unconscious and fantastical fashion, to allow them to bleed into its aesthetic in an organic and involuntary fashion like a sponge soaking up dye.

In the same vein the Munchkins clearly have some kind of grounding in the American historical scene – in particular the displaced indigenous peoples of the region. Some have argued that this is unlikely, given Baum portrays the Munchkins in sympathetic colours and yet, a decade before the publication of *The Wonderful Wizard of Oz*, the author was anything but sympathetic to the plight of the indigenous in the US – advocating their conquest and extermination in the most chilling language: "The Whites, by law of conquest, by justice of civilization, are masters of the American continent, and the best safety of the frontier settlements will be secured by the total annihilation of

the few remaining Indians."[135] But again, the author's conscious political sensibilities provide no hard and fast guide to the way his aesthetic assimilates certain themes latent in the historical background and syphons them into the symbolic, dreamlike images and shapes of the novel itself. The Munchkins are demarked by their small stature and their "ethnic", "primitive" forms of dress – "all were oddly dressed. They wore round hats that rose to a small point a foot above their heads, with little bells around the brims that tinkled sweetly as they moved. The hats of the men were blue."[136] The Munchkins are nervous, servile, kind and profoundly innocent – on seeing Dorothy for the first time "they paused and whispered among themselves, as if afraid to come farther".[137] The Munchkins could very well be taken from the classical playbook of Jean-Jacques Rousseau; they are in a state of nature – of profound, childlike innocence – and their tragedy lies in the fact that their lack of intellectual agency and self-determination has left them vulnerable to the deprivations of the Wicked Witch of the East who, until the arrival of Dorothy and her house from the sky, had enslaved them. Of course, now that the witch is dead and the Munchkins are free, they cannot be left to their own devices and instead require the leadership of a more benevolent figure, at which point Glinda (the Good Witch of the South) can step into the breach.

Such a vision of one of Oz's "indigenous" peoples represents a kind of settler liberalism; the racism of the colonist is preserved in the guise of a concerned paternalism which seeks to take care of the natives because they lack the agency and self-determination to take care of themselves. It is some way away from the vicious and genocidal language Baum himself employed in a conscious political manner a few years before. For despite its racist and paternalistic overtones, the sympathy of some liberals toward the plight of the Native Americans in the late-nineteenth century was real and was perhaps aided by a string of novels and comics from *The Last of the Mohicans* (1826) onwards which

departed from a traditional narrative that tended to portray the "Red Indian" as an unreconstructed savage and were now more inclined to describe the stoical wise "red man", the wizened, weathered noble "chief" who was at one with the natural world and in tune with the rhythms of the universe. It is these kind of literary traditions which inform Baum's own depiction of some of the "original peoples" who populate Oz. Of course, when these sensibilities have been unconsciously condensed into a set of fantasy characters like the Munchkins, they have lost all the venom of their real-world racism; indeed the paternalistic depiction of the sweet little people is exactly what makes them so relatable and so unthreatening to the child reader. But if the Munchkins are drawn in the (fantasised) context of a nineteenth-century vision of the more benevolent, pliable and unassuming native, then there is still room in Oz's fictional landscape for the depiction of the more truculent, dangerous and uppity variety. In the Winged Monkeys such a depiction is realised. Again, these characters are originally imagined as being in a state of nature – "we were a free people, living happily in the great forest, flying from tree to tree, eating nuts and fruit, and doing just as we pleased without calling anybody master".[137] However they lacked the more benevolent kindness of the Munchkins, and remained "too full of mischief".[138] Eventually the whole troupe were enslaved by a powerful sorceress, and in this capacity, went on to commit all sorts of evils including subjugating other peoples in Oz (the Winkies) and eventually persecuting Dorothy and her helpers.

What the Munchkins and the Winged Monkeys have in common are two central things. Firstly, each group of people are revealed to have been enslaved by some external conqueror, subjected to the will of a power outside themselves. In this aspect, the author displays sympathy with both the kind-hearted little folk and the malevolent, mischievous magical monkeys. At the same time, however, both the Winged Monkeys

and the Munchkins are demarked by the fact that they lack any fundamental power of self-determination themselves. It is true that the monkeys appear as truculent and even rebellious, but they are only really rebellious in the most frivolous sense; like an errant child, they are unable to stop themselves from making the involuntary type of "mischief" which often works against their own best interests. The descriptions of such "peoples" draw upon a series of visions of what indigenous people are in the eyes of foreign settlers – visions which shade through a variety of political hues, from the romantic and benevolent belief in the "noble savage" to the darker and more murderous depiction of the untameable one. At the bottom of them all, however, lies the sense that indigenous peoples lack the capacity to make their own informed political decisions and to consciously regulate the lives of their communities in a manner of their own choosing.[139] Again the question should not be: Has the author carefully and consciously contrived these various sets of peoples – the Winged Monkeys, the Munchkins, the Winkies – to accord to a particular political description of the colonised syphoned through the prism of the coloniser? The question should be: Could Baum have arrived at these chaotic, intuitive and unconscious descriptions of all these fantasy sets of people if he had not been living at a time when an emerging national consciousness – through politics, through a richly developing literature – was trying to justify – and on occasion critique – the basis of its own genesis in the displacement, subjugation and mass murder of a vast array of different indigenous groups and tribes? Again the answer must be a resounding no! Without the backdrop of nineteenth-century America – and the art and literature which mediated the issues and tensions in the dark recesses of the national ID – Baum's mid-Western fairy tale could have hardly been called into being. Again these elements seep into the aesthetic through the backdoor if you will, the intuitive, instinctive capriciousness of the author's own unconscious.

The aesthetic dialectic between the fantasy landscape and the political one is mediated by the unconscious mind – and through this process the work of art attains its own harmony and own equilibrium while retaining the tenor of profound human truth. Sometimes commentators fall into the didactic when they emphasise the political moment one-sidedly, and this, unfortunately, Littlefield is often guilty of. For example, in what is probably the most erroneous statement in his otherwise interesting piece, he argues that the Cowardly Lion was drawn to be a representation of the radical democrat and free-silver advocate William Jennings Bryan. The Lion, argues Littlefield, tries to strike the Tin Woodman with his claws but to his surprise "could make no impression on the tin, though the Woodman fell over in the road and lay still".[140] According to Littlefield, this incident refers back to the real world and "the fact that in 1896 workers were often pressurised into voting for McKinley and gold by their employers"[141] – and so Jennings Bryan's arguments for silver, like the lion's claws, were irrevocably blunted and failed to have the desired impact. One is tempted to observe that such an account is as mechanical as the Tin Woodman himself. Firstly, in the novel the Cowardly Lion shows no real interest in the silver shoes for the most part – and if these represented the silver standard surely he, the Lion (William Jennings Bryan) would be trying to get the Tin Woodman to make use of them. Secondly, if one tries to graft so literally a precise political incident (Jennings Bryan's failed arguments for silver) onto the fantasy occurrence (the Lion striking the Woodman) then one would also be compelled to look for the fictional version of "McKinley" whom the Woodman (the American workers) is compelled to support in place of the Lion (Jennings Bryan). Of course, there is no such figure in Oz. The issue here is about the impossibility more broadly of mapping a concrete real-world set of political relationships directly onto a fantasy narrative which, of necessity, warps and abstracts human categories into a far

more simplified structure, such that it can be appreciated in its immediacy by both young children and adults.

Nevertheless, the spirit of the historical development of the US in the late-nineteenth century does rise from the fantastical world of Oz like a vapour. In particular, Dorothy's tale is pervaded by the anima of the itinerant labourer, the displaced farmer, the idealistic wanderer; the sense of a vast space which was constantly in flux, where new terrains and new horizons were all the time being called into being by modern day acts of pilgrimage and adventure. For the earlier pioneers, the vast landscape of the United States must have seemed at times as imaginary as the world of Oz itself; the notion that even a poor, ramshackle group of misfits could find their own Emerald City, their own piece of land, became the collectivised dream of a generation of poor and displaced people – both newly arrived immigrants and those restless citizens who flitted from one job to another, from one state to the next, all in pursuit of that illusive, seductive chimera, the American Dream. The American Dream was about hard graft and audacity, about getting your slice of the pie at your place at the table, but it was more than simple financial remuneration; the dream was about position yes, but it became embodied in place and time too. It was first and foremost a dream about an exotic Utopia to the West which remained, for a long time, largely undiscovered and seemed to promise great fortune and fame. Such longing pervades the pages of *The Wonderful Wizard of Oz*. The author himself indulged it throughout his own life, for he was something of a nomad, taking on various and diverse jobs, involving himself in a number of haphazard schemes. L. Frank Baum bred poultry, he sold fireworks, he took to the stage as an actor, worked as a translator, opened a store (which swiftly went bankrupt), founded his own newspaper, edited a magazine, published a monograph on advertising and window displays, and worked as a travelling salesman to boot. He left his beloved childhood home, the village of Chittenango

in New York State, and roamed far and wide. He made a new life under the bright lights of cities like Syracuse to the east, all the way to the arid flatlands of rural South Dakota in the mid-West; from the overflowing, colourful cosmopolitan neighbourhoods of downtown Chicago to the verdant forests of Macatawa Park on the shores of Lake Michigan.

But while *The Wonderful Wizard of Oz* does contain the early pioneers' longing for a mythologised land whose rich expanses open up in the West, Baum was also writing in a period when such utopias had already been paved over with the mortar of modernity – where the last bison had been slaughtered, the railroads had been laid down, and the big concrete metropolises like Los Angeles had already begun to bloom. The West, then, might still emit the gleam of adventure, possibility and open horizons, but in reality the intrepid traveller was far more likely to encounter more of the same – the same smoke encrusted cities where they would work for a pittance while a salubrious political elite preened and pandered in city hall, jostling to fill the coffers of the Republicans and Democrats, crafting glitzy political campaigns which were designed to bedazzle the masses and relieve them of what little cash they had. The modern era of a more cynical, stage-managed politics had opened up. Perhaps the one exception, the single mass party which did not represent flagrantly the interests of the rich and powerful, was the Populist Party, and as more and more people rallied to its cause, the giants of American Politics – the Republicans and the Democrats – did everything they could to rip the fledgling organisation out of the ground, to demobilise outright any possible challenge to their own political hegemony. Cynically the Democrats co-opted and rebranded many of the causes which the Populist Party had espoused, and on this basis the Democrats floated their own candidate – William Jennings Bryan – whom the Populists were invited to support. This led, controversially, to the fusing of the two parties which then saw the independent programme of the

Populists annulled and their political base collapse. No doubts exactly what the more experienced, Machiavellian political operators working behind the scenes at the highest echelons of the Democratic Party intended from the get-go.

In any event, by 1900, though the pioneer spirit was still very much part and parcel of the cultural ethos of the US, the notion of a promised land which lay at the end of it was more and more the type of vanishing mirage which seemed plausible only to those wearing the most rose-tinted glasses. To return to the world of Oz once more, when Dorothy and her companions have braved all their tribulations, have traversed the length of the yellow brick road in order to reach the Emerald City, to realise the promise of Utopia, something strange occurs. At the threshold of the great city Dorothy and cohorts encounter a guardian who has a singular demand: the migrants must wear spectacles before they pass through the city walls. Why? "Because if you did not wear spectacles the brightness and glory of the Emerald City would blind you. Even those who live in the City must wear spectacles night and day."[142] The adult reader might already guess, while the child reader is sure to be deliciously delighted by the deception – but it is eventually revealed that the spectacles themselves are tinted with green, and thus the Emerald City only appears to be made of emeralds. It turns out to be a false promise, a scam, a surreptitiously orchestrated con job which makes dupes of a whole population. Again, could such a moment be arrived at if Baum was not writing from a point in time when the promise of the pioneering spirit of the past had not, to some degree, run aground against the more cynical political realities of the US at the turn of the century when industrial capitalism had established itself and taken root throughout the nation? When Dorothy and her merry band are finally admitted into the inner sanctum of Oz the Great, Oz the mighty, Oz the one with a plethora of other titles – they are amazed because to each the magician appears in a different

guise. To the Scarecrow he appears as a beautiful lady, to the Tin Woodman a great beast, to the Lion a swirling ball of fire. The point is that the wizard's defining characteristic is the ability to appear as all things to all people. A more adept description of the centrist politician of the modern epoch would be difficult to find. And just as with much of modern politics, the whole thing is revealed to be something of a sham. Oz himself is a charlatan – a perfectly charming, friendly and unassuming charlatan – but a charlatan nevertheless. In the big reveal, the author shows how the wizard of Oz is in fact "a little old man, with a bald head and a wrinkled face",[143] unveiled to them when Dorothy's dog Toto tips over a screen which is placed discreetly in the corner of Oz's great chamber. Oz himself is a kind of puppet-master, working behind the curtain to create the illusion and spectacle of a powerful, charismatic figure who is able to command the will of those who enter into his orbit. Again, a better metaphor for modern day politics, for PR and the art of spin – one would struggle to discover.

The hallucinatory and surreal landscape of Oz itself represents a form fashioned from the composite scraps of various literary traditions. The presence of the fairy story, of the Brothers Grimm and Hans Christian Andersen is writ large and the forests and the flowers of the rich flora which carpets the terrain are possessed of a ghostly and deathly life. Dorothy and her companions are attacked by wiry spindly trees in the type of sinister dark wood which was once spread across medieval Germany, and they are intoxicated and narcotised to the point of eternal sleep by a field of magical poppies which could have come from the playbook of *Snow White* or *Sleeping Beauty*. At the same time, the childlike sense of innocence, earnestness and vulnerability in the face of encroaching dark forces which pervades the traditional gothic fairy tale is tempered by a modern form of children's literature; figures like Lewis Carroll who had introduced into children's stories a more surreal and humorous bent. Like Carroll's work

Oz is populated with anomalies, the Tin Woodman lacking a heart, or the rather surreal Quadlings who have no arms and are able to extend their necks at a lightening-like speed striking their enemies with their heads, or the infamous all-powerful witch who is vanquished by, of all things, a bucket of water. The more surreal qualities of these creations, I think, help counterbalance the more terrifying elements of the gothic fairy story, so there is a sense of both menace and playfulness, of a dark background against a colourful plateau, and this works in something like *The Wonderful Wizard of Oz* because it is important that the hero – herself a child – isn't simply at the mercy of a set of forces which overwhelm her, and that she is – in contradistinction to the typical fairy tale of yore – the agent of her own salvation. There is no handsome prince who will make an appearance at the final hour and save the day here.

This, in particular, provides for a more modern type of children's story where the agency and self-determination of the child protagonist is brought to the fore. And, in contrast to the Victorian children's stories that were doing the rounds in the same period, *The Wonderful Wizard of Oz* has no simple moral message. It is not structured along the typical, traditional lines of the protagonist in some way transgressing – wandering deep into a forest she has been warned against, eating a piece of forbidden fruit, or failing to arrive home before the clock strikes midnight – and then having to deal with the consequences, having to redeem herself in the process by exhibiting a higher form of moral behaviour. And yet, although there is no clanging claxon and clearly adduced moral message in *The Wonderful Wizard of Oz* (it is too surreal for that) there remains nevertheless a strong moral pulse which runs through Dorothy's adventures. I think it is tied into the novel's themes of self-determination more generally. The sham wizard eventually offers to meet the wishes of the Scarecrow, Lion and Tin Woodman – he offers the Scarecrow "brains" and proceeds to fill his head with pins and

needles. He puts a silk cushion in the Tin Woodman to substitute for a heart. And gives the Lion a green liquid to drink to act as courage. The point is that all three of them are prepared to believe in Oz's chicanery because they so desperately desire these things, and in the instant they do so, they begin to act in accordance with their better natures. The Scarecrow manifests great wisdom and becomes the new leader of Oz. The Lion acts ferociously. And so on. But Dorothy, and vicariously the young reader, understands with fondness – and perhaps a dash of amusement – that such qualities inhered in her friends as potentials from the very start. It is a wonderful and profoundly philosophical conclusion; in as much as the key to the characters' natures – and therefore the human nature which lies behind them – is derived not simply from some static form of being, some generic quality which attaches itself to the person as an innate aspect of themselves from birth. Rather, the true key to their personalities lies in the fluid nature of their social being; their activity in the world and the set of social relationships they participate in and how. This is no mean feat; even today there are plenty of adults – racists, sexists, conservative politicians – who register the human nature only in terms of some biological or generic template. That *The Wonderful Wizard of Oz* transcends such immediacy, and does so effortlessly, with such humour, and without any heavy-handed moral message, is yet another reason why the fabric of its aesthetic has been woven so finely.

In the 1939 film of the book, the director and scriptwriter do something very interesting. Many of the characters who appear in the fictional world of Oz are also paralleled in Dorothy's existence in Kansas. So, for example, at the start of the film Dorothy encounters a mysterious fortune teller named Professor Marvel who is played by the same actor who plays Oz (Frank Morgan). In a similar vein, the Scarecrow is played by the same actor who plays Hunk, a kindly and intelligent land labourer who works on the farm of Dorothy's guardians and befriends

her. His connection to the Scarecrow is nodded at when he urges Dorothy to use her brains. I think this "mirroring effect" provides a superb touch, because even though it doesn't occur in the original novel it very much encapsulates the spirit in which the novel was written. That is to say, the novelist L. Frank Baum is constantly moving from the world of Oz to his own and back again, and thus the contours of late-nineteenth century America bleed through the fantasy membrane and come to inform many of the characters and contexts of a mythological world – albeit in a hallucinatory and surreally bright fashion. And this creates an almost eerie effect; Oz becomes somewhere which is both strange and alien and yet vaguely familiar, it holds a whisper of menace and at the same time it promises a fundamental safety; it is a place we feel we know in the marrow of our bones, and yet we know it only as a memory glimpsed through a dream. It is both wonderful and mundane, distant and domestic, and thus it never ceases to remind the child reader that there really is no place like home.

Chapter Seven

Madeline Miller's Circe: Working Old Magic in a Time of Modernity, Fourth Wave Feminism and MeToo!

The abiding force in all Greek myth is that which Hegel would have described as the "abstract universal" or what you and I might call fate. Even the greatest of mythical heroes has little purchase in the face of overarching destiny. A powerful Corinthian king is humbled by fate, made to roll a boulder up a hill, only to have it roll back down again over and over for all eternity. A mighty titan is strapped to a rock, in the day to be visited by a giant eagle which pecks his liver out, in the night the liver regenerates – the process repeated *ad infinitum*. Even those who use their guile, their intelligence, to evade and thwart their fate end up welding themselves to it with redoubled force. Oedipus seeks to avoid his destiny – the prophecy which says he will sleep with his mother and kill his father – by moving to Thebes, but the attempt to escape his fate paradoxically yields its realisation; he kills a stranger on the way to Thebes who, unbeknownst to him, is his father – and in Thebes itself he marries the queen who, unbeknownst to him, is his mother.

The pre-eminence of the universal, of the objective – the broader movement of fate which takes place at the expense of individual subjectivity, whim and desire – has certain aesthetic consequences too. In the Greek epic *The Iliad* we understand that when Achilles enacts his final, genocidal slaughter of the Trojan soldiers, he does so not in his capacity as a professional soldier, but because the Trojans have killed his beloved Patroclus. But we only ever experience the tenor of Achilles' grief and rage through the series of outward objective actions he enacts – the bloody mass slaughter of the opposing soldiers. But Homer

does not, and cannot, reveal explicitly what is going on inside the great warrior's mind; we are not apprised of his subjective thoughts and feelings about his loss and suffering; there is no equivalent in the epic of old to the soliloquy.[144]

For this reason, one could argue that the task of reimagining the Greek myths for the modern period involves the need to fill the lacuna. In Madeline Miller's exquisite and brilliant 2012 novel *The Song of Achilles* she reinvented the Achilles' story, but went back to his childhood. She showed with beauty and deft simplicity the way in which he and Patroclus became friends as children, and how that friendship, drawn into adolescence, became something more; riven with tentative and wonderful implications. She showed how their romance developed, by providing a window into adolescent subjectivity; all the doubts, insecurities and uncertainties, before finally it gives way before the brutalities of adulthood and war. By the time Patroclus is dead, and Achilles embarks on his killing spree, we the audience feel his searing grief more vividly, for we have experienced, immanently and inwardly, his love for Patroclus bloom in and through a rich inner consciousness replete with childhood suffering and childhood joy. Miller's novel was acclaimed across the board, for its beautiful and fluid writing, its quick pace, its evocative atmosphere mired in a profound knowledge of the ancient Greek world; but most significantly of all, it allowed for the fusion of the antique with the modern, the objective with the subject, and in so doing, created a work of tragic harmony. As I wrote in 2015, *The Song of Achilles* allowed the original epic to become more fully itself.[145]

In raising up the subjective moment, Miller was also able to give life to supporting characters who in the original were somewhat side-lined. While *The Song of Achilles* is the story of the eponymous hero, it is told from the perspective of Patroclus; we see Achilles through his eyes. Patroclus is an outsider, a character who has little "screen time" in the original epic poem,

because he is really the means by which his swifter, stronger lover achieves his heroic deeds and reaches his tragic fruition. But Miller, it seems, is fascinated with all those secondary characters – the marginalised and the "insignificant" – who live on the frayed edges of myth, and who often have little more than a walk on part. They are often exploited by the main characters but also the poets themselves, who conjure them up merely as a means to throw into relief the greatness of the central characters: mostly notably aristocratic Greek males who are seeking to stamp their heroism on the world. Of course, in Homer's time, it would have been inconceivable to write or sing an epic poem which had as its protagonist one of the lesser figures in the mythological pantheon, but for Miller such character types are the most alluring of all.

For her much-anticipated new book, she alights on the figure of Circe. Circe, depending on the source, was a titan/nymph/ minor goddess who is most famously featured in Homer's *The Odyssey*, a seductive and beguiling femme fatale of an immortal persuasion who seeks to enchant and bamboozle the plucky Odysseus, before eventually falling in love with him. As with *The Song of Achilles*, Miller goes back into the childhood of her central character; she endeavours to depict the forces which mould her protagonist into the lethal sorceress who can turn men to pigs and pigs to men again. Because Circe is an immortal, the daughter of Helios god of the sun, she might seem less a marginalised outsider and more one of the Olympian elite, but Miller unveils a childhood which is brutal, exploitative and demoralising.

Circe is born into the Great Hall of the Titans which is presided over by her father and his brothers. It is structured according to a glittering hierarchy of aristocratic privilege and cruelty, in which the nymphs and goddesses are the lowest in the chain, subordinate to the task of pleasuring the men, birthing the children and providing the decorative paraphernalia for a

world which is riven by a murderous predilection for deference, homage and glory. The titans are a bunch of omnipotent nobodies, all-powerful parasites, frittering away their immortality on purely sensual pleasures, court intrigues, furtive love affairs and bitter feuds. The children, the female children in particular, are treated as less than worthless – Circe most of all, whose voice is shrill and whose eyes do not shine as brightly as the other immortals. In a world where sleek beauty and vulpine cunning are prized among the females competing to raise themselves up, the curious, credulous Circe is ill-equipped to flourish, and her sisters mock her remorselessly: "Her eyes are yellow as piss. Her voice is screechy as an owl...she should be called Goat for her ugliness."[146]

Circe is neglected and derided because she does not live up to male expectations of what being female should be: another presciently modern theme which Miller teases out throughout this work. Like many neglected children, Circe spends most of her time alone, exploring the secret crevices of the world around her, wandering in the forests and the rocky beaches, retreating into the rich inner world of her imagination as a palliative to the perpetual, everyday cruelty she receives. Circe becomes something of an anomaly, a blight, an outsider, but her very negation is something which the sorceress in the making is able to transfigure; while she lacks the shimmering beauty and the resplendent magical powers of her immortal brethren, her lonely sojourns outside the Great Hall – the seat of titan power – allow her to start working with her hands, to explore the plants and roots of the forest around her, to milk the sap from strange, otherworldly flowers, to capture their fragrances, to enchant the animals around her. Miller's writing style is delicate but rich, and perfectly equipped to render the processes of agriculture and animal husbandry with a divine, magical sheen:

My powers lapped upon themselves like waves. I found

I had a knack for illusion, summoning shadow crumbs for the mice to creep after, making pale minnows leap from the waves beneath a cormorant's beak. I thought larger: a ferret to frighten off the moles, an owl to keep away the rabbits. I learned that the best time to harvest was beneath the moon, where dew and darkness concentrated sap. I learned what grew well in a garden, and what must be left to its place in the woods. I caught snakes and learned how to milk their teeth. I could coax a drop of venom from the tail of a wasp. I healed a dying tree. I killed a poisonous vine with a touch.[147]

The book is peppered with descriptions of this kind, lavish prose heaving with colour and life, a richly poetic homily to Circe's encounter with nature through her mystical, magical labours. But the idea here involves much more than literary atmosphere and prettification. Miller contrasts Circe's form of labour practice with the decadent idleness of the divine more generally: "By rights, I should never have come to witchcraft. Gods hate all toil, it is their nature…There is no tedious mining, the ores leap willing from the mountain. No fingers are ever chafed, no muscles strained. Witchcraft is nothing but such drudgery. Every herb must be found in its den, harvested at its time, grubbed up from the dirt, culled and stripped, washed and prepared."[148] The titans, for all their omnipotent power, leave no true trace on the world; they kill and they maim, they solicit obeisance and revel in ancient glories, but they do not create, they do not transform matter, they do not shape it into something fundamentally new. They remain supremely decadent, idling away eternity and – for all their strength – they lack imagination. Like this, Miller carefully cultivates an ideological opposition between the manual labour of the oppressed and the pronounced aristocratic parasitism of the oppressor – an opposition which opens up between the human world and the world of the divine. Such an opposition, in fantasy form, has a real and historical resonance

in the ancient Greek world. Homer, for instance, writing about Odysseus, describes how the Ithacan ingeniously fashions his marriage bed out of the roots of a great tree, so that the bed itself remains immovable and sturdy; a testament to the wily Odysseus' craftsmanship and also a monument to the love between him and Penelope. In book XXIII of *The Odyssey* Odysseus says:

> For a great secret went into the making of that complicated bed; and it was my work and mine alone. Inside the court there was a long-leaved olive-tree which had grown to a full height with a stem as thick as a pillar. Round this I built my room of close-set stone-work...I lopped all the twigs off the olive, trimmed the stem from the root up, rounded it smoothly and carefully with my adze and trued it to the line, to make my bedpost. This I drilled through where necessary, and used as a basis for the bed itself, which I worked away at till that too was done, when I finished it off with an inlay of gold, silver, and ivory, and fixed a set of purple straps across the frame.[149]

Homer, like Miller, provides a meticulous almost loving description of the empirical details of manual labour, and in the eighth century BC– the point in time when the ancient bard was supposed to have written – manual labour could still be regarded as something to be respected and revered. Fast forward to the height of the Athenian polis. Here, a class of slaves – organised on a systematic scale and in a much greater number than that which had existed in the Mycenaean Greece of Odysseus and Agamemnon – shouldered much of the burden of the manual labour which helped prop up Athenian democracy and the rich literary and philosophical culture which arose from it. For this reason, the role of manual labour was ideologically reconfigured; whereas Homer, and the heroes he wrote about, would have regarded it as an ennobling endeavour – the great philosopher Plato described "mechanical crafts" or the raising

of "sordid beasts" (farming) as activities which belong to the "lowest rank", allowing their participants to become sundered in materiality, to turn away from the ideal and the "soul".[150] Both Plato and Aristotle described those free men who engaged in manual labour as "banausic", a word which came from a pre-Hellenic term for "fire-worker" and which denotes the degraded state of one whose living comes from some other means than the hereditary possession of land. For Plato and Aristotle, hereditary wealth and the aristocratic lifestyle, free from the drudgery of manual labour, was that which was most able to bestow the sublime and human qualities required for a worthwhile life.

In marshalling the distinction between the hereditary, the aristocratic, the immediate – and the type of labour whose rewards are hard fought for in and through a practical engagement with the objective world – Miller harnesses a fundamental historical distinction which she then superimposes on her magical realm to great aesthetic effect. Because Circe is estranged, because she is in effect an exile in her own home, she begins to develop the type of power that one has to struggle for – to win through for yourself, by your own efforts; something which does not inhere in divine genes and cannot emerge fully formed like Athena springing from Zeus' head. Circe's alienation from the world of the divine, simultaneously presupposes a fascination with the creative imagination, the fight to shape and transform the world through a practical engagement with it, even if the process is hard and drawn out and strewn with failure along the way; or to say the same, in turning to manual labour and the land, and in turning away from divinity, *Circe becomes fascinated with mortality itself.* A fisherman's boat washes up on the island, and she encounters her first real human being. Her fascination with mortality grows:

> His name was Glaucus and he came every day. He brought
> along bread, which I had never tasted...and olives that I liked

to see his teeth bite through...No one had ever confided so in me. I drank down every story like a whirlpool sucks down waves, though I could hardly understand half of what they meant, poverty and toil and human terror. The only thing that was clear was Glaucus' face, his handsome brow and earnest eyes, wet a little from his griefs but smiling always when he looked at me.

I loved to watch him at his daily tasks, which he did with his hands instead of a blink of powder: mending the torn nets, cleaning off the boat's deck, and sparkling the flint. When he made his fire, he would start painstakingly with small bits of dried moss placed just so, then the smaller twigs, then larger, building upwards and upwards. This art too, I did not know. Wood needed no coaxing for my father to kindle it.[151]

Again the same patient, lyrical descriptions of manual labour, the weaving of it with the human life, and Circe's own developing fascination for mortality. From such fascination comes love too, a love for the unassuming and gentle sailor who has washed up on the divine shore – someone so unlike the frigid, power-saturated, imperious creatures who populate her own inner circle. Can gods love? Miller seems to suggest not: they hunger for homage, they are ravenous for worship and placation, but they can only relate to others from the position of absolute power, from the heights of the heavens and the sun. In her fascination with the earth, and with mortality, however, Circe is infected by one of its most profound traits – she comes to love Glaucus. And with love comes terror; a mortal terror, the awareness of death, the inevitable and irretrievable loss of the beloved, and this is something the young goddess experiences too – a splitting tearing pain against an eternally beating heart. Circe is subdued, yes, but determined; quietly stubborn she resolves to gird her beloved against death by transforming him through her witchcraft into one of her immortal brethren. But in rendering

Glaucus immortal, she also warps everything that is good and noble in his personality; more and more does he develop the imperiousness of the other gods, the disregard for mortal life, the empty-headed fascination with beauty and glory. He drifts away from Circe and into the arms of Scylla, the most beautiful of the nymphs. Scylla taunts Circe about the fact that Glaucus has asked her to marry him. Circe mixes a terrible potion from the herbs which surround her, from a sense of rejection and bitter jealousy. She transforms the nymph into the monster.

The incident is crucial to the plot, it is what presages Circe's expulsion from the realm of the titans and her exile to the solitary island of Aeaea. But what happens to Scylla herself is also noteworthy. Before Circe has transformed her into a monster, she is described as "one of the jewels of our halls...The river-gods and nymphs sighed over her....When she moved she clattered faintly from the thousand presents they pressed on her: bracelets of coral, pearls about her neck in strings."[152] Though, in one sense, the other gods relate to her positively – they desire her, they appreciate her beauty – nevertheless one has the sense that Scylla's being is objectified; her individuality is thing-like, set against the other "jewels" in the halls. The others relate to her in purely material terms, "the thousand presents they pressed on her". Again there is something hollow, something reified in these exchanges between the gods and the beautiful nymph, and once Circe has denuded Scylla of her beauty, once she has made her monstrous – the loathing and resentment which the others have always secretly harboured toward the "object" of their desires at once manifests in scathing and hate-filled terms:

> I would have said that Scylla was their darling...But now when I looked around me, all I saw were faces bright as whetted blades. They clung to each other, crowing...My cousins' voices swarmed up to the ceiling. You know she's lain with half the halls....And one of the river-gods voices, rising over

all: Of course she barks. She always was a bitch! Shrieking
laughter clawed at my ears. I saw a river-god who had sworn
he would fight Glaucus over her crying with mirth. Scylla's
sister pretended to howl like a dog. Even my grandparents
had come to listen, smiling at the crowd's edge.[153]

The almost manic sense of glee which accompanies Scylla's
downfall expresses how the female goddesses in the pantheon
are simultaneously desired and despised, both raised up and
demeaned, possessed and destroyed. The way in which Miller
exhibits the contrary elements within a specific type of sexual
objectification has again a very modern resonance; this is
a book which I don't think could have been penned 20 years
ago, before the Slut Walks, fourth wave feminism and perhaps
even the MeToo movement. It provides a highly modern (and
truthful) reading of an ostensibly ancient fantasy world. Scylla's
monstrous fate and the double standards of those who gloried in
her downfall becomes a keen metaphor for the way society can
use a woman's own body against her, as a means to reduce and
demean her. In 2014, for instance, a celebrity hacking scandal
broke. A number of famous and talented actresses had private
pictures of themselves naked, hacked and made available to the
public online.

But the exposure of these women was about more than just
titillation. It was about the attempt to remind them however
elevated they had become in society, nevertheless they could
always be easily pulled down, reduced to their bodies in
isolation, converted into an objectified sexualised thing which
can be possessed and diminished. When some of them spoke
out against this criminal invasion of their privacy, much of
the press bayed in unison that the victims had brought this
treatment on themselves by being too public, too brazen. Again
the line between the adoration of the female body and the hatred
for it becomes a thin one. Writing about the celebrity hacking

scandal, journalist Kelsey McKinney noted: "The response to these pictures is terrifying. It is a perfect, encapsulated reminder that your body can be used as a weapon against you. That slut-shaming is so prevalent and accepted in this culture that you could lose your job, or your boyfriend, or your credibility if a photo you once took was stolen from you — and then you will be the one blamed for it."[154]

In the crime which is visited on Scylla, her body is quite literally "used as a weapon" against her; not, however, by one of the more entitled male gods, but by Circe herself. Again this testifies to the strength of Miller's writing – Circe is, from the outset, a complex character, often morally ambiguous, sometimes tainted by the type of imperiousness and hot-headedness carried by the blood which flows through immortal veins. Her crime against Scylla has the most awful of consequences; in transforming the nymph into a gigantic, snapping, multi-headed hound, she ensures a legacy of murder and mayhem visited on the mortal sailors who have the misfortune to pass their boats through Scylla's cove. In the same vein, Miller presents Circe's sister Pasiphaë as someone who displays all the typical traits of immortality; she is preening, vengeful, superficial, vindictive and delights in subjugation, torture and mass murder. Because Circe, as a child, is an outsider, Pasiphaë bullies her relentlessly and continues to delight in her humiliation as the centuries roll by. Pasiphaë is a nightmare, it is true, but a third of the way through the book the two sisters meet again, and Miller allows an element of ambiguity to slip into the vicious persona the divine Queen of Crete has so ruthlessly cultivated. Pasiphaë comments on the world of the gods in the following terms:

They take what they want, and in return they give you only your own shackles. A thousand times I saw you squashed. I squashed you myself. And every time, I thought, that is it, she is done, she will cry herself into a stone, into some croaking

bird, she will leave us and good riddance. Yet always you came back the next day. They were all surprised when you showed yourself a witch, but I knew it long ago. Despite your wet-mouse weeping, I saw how you would not be ground into the earth. You loathed them as I did. I think it is where our power comes from.[155]

Circe is shocked by this revelation: "She hated our family? She had always seemed to me their distillation, a glittering monument to our blood's vain cruelty."[156] Miller does not absolve Pasiphaë of her cruelty, but shows how she too developed in a condition of alienation, the suffering wrought from being female in a male dominated world; her powers developed in and through the struggle to survive and indeed flourish in such a world. Circe then understands, for the first time, that there is this bond between herself and her sister. The fundamental difference lies in the fact that Pasiphaë has sought her own form of self-determination by accommodating herself to the ruthless patriarchal system in which she is located; she becomes as deadly, callous and ruthless as the most belligerent of the male gods; this is key to her own "survival". Circe's story, on the other hand, involves a radical break with the social system in which she is located; the discovery of her own powers is essentially a revolutionary act which allows her to take the side of the oppressed, of the mortal world.

But even if the opposition between divinity and mortality is, in *Circe*, an opposition between oppressors and oppressed, Miller never portrays the world of "men" as being one of untrammelled goodness. The mortal world, just like the immortal one, is multi-layered and its interactions are complex. The men in question are often brutal, seeking out glory through conquest, pillage and prolonged war, desperate to win the approval of the divine spectres who entertain themselves by rearranging mortal lives, sending them into collision, like pieces set out on a chess board.

Any illusions Circe has in the innate goodness of men are shattered by the rape she endures at the hands of sailors who have washed up on her island in a storm and to whom she has provided hospitality and food. As soon as the goddess is able to recover herself, the men in question are treated to a brutal transfiguration which the author describes in satisfying detail, and the stage is then set for the other elements of the myth – the sailors that are lured to the island to be transformed into pigs, and eventually the arrival of Odysseus himself.

I say "myth" but that really should be plural. *The Song of Achilles* was a single myth; it took flight from *The Iliad* and its perfection had a certain kind of simplicity, resting on the detailed, meticulous unfurling of the relationship which develops between Patroclus and Achilles. *Circe*, however, does not encompass one myth but many: the myths of Prometheus, Scylla and Charybdis, Jason and Medea, Icarus and Daedalus, Minos and the Minotaur, and many others besides. The plotline by which Glaucus falls in love with Scylla is influenced by Ovid, while the concluding part of the novel draws heavily on the mysterious lost sequel to *The Odyssey* – *The Telegony* – which tells the story of Circe's son Telegonus, sired by Odysseus; a son who eventually kills his father as yet another of fate's mysterious but inevitable prophecies is unfurled. The author mixes all these jostling tales into a seamless, harmonious potion worthy of her protagonist. And, in expanding on elements from *The Telegony*, Miller again manages to introduce a more modern tone; specifically, the relationship of Circe to her child, which then becomes very much the story of a single mother – a working woman if you will – who is desperately trying to balance a sorceress' career with the demands of a young squalling child; as the cultural critic Aida Edemariam quips – "even goddesses, in this telling, can run out of nappies".[157] The pressures of motherhood, society's expectations of the mother figure to be both saintly and serene, and the actual messy, visceral work of motherhood itself – the

demanding sucking hunger, the tantrums and the exhaustion – are by Miller harnessed and deftly woven into Circe's isolation as she struggles to bring up Telegonus alone. The complex of emotions – of resentment, fear and love she feels – is raised by Miller to beautiful and humane heights:

> He was not happy. A moment, I thought, I only need one moment without his damp rage in my arms....He hated this great world and everything in it, and me, so it seemed, most of all. I thought of all those hours I had spent working my spells, singing, weaving. I felt their loss like a limb torn away...I wanted to hurl him from me, but instead I marched on in that darkness with him...I held his fierce little face against me. The tears were standing in his eyes, his hair disordered, a small scratch on his cheek. How had he got it? What villain dared to hurt him?...I felt each breath in his thin chest, how improbable it was, how unlikely that this frail creature who could not even lift his head, could survive in the world. But he would survive. He would, if I must wrestle the veiled god himself.[158]

Again there is little place in the original myths for such an inward exploration of the often contradictory emotions which suffuse motherhood. The rage and frustration the mother can feel toward her child at times – emotions which are often denied expression or validity by the rather patriarchal demand that the mother be only ever a willowy soft, unfading source of warmth and love. Of course, in the original poems and myths female characters such as Medea sometimes did exhibit very dark and contradictory behaviours toward their progeny. But it is worth noting that Medea's horrific killing of her children does not emanate from the organic nature of her relationship to them – but from the fact that she is a woman scorned; she does what she does because her actions are a response to the way she has

been used by a man, by Jason. Even in this, the most deliberate and cruel of acts, her fate has been, by and large, determined by forces outside herself, shaped as a desperate lovelorn response to masculinity. It is not only horrific, but it is in some sense fundamentally pathetic. Miller's achievement is to show how single mother Circe struggles with her child, struggles to make of herself an effective and decent parent in conditions of loneliness and ostracisation, and Telegonus' graduation into a kind, curious young man is stamped with the ferocious and unrelenting determination of his mother's love. This, of course, helps set the basis for the finale of the novel, the way Circe's story ends. The conclusion is fittingly moving, and without giving too much away, it is in keeping with the central theme of the novel, teasing out the one condition of life which is capable of enchanting the sorceress herself.

Hilary Mantel recently argued in her Reith Lecture speech that a "persistent difficulty for women writers who want to write about women in the past" is that often those same writers "can't resist retrospectively empowering them".[159] In my view this is not a "difficulty" in Miller's *Circe* – rather it is one of the novel's highest aesthetic attributes. But the form of empowerment Miller develops is a very specific one; it is conjured up from disempowerment – *in Hegelian terms it represents a negation of negation* – its possibility is created in and through alienation and subjugation. Circe becomes strong and authentic and genuine and most truly...human because she is an outsider subject to the deprivations of a social system which is geared to work against her. It is in this context that the possibility for true freedom and self-determination is grown. Looking at the American political landscape, the MeToo movement, Black Lives Matter, the Slut Walks, Occupy Wall Street – it is difficult, for me at least, not to feel in Circe's ancient, epic struggle something of the form and the impetus of these broader political movements, which were also shaped by those who have been in some way exiled

from the political mainstream and who begin to develop their own powers of freedom and self-determination in response. In bringing out the lives of the marginalised in ancient myth, in delivering to them an authentic voice through their subjectivity and pathos – Miller not only brings out more fully the dialogue between freedom and oppression which pervades the modern age, she is also, perhaps, spearheading a literary revolution of types. As the journalist Lucy Scholes writes:

> The Classics are undergoing something of a feminist revisionist revolution right now. Emily Wilson's new translation of *The Odyssey* – the first to be written by a woman – was published to great acclaim at the end of last year, and this August brings Booker Prize-winner Pat Barker's new novel, *The Silence of the Girls*: a "radical retelling of *The Iliad*" from the point of view of Briseis, the captured queen-turned-slave. So too, Miller's Circe is a woman who will not be silenced.[160]

Chapter Eight

The Nature of Conceptual Art in the Epoch of Finance Capital

This chapter involves a critical response to an article by Marxist writer John Molyneux – "The Legitimacy of Modern Art". His article provides a defence of the art of Tracey Emin, Damien Hirst and others who participated in the Young British Artists movement. In so doing, it provides a broader defence of "conceptual art", going back to Duchamp and his infamous work *The Fountain*, arguing that the conceptual art movement represents a positive, vibrant and radical development in art history as a whole. In fact I would suggest that many of the works he cites do not fall under the category of art at all. I will endeavour to show how the weakness in Molyneux's root understanding of what art is and his confusion in the way he applies the concepts of use and exchange value in Marxist theory inexorably generates a series of errors on his part.

The first section of "The Legitimacy of Modern Art" contains much of value. Molyneux goes back to the initial development of modernism in art and notes how such development was more extreme and more radical than its counterparts in either literature or music. He suggests this was partially due to the invention of photography. Prior to the mid-nineteenth century artists were often commissioned to paint individuals or things as "realistically" as possible. But with the advent of photography – "the camera placed the ability to achieve a more or less exact likeness in the hands of millions of people at minimal cost and with minimal skill".[161] Molyneux also cites a change in social relations.

Somewhere between the Great French Revolution and the revolutions of 1848 there is a change both within the ruling

class itself and within the stratum of the middle class that produces most artists. On the one hand, the rich and powerful become coy. Gradually they lose the desire to be visibly personally glorified – perhaps it makes them feel too exposed as tempting objects of expropriation.[162]

One can't help but feel it would not have been easy to be an artist at this time. Much of the traditional material of artists had been rendered obsolete, and this is why modernist art was often so radically orientated; it was art which was violently striving to find its place in the world once more, to overcome its disorientation and stand firmly on its own two feet.

Molyneux suggests that much of the criticism that was levelled at modernist art was the result of this. Because modernist art was forced to break so radically with its own past it attained a character which, at first glance, often seemed strange and disturbing. Molyneux references the controversy generated by Picasso: "So shocking was *Les Demoiselles D'Avignon* that it offended even Picasso's avant-garde artist friends and remained face to the wall in his studio, un-exhibited until 1937."[163]

Molyneux argues that the controversy generated by modernist art in the early part of the twentieth century has much in common with the controversy which surrounds the works of people like Tracey Emin today; it is generated by the radical and visionary nature of the art itself.

Molyneux examines the particular forms which the criticisms of contemporary conceptual art tend to take. Such criticism often stipulates that the modern art of the kind produced by the Young British Artists movement is not really art at all. It is somehow illegitimate, something other. But, Molyneux argues, to say that something is illegitimate – that is to say it is not really art, one must have some notion of what genuine art should be. The question of what art is becomes the centrifuge on which Molyneux's defence of conceptual art is premised.

So what is genuine art? Molyneux begins by demolishing the assumptions which some of the critics make. There is a common assumption, for example, that real art must involve some degree of naturalistic representation; that it should seek to mimic or imitate a material world object as keenly as possible. But, as Molyneux correctly points out, once this criterion is applied with any comprehensiveness, one would have to exclude "a lot of Picasso, Braque, Mondrian, Pollock, Mirç, Moore and Brancusi, but also African art, Muslim art, Australian Aboriginal art and even Giotto".[164]

Molyneux draws attention to a reaction which contemporary modern art sometimes elicits – "my four year old child could do that". Molyneux regards such criticism as a superficial, reflexive response to an issue which is far more complex. He points out that Picasso was an extremely skilled naturalistic painter by his early twenties, and that later Cubist and Surrealist works have profound technological merits when closely scrutinised. It was not the case that Picasso lacked the traditional expertise or that Cubism was simply the medium in which such shortcomings were disguised.

The same is true of Pollock whose paintings at first glance could be construed as a chaotic mess but on closer examination it is seen that the control needed to handle "the drip technique" demonstrates great skill.

These points are not without merit. Certainly Molyneux is correct – technical skill is not always visible at a single glance but at the same time demonstrating the presence of technical skill is not the same as demonstrating that something is art. Molyneux tends to ignore this in the examples he cites, where he focuses on technique to the exclusion of other factors. For example, he comments on the artist Mona Hatoum and one of her more infamous works:

Hatoum used an endoscope to film the passages inside her

body and then projected the resulting video onto the floor within a cylindrical structure which the viewer has to enter to see the work. Once again all sorts of technical skills are involved but not traditional art skills.[165]

Molyneux argues, for better or worse, this is a form of art. It is his one-sided emphasis on the technical skill involved, I think, which has allowed him to perceive artistic process where there is in fact none. All Hatoum has done is to project a medical procedure outward onto the floor of a museum. This involves a scientific procedure rather than an artistic one.

It is true, however, that modes and forms of culture are not mutually exclusive. All modes of culture borrow from one another experiencing a perpetual transformation; art is influenced by the developments in society at large: science, technology and the set of social relations which underpin them. Art, in all its specificity, must at the same time invigorate itself by drawing sustenance and strength from the totality; the social whole. It must filter social change through its own individual dynamic.

But the case of Hatoum using an endoscope to film passages inside her body and displaying this on the floor of a museum does not present us with an example of such organic cultural synthesis. Instead Hatoum's "art" provides an external and artificial unity between art and science – the scientific procedure is brought to bear from the outside and simply imposed. It appears as art only for the arbitrary fact that it exists here within the walls of a museum in the context of an exhibition. The same thing confined to a screen in the hospital would simply be medicine. The so-called art work it not, therefore, distinguished as art in relation to itself, but only as a related-ness to an other – i.e. context and location.

But Molyneux contends that such a thing is art. It might not be an example of good or great art, he says, but nevertheless it falls under the category of art more broadly. In order to understand

why Molyneux reaches such an erroneous conclusion we must scrutinise more fundamentally his account of what art is.

Molyneux argues that art, in the last analysis, involves unalienated labour. This is correct but also abstract, something Molyneux himself realises. He points out that "scientific" texts are as well often the products of unalienated labour but few would regard them as art – for instance "Lenin's writing of *The State and Revolution* was undoubtedly un-alienated labour." Thus a further question is raised. What differentiates the unalienated labour involved in science from that involved in art? Molyneux argues this involves a distinction of form and content. He states:

> Only a particular kind of non-alienated labour produces art, namely labour in which there is a unity of form and content or, to be more precise, where the form is the content. Lenin's writing of The State and Revolution was undoubtedly un-alienated labour but it was labour in which the content – the exposition and development of the Marxist theory of the state – far outweighed in significance the form – the specific words employed to convey the meaning.
>
> State and Revolution in English or in French is essentially the same work as in the Russian original, provided the translation is competent nothing fundamental is lost. It is quite otherwise with the poetry of Mayakovsky. A translation of a poem is not at all the same as the original because in poetry the exact words count: the meaning of a poem consists not merely of the sum total of the dictionary definitions of the words used but also of all those words' connotations, their sounds and their rhythm.[166]

Such an account is riddled with errors and arbitrary assumptions. It is true that poetry loses much in translation because in poetry the rhythm and the rhyme of the original words are unlikely to find their precise echo in another language. The rhythm

and rhyme (the form) has a powerful bearing on the content. If one wants to express anger in a poem, the poet might employ sharp, staccato-like sentences peppered with alliteration, and thus the sense and feeling of the poem would be as much derived from the form of the sentences as the actual meaning or content of the words. But this does not justify Molyneux's emphatic declaration that the "form is content" more broadly. It is possible that Molyneux is borrowing from Lukács here[167] but, if so, he has substituted an empty unity for the dialectical interplay between form and content which the great Hungarian Marxist so deliberately cultivated.

In most literature the form is not, in the last analysis, the critical issue. It is the content – the array and subtlety of the ideas which are expressed through the development of character and plot, and which have a universality that resonates as truly for the Russian reader, as it does for the English reader or the Spanish one.

It is the content rather than the form which has logical priority in most forms of literature and this is something every translator worth their salt understands; you do not move from the one language to the other by remaining loyal to the form and framing the words in literal translation; rather you must use different words and different idioms, longer sentences or shorter ones, in order to capture the gist, the (social) essence, of what is being conveyed. Whether one thinks in Hindi or Portuguese, as a human being one knows what it is to struggle, or to be in love, or to feel hope. These are the types of experiences which predicate great art, and they pervade the multiplicity of its forms.

This is not to suggest that a bad translation can't ruin a good book because of course it can. And there are some writers, the magical realists in particular, who tend toward a fluidic prose which often leans quite heavily, in my opinion, on the form rather than the content. That is to say the beauty of the language sometimes obscures the fact that the characters are often sparse

and one dimensional. The reader might disagree with me about magical realism but it seems quite clear that the form/content question must be approached organically and in each case and not simply asserted as an undifferentiated unity. Behind this rather undialectical and mechanical assertion that in art the form is identical with the content, there lies a deeper methodological antagonism. Molyneux emphasises that art as unalienated labour has an explicit social content. He cites Marx: "A negro is a negro. He only becomes a slave in certain relations. A cotton spinning jenny is a machine for spinning cotton. It becomes capital only in certain relations."[168]

Molyneux goes on to say: "If we apply this approach to art we can say that paint or other marks on a flat surface, arrangements of words on paper, sequences of sounds in the air etc., only became art in certain social relations."[169]

It is true that a person becomes a slave only in a particular set of social relations. The fact of the body is a natural thing; it derives its personality, its humanity, from the set of social relations it enters into which allow for the realisation of "myself" as a philosopher or a builder or artist or slave. But the "paint or other marks on a flat surface, arrangements of words on a paper, sequences of sounds in the air etc." are not naturally given in the way the body is. They are things which have already been socially constituted as writing or painting or speaking or singing.

Van Gogh's *Sunflowers*, for instance, is constituted as a work of art because it has already arisen out of the life processes of society. It is not the case that the already constituted thing – *Sunflowers* or any other type of "paint or other marks on a flat surface" – awaits the moment in which it enters into a set of social relations, and these confer upon it retroactively a supra-social meaning as art. In other words the notion that the "paint or other marks on a flat surface, or arrangements of words on paper, sequences of sounds in the air etc., only become art in certain social relations" is to pose things upside-down – in fact it

is "certain social relations" which are first embodied in the object as art. Such an inversion might seem trivial but it is decisive in terms of the conclusions Molyneux eventually arrives at.

Let's consider Molyneux's own comparison more closely. He suggests that "paint or other marks...become art" in much the same way as a spinning jenny becomes realised as "capital". This collation contains within itself the germ of Molyneux's theoretical confusion. Commodities are bearers of both use and exchange value. The use value, however, is logically prior in as much as the use value of a product is inherent to it from the very moment it is called into being. Exchange value (at this point) only exists as potential; that is to say it exists as a potential to be actualised through exchange in the sphere of circulation. In other words the commodity yearns to realise its exchange value through its mediation in circulation, but its use value remains prior in as much as use provides the premise of exchange in the first place – a product must appear as a use value to the buyer who wishes to purchase it for purposes of consumption (assuming they are not large capitalists or shop-owners purchasing for reasons of reinvestment).

But so too does the work of art – as a finished product of labour – contain its use value, not as a potency but as an actuality which is present in it from the moment of its creation. The ability of a Van Gogh painting to move one with its beauty (its most significant use value) is not something which "becomes" in the way in which exchange value does. For its true nature as an end in itself, as a use value, is already given in the process of artistic labour which has called it into being. It doesn't "become" art in certain social relations – rather it is already that art which, in containing a use value, embodies certain social relations that have been mediated in and through the unalienated labour of the artist. *Sunflowers* by Van Gogh would be an objective work of art in its own right whatever the nature of the set of social relations it was located in. It would move us whether we encountered it in

the resplendent setting of the Louvre or in a dank underground basement.

This problematic is crucial. Molyneux's comparison of the art work with the spinning jenny as realised capital allows him to conflate use value with exchange value – that is, the use value of the work of art only "becomes...in certain social relations" – or to say the same thing, the use value here behaves as an exchange value because it is posited as a "becoming". Before this "becoming" the artwork is not a genuine work of art at all but merely subsists as "marks on a flat surface".

The many erroneous assumptions and arguments Molyneux goes on to make flow inevitably from his clouding of "use" and "exchange". For example, if the use value – the thing as art in itself – "becomes", then it quite naturally follows that something like a urinal or an unmade bed "becomes" art, i.e. realises its use value as a work of art, in and through the social context in which it appears. This is all important. We can now see why it must seem to Molyneux that an orderly pile of bricks on a building site is not art, yet when "137 firebricks" are "laid side by side across the floor in a single row at right angles to the wall" in a museum – this becomes art because:

> Andre's bricks...retain one crucial skill that they share with Hatoum and Whiteread, Pollock and Picasso, and, indeed, with Michelangelo: the intellectual skill to conceive of the work...the intellectual understanding of art, art history, society etc. to conceive how a particular intervention such as exhibiting a urinal or line of bricks could make a meaningful point or raise significant questions.[170]

And so the "use value" of much conceptual art, and the art of the Young British Artists movement in particular, does not operate according to the *modus operandi* of use value in general but rather according to the logic of exchange. The art object "becomes" art

only in certain social conditions (exhibition in a museum), just like a spinning jenny only "becomes" an exchange value when brought into the sphere of market relations. The true use value of a work of art (its truth and its beauty), which should inhere in it from the moment the art object has been created by the artist, is – in conceptual art – transformed into an "exchange value" which is only realised when the object is placed in a certain social context. Thus in conceptual art we might say that exchange value overwhelms use value.

What this logic allows us to perceive is not that people are revering these "art works" as cutting edge and avant-garde simply because they are desperate to keep up with some empty but fashionable standard, though this may be superficially accurate. What is exhibited here is a more profound truth; that is, the way consciousness is mediated by the forms and structures of social existence. One of the fundamental features of the ongoing global economic crisis of 2008 is the predominance of exchange value over use value, in as much as it is a crisis of finance over and against industry. Less manufactured goods are produced in proportion to the creation of financial incentives such as subprime mortgages, the packages which combine these and the subsequent speculation on such packages; all of which, in tandem, created the financial bubble.

The use value of a chair for most consumers (as opposed to capitalists buying the item in bulk for purposes of investment) consists in its ability to be sat on (though of course it has other plausible use values – firewood, for instance). But when someone purchases a "package" of subprime mortgage loans the use value for the buyer consists in the product's ability to make him or her more money. In other words the use value here appears as something which accords explicitly with exchange and the reproduction of capital. Profit is increasingly generated from the packaging of mortgages and the insurance of these packages instead of the actual productive activity of building new houses

in order that people "use" them to live in.

Likewise in the sphere of conceptual art, the meaning of art is increasingly abstracted from the process by which the artist creates the object through his or her unalienated labour activity. In the Young British Artists we see this vividly – the artist merely presents a ready-made object – the creation of which was nothing to do with the artist. The artist's activity is abstracted from the process of production in a similar way to that of the financial speculator. In the case of Damien Hirst, the abstraction was so extensive that he actually had assistants create the vast number of spot paintings he puts his name to. Hegel says "essence must appear". In conceptual art we see the appearance of the fundamental conflict of capitals, industrial and financial, which is, as Marx would say, a "practical abstraction" that takes place at the level of social being in its historical unfolding. Conceptual art is one of the forms in which that abstraction appears to consciousness.

There is a saying which I remember from childhood. It comes from Michelangelo who said that every block of stone has a statue inside it and it is the task of the sculptor to discover it. The simplicity of this expresses perfectly the nature of the artistic process: the way in which beauty and humanness become embodied in an object, how the ideal is, quite literally, concretised in and through the delicacy and deftness of the artist's labour as he shapes and transforms the marble block.

Now imagine if, at the height of the Renaissance, it was not the statue of David that was presented at the entrance of the Palacio Vechioo but instead a large slab of stone from which a statue might have been carved. Or perhaps several slabs of stone arrayed in a nice pattern. One can imagine the surprised and dumb-struck expressions of the Florentines who had gathered to witness the great unveiling. One might even imagine that those expressions of surprise would deepen, had the artist Michelangelo stepped forward and announced, "It may not be

art as you know it but I am certain it will raise some interesting questions." And it almost goes without saying that Renaissance art would have been poorer as a result.

Molyneux tries to qualify the inherent methodological weakness of his approach. In his discussion about the bricks and the urinal he goes on to say the "intellectual skill" could also involve:

> The understanding or perhaps intuition (and, indeed, courage) to see that a pile of bricks or whatever could be moving or beautiful; the aesthetic skill to arrange the bricks etc. in a form that would be moving or beautiful.[171]

But this too is a subjectivist adjunct. Here the artist sees that the given thing has the ability to be beautiful, rather than imparting to the thing its beauty. Art does not involve recognising a given object as beautiful or even arranging several given objects on the floor of a museum, because none of this manages to make the leap from the quantitative to the qualitative; the object or objects are either re-located or re-arranged but they have not been transformed into something fundamentally new. They remain given, rather than created.

Unlike Molyneux, I fail to see how a row of bricks or a urinal can be moving but even if we consider something which seems more immediately beautiful like a rock formation or an uncut diamond, nevertheless placing it in a museum and arranging several in a row does not bestow upon it the status of art. Molyneux is correct in his assertion that art involves unalienated labour but he does not differentiate between the external unalienated labour as a pure subjectivity which falls from its object like water off a duck's back, and the unalienated labour which manifests in the object, transforming it immanently, recreating it in its own image. Because he does not make this distinction in content, he is then compelled to make form the

determinate factor in differentiating between the unalienated labour of art and political science.

Molyneux fails to develop a more concrete definition of art from his correct summation that art involves unalienated labour. He presents us with a form/content relation which is rigid and ahistorical and which cannot withstand examination. He confuses the function of use value and exchange with regard to the production of the art object. And that is why when he comes to defend the specifics – the bricks or the unmade beds as art – he has little to fall back on in the way of a coherent theory and can only conclude that such things are art because they enjoy a degree of popularity.

> A work of art no matter how much it develops out of or against a tradition must stand in its own right and work visually on its own account if it is to be taken seriously. I believe the better examples of modern art do precisely this and the evidence I would cite is the relative popularity of modern art.
>
> Obviously modern art is not popular in the sense that football or EastEnders are popular, but it is popular in the sense of appealing to a substantial constituency of people, a constituency much wider than the art world elite, pretentious bourgeois, or people with expert knowledge.[172]

This spawns a further set of problems. The main one being the way in which Molyneux notes how "obviously modern art is not popular in the sense that football or *EastEnders* are popular". But he does not bother to go beyond the immediacy of something which is "obviously" true. He does not feel that it is important to show how the popularity of modern art differs from the popularity of *EastEnders*. Is it merely a question of numbers; i.e. is it purely a quantitative question?

In actual fact it is not, though the qualitative content is

expressed in a quantified manner. *EastEnders* and fictional television stories more generally (soap operas, films, cartoons, plays etc.) enjoy more popularity not simply because larger numbers of people happen to tune into them but because they have the potential to express and mediate broader forms of social consciousness, and (to a greater or lesser degree) the revolutionary aspects which inhere in these. Painting and sculpture, at least in British society, is no longer able to achieve a deep penetration of the wider forms of mass consciousness. More concrete forms of art such as film and contemporary music have taken their place in this respect. To point this out is not to lapse in a stale form of philistinism. Indeed the truth of it can be adduced from another section in Molyneux's article. It is necessary to quote him extensively. He says:

> There is also the peculiar way in which the art market works that is distinct from the operation of the literary market or the music market or the cultural market generally. Despite the hopes and expectations of Walter Benjamin, the art market, and with it the art world, is dominated by the individual or institutional ownership of individual "unique" works of art.

This has a series of complex effects on the nature of the art world and on the production and consumption of contemporary art. Art works are surprisingly expensive to produce, requiring costly materials, studio and other storage space and exhibition space. This is true of the traditional oil painting, especially if it is large. It is even truer of sculpture and modern installation works – Damien Hirst's *Shark (The Physical Impossibility of Death in the Mind of Someone Living)*, for example, is rumoured to have cost £80,000 to construct. It costs many millions to buy.

One consequence of this is that the art market and the art world are dominated by an extraordinarily small number of

rich and powerful individuals – a few immensely wealthy collectors and patrons, of whom Charles Saatchi is currently the most important in Britain, and the managers of a few key institutions, such as the Tate Gallery in London or the Museum of Modern Art and the Whitney Museum in New York. The other significant players are those big corporations who decide to invest in art such as the Japanese company that paid over £27 million for a Van Gogh Sunflowers and state institutions and local authorities who have significant commissions in their gift.

In other art forms, with the exception of the special case of architecture, the logic of the market links financial reward with some degree of mass popularity such as numbers of books or records sold, numbers of seats sold for performances etc., while both rewards and popularity are distinct from critical acclaim. In painting and sculpture mass popularity is almost irrelevant; both financial and critical success depend on appealing to the tiny elite of art world makers and shakers.[173]

Herein lies the secret to the contemporary "art" which is produced by the Young British Artists movement. Not only the workers but also the small bourgeoisie have a great deal of difficulty participating in contemporary art in Britain because of the expense which is involved. It is a realm dominated by the elite – even if the individual "artist" emerges from the lower ranks. But this is more than a directly economic question. In modern art, the costs of production and the investors who provide the patronage are the decisive factors in determining what will and can be exhibited whereas "mass popularity is almost irrelevant". A truly Marxist analysis cannot afford to under-estimate the significance of this.

In modern music the situation is quite different. A band like The Beatles will eventually go on to make more money in and through the commodification of their music than will any modern

artist. But what was crucial in bringing The Beatles their economic success was not the judgements of the music executives (though these eventually intervened) but the judgements of the masses themselves. The Beatles tested such judgements time and again through their organic development as musicians – through the gigs they performed at various bars and clubs across the country and in Europe before they attained wealth and fame, and earlier still, when they were swapping records and discussing the latest music as teenagers. The formative experience of their early years was conducted against a perpetual throb of music – a soundtrack which was a ubiquitous and integral element of the era itself.

In other words every level in their musical development, first as early individuals, then as a band, was mediated by a culture in which music as an art form had been generalised, allowed to permeate every social sector – from the music people listened to on the radio as they were working on the factory line, to the music of early rock and roll which was flooding the dance halls, or the stuff the kids would imbibe from their record players at home. Can one seriously suggest that Tracey Emin's unmade bed – from the moment that she got out of it to the point at which it appeared in a gallery – had been mediated by a similar dynamic?

Molyneux acknowledges how "in painting and sculpture mass popularity is almost irrelevant: both financial and critical success depend on appealing to the tiny elite of art world makers and shakers" but he has failed to register the sheer significance of this. The fact that this particular art form has ceased to be mediated in and through the majority in any meaningful way – "mass popularity is almost irrelevant" – is what gives to it its degenerate character. Molyneux again has things upside-down – for him much of the hostility to such "art" comes from the fact that "the art market and the art world are dominated by an extraordinarily small number of rich and powerful individuals – a few immensely wealthy collectors and patrons". For Molyneux

this presents as an unhappy but incidental fact.

But it is not the case that most people resist this type of art because it emerged on its own terms through a broad social spectrum and was then co-opted by an elite – as happens with a lot of modern music and which often results in a crass form of commercialism. Rather the social basis of such modern "conceptual art" flows inexorably from the sleek upper circle "of rich and powerful individuals – a few immensely wealthy collectors and patrons". They provide its foremost mediation. That is why people resist it! They experience in it something alien to themselves. That is not to say that such "art" doesn't attract some proportion of the masses because of course it does. As do circuses. However, the majority of this type of "art" is produced by the petty bourgeoisie but a petty bourgeoisie whose artistic activity is disconnected from the masses more broadly. It is not the case (as Molyneux realises) that such "art" is contrived as a form of making money on the part of the individuals, of fooling people for profit. The truth is that such "art" like most art issues from the small bourgeoisie organically but unlike genuine art it has ceased to draw its inspiration from the life of the whole. It remains isolated and formless, unable to rise to the level of "the good, the beautiful and the true".

Figures like Tracey Emin or Damien Hirst might genuinely believe in the "art" they create but as artists they themselves remain atomised; the content of their work finds no resonance in the development of contemporary life more broadly, and is not infused with it. That is why their "art" comes to constitute itself, in the last analysis, as a despair – an empty, hopeless utterance which tells us above all that there is nothing possible beyond an arrangement of bricks or an unmade bed. What does that unmade bed represent? Above everything it embodies disarray. What does a cow pickled in formaldehyde convey? Stagnation perhaps. And a human skull bejewelled in diamonds – is this not decadence and death? These representations of modern

"art" are not simply coincidental or contrived but, as Molyneux might say, here the form really does embody the content, for the content itself has become degraded such that what remains is nothing more than an empty husk. What is expressed by these works is how a once mighty cultural form has decayed to the point that it has ceased to be shaped by the life processes of the masses in any meaningful way. Contemporary modern art in Britain as expressed by the New British Artists' movement is not the fact of art but the fact of its negation.

This isn't true of all contemporary art across the board, however, for all economies and cultures experience an uneven and combined development. In Ecuador, South America, for instance, there is a rich and vibrant artistic tradition among the substantial indigenous population; their art is everywhere – in the markets, the shops, the museums and on the beaches. Many of the paintings are rich and colourful; if they depict death they tend to do so in light of life; the pictures are powerful but also fantastically innocent. The joy and vitality involved in a lot of this art gives a vital impetus to the artistic drives of other layers of society; the traveller can't help but sense a burgeoning, a flowering all around her. It is not true that contemporary art as painting and sculpture is in abeyance in all places at all times, but it has decayed in Britain irrevocably because of the set of conditions peculiar to Britain.

What is art? – Molyneux has asked. He is correct in describing it as unalienated labour but he runs into problems when he tries to distinguish between the unalienated labour embodied in a work of science and that embodied in a work of art. He argues that it is a question of form and content but his theorising of this relation is at best schematic and arbitrary. Even if we were to admit that, in art, the form is the content, while in science the content is separated from form to such a degree that the form means very little; even if we were to admit such an opposition, it would still leave the question of what art is, and what it does,

fundamentally untouched.

I will confine myself to a few remarks on the issue. Dostoevsky's fictional masterpiece – *Crime and Punishment* – is a work of art which tells a story against the backdrop of Russian society in the latter part of the nineteenth century. It was a time when the bonds between peasants on the land, tested and strained under the brutal and oppressive weight of serfdom, were now breaking apart as that archaic system collapsed. As a result there were mass emigrations from the countryside to the city as whole populations were pulled inexorably into the whirlpool of urban life; an upheaval that naturally found a corresponding echo in art and politics and culture more broadly.

Dostoevsky's vision in *Crime and Punishment* is bleak and perturbing; he calls into being an urban landscape which overshadows the fragmented and atomised lives which inhabit it; the world of the underground in which a million souls are pressed tight together, and yet each, for the most part, is entirely alone. Dostoevsky uses a fictional story to demonstrate what it means to be a human being living in such a world; in the character of Raskolnikov he gives life to the despair and rootlessness that such a life entails. At the same time despair is merely a moment in an ongoing dialectic, for though it is despair which causes Raskolnikov to commit his terrible crime, after everything else, he is still able to find his redemption. This happens not only through the acceptance of his punishment, and indeed his rather Hegelian need for it, but more importantly, through the love he inspires from Sonia, a poor prostitute.

So Dostoevsky is able to show us, nay, make us feel, not only the sense of abiding alienation which the individual experiences under capitalism but also the moment of hope in which such a contradiction is transcended or overcome. In Dostoevsky it is important to note that the agent of such overcoming is often someone drawn from the poor and oppressed. The truth which resonates in this type of art is the same truth which lives in the

pages of Marx's *Capital* and Lenin's *The State and Revolution*. The difference is that the truth of art is expressed in an emotive and intuitive manner; a semi-conscious and fantastical way which reduces the forms of social reality to the interplay of imaginary characters in a novel, or colours on a canvass.

Art is the medium in which history dreams; it comes to life as the revolutionary agency awakens, for art desires what revolution eventually achieves; that is the superseding of one epoch by the next and the outpouring of freedom which goes alongside this, but while great art feels the truth of this, and is the truth of this, it can only embody that truth, that sense of freedom, in a beautiful and mystified and individual form. Through the emotive relationship of characters or colours rather than the scientific relationship between sociological categories. Such truth is confined to the realm of feeling and imagination for the revolutionary agent has not developed sufficiently for it to be posited as a "scientific" fact.

Thus Dostoevsky was not merely distinguished from Lenin and Trotsky by the fact that the latter two happened to be more interested in political science and the former was more involved with literature. The revolutionary impulse was given its best expression at that particular time in Russian society through literature; the conditions in which it might be politically posited did not yet exist, for the urban proletariat had not yet developed as a coherent and independent entity. The main political current came from the young socially conscious men and women from the middle classes, the *Narodniks*, who drew their faith in the revolution from the character of the peasantry, and the political disorientation which this provided was very quickly translated into terrorist tactics. One can well imagine that there must have been a good few Raskolnikovs in their numbers. But the same tendency which would prove disastrous in terms of political activism was realised as the highest and most sublime form of art in literature.

To express the difference between art and political science as an identity in difference is to show that both have at their hearts the one and the same object; the potentiality of human freedom in the context of class exploitation and the revolutionary moment which mediates and transcends it; in art this object is projected onto an imaginary realm where it attains a beautiful but ultimately distant and individualised character.

In his *Third Critique*, Kant pointed out how, when you look at a great painting, you sense that a great truth has been conveyed but at the same time it is a truth which feels impossible to articulate. This is not, as Kant claimed, a result of an element of the noumenal, of the (rationally) unknowable, shining through. Rather the Hegelian insight – that art provides a more abstract moment in the necessary journey of Spirit – is more germane here. For the difference between art and political science is exhibited in the movement from the abstract to the concrete which political consciousness (in the broadest sense of the word) is compelled to traverse. Art is the expression of the truth of the political consciousness which has not, as yet, descended from heaven to earth; it contains the truth of the social world but only through the distorting prism of its fantasy.

In the film *V for Vendetta*, the protagonist Evey Hammond suggests "artists use lies to tell the truth". Concise but exactly right. The real distinction between political science and art lies, not as Molyneux has imagined, in an abstract unity of form and content; rather the truth of political science rises in the world when the conditions have matured sufficiently such that the same truth, expressed in an artistic form, has shed its fantastical character. Such truth no longer requires its mystical shell – it no longer needs the "lie" – for it is no longer the beautiful and melancholic yearning for social transformation; but rather apprehends the possibility of change as a concrete and practical fact with its basis in coherent social agency. Nevertheless the horizons of the future will nearly always become visible to the

artists first, even if in a dreamed form. And where older modes of art cease to be able to mediate the structures and forms of social existence, new modes will arise in their stead.

Chapter Nine

Three Billboards Outside Ebbing, Missouri

This is a film which is, in the idiom of the industry, "Oscar bait". It would go on to win a selection of trophies, including the Oscar for best actress, and it would be nominated for many more, including that of best original screenplay. But what makes it so Oscar-worthy is it pulls off that trick of looking like a film which has a radical, ground-breaking slant, while in fact harbouring a rather conventional core. It starts off very well indeed, and its premise is undoubtedly powerful and original. Mildred Hayes is grieving for her daughter who was raped and murdered a few months previous, but the crime has gone unpunished, and now her grief has taken on the tenor of cold, abiding fury and an incredible determination to see justice done. With this in mind she rents the three billboards of the title, and has written across them in succession: "Raped While Dying", "And Still No Arrests?" and "How Come, Chief Willoughby?"

Naturally this sets the stage for a conflict with the local police force, their embarrassed chief and the people in the larger community who support him. It is a not-so-secret secret that Chief Willoughby is suffering from a terminal cancer and his is a beloved and admired presence in the small town. It eventually transpires that the chief is a competent investigator and a good man, and this is set against Hayes' irreconcilable determination to great dramatic effect. The two characters are rather well-balanced antagonists; both are gritty, stoical, sly and shrewd; if they hadn't been thrown into collision by fate's forces you get the impression they might have been great friends. As it is, they settle into their battle of wits, each displaying a great relish in the combat. One of the most moving scenes occurs when they are sniping at one another, caustic digs flying back and forth,

but from the midst of the banter the chief suddenly coughs up blood onto Mildred's face. The flash of pathos and pity which crosses her face in response to the humiliation and shock the chief displays is a testament to the astounding range of actor Frances McDormand, who is able to provide not only the gritty exterior but also a profound inward sense of humanity with just a look or a word.

So why does it go wrong? Part of the answer lies with the "schizophrenic" character of the chief's second-in-command, Officer Jason Dixon. When I say "schizophrenic" I mean that the writer has essentially written two independent characters here and fused them into one and the same person. On the one hand Jason is an ignorant, naive, blundering and tantrum prone momma's boy who is overly aggressive but also lost; behind the angry exterior lies a frightened but essentially good person. On the other he is a racist psychopath, a torturer and a sadist whose crimes are shielded by his uniform. In the humorous exchanges with the more worldly-wise Mildred, he always comes off the worse, while the film emphasises his cloistered relationship with a domineering mother – all to create the impression of a rather ridiculous, baffled boy who has never quite grown up. Chief Willoughby becomes the stern but benevolent father figure Dixon lacks, and when the chief dies he leaves his protégée a letter which outlines his true feelings: "I think you've got the makings of being a really good cop, Jason, and you know why? Because, deep down, you're a decent man. I know you don't think I think that, but I do, Dipshit. You play hopscotch when you think no-one's looking, for Christ's sakes..."[174]

At the same time, the film suddenly lurches into the second archetype – a corrupt sadist who brutally beats an innocent man before throwing him out of the window, a cop who has a reputation for torturing blacks in the prison cells. A real cognitive dissonance opens up here; if he is a good man deep down, if his aggression is just displaced, estranged anger which harkens

from a sense of loss and melancholy, then the horrific nature of the crimes he is said to have committed is inevitably trivialised. This is exposed rather jarringly in a scene when Mildred, having been detained by the police, is confronted by Dixon. She looks at him before remarking in a wry, deadpan tone: "So how's it all going in the nigger torturing business, Dixon?" He responds with wounded dignity: "It's 'Persons of color' torturing business, these days, if you want to know."[175] The exchange is obviously intended as a comic one and in some ways it is. The droll, no-nonsense way in which Mildred broaches the subject of the young man's violent tendencies. The way in which the redneck cop is gripped by a sudden, earnest, politically correct fervour. But at the same time Mildred's use of the word "nigger" is somewhat jarring, especially given the setting – the American South, the home of Jim Crow, the Klu-Klux-Klan and those trees whose branches so often hung heavy, bearing their "strange fruit". I am not saying that the protagonist and the heroine of the film – a redoubtable, stoical and practical white woman in her early fifties who has lived a hard, rural small town life in the American South – should have been drawn as an archetype of political correctness, that her language should necessarily be purged of all racist inflection. To do so would run the risk of creating an unlikely or atypical character, and perhaps one who is too smooth, too unblemished, to be believable. But my impression is that the racism here is handled too lightly – when the acts it refers to are so genuinely horrific and have a real resonance in the historical context in question. Mildred's off-the-cuff racism should be more than a device for some snappy, ironic dialogue which provides a moment of casual humour. It should tell us something more profound about the character, the contradictions which exist within her, and the world she lives in more broadly.

In other words, it should be "problematised". It should be presented as something inhuman – a deficit which exists in an

otherwise profoundly humane character; and the way in which she deals with such an *aporia* at the heart of her own being should become a significant dramatic focus for the film. It requires more than a breezy and superficial treatment which is coated with more than a little of Tarantino-like hipness and edge. Likewise, the acts which it alludes to, the acts of the torturing of blacks – which we are led to assume the deputy has carried out – should mean that the character of Dixon is drawn in far more serious terms. The glib casual treatment of the racism is bound up to the treatment of his character as a somewhat aggressive but goofy, and essentially goodhearted individual; a depiction which is utterly out of sync with the horror of the acts the deputy has participated in. For this reason, the glib treatment of racism in this context becomes more than simply a political-moral question; it also has a powerful aesthetic bearing on the film. The character of Dixon is distorted aesthetically, precisely because his racist actions aren't taken seriously by the writer; he therefore becomes a caricature of himself. A more serious film would have given his racism and his racist actions the gravitas they deserve; if the character of Dixon is to be granted some kind of moral redemption (and in the film as it stands he eventually is), it should have come as a result of the conscious awareness of the pain and suffering he has visited upon others; his own eventual comprehension of the moral consequences of his brutal and inhuman racism, and the haunted, belated attempt to make some kind of amendments for it. In turn this would have delivered to his character an aesthetic breadth and depth which the current incarnation lacks.

But the deputy's redemption does not come this way. How does it arrive? It arrives with the letter, the letter which comes from Chief Willoughby, one of a series of letters which the chief writes after he commits suicide in order to spare his family from the pain of witnessing his slow and terminal decline from cancer. The letter – already cited – expresses the fact that the

chief, wistful and paternal, recognises that Dixon is a good man and has become a little wayward since the death of his father. It is the reading of this letter which delivers at once and in pristine condition the full moral redemption of a character who has committed such awful atrocities. The atavistic race hate, the sadistic brutality, the amoralism and utter corruption at once vanish, and we are left with only the essentially goodhearted but naive young man who has now decided he will support Mildred in her struggles. His doppelganger, the other Dixon, is banished absolutely. Mildred too is a beneficiary of one of Chief Willoughby's letters, and in it he explains that the killer of Mildred's daughter has not been brought to justice – not for the lack of trying, but because there "are just some cases...where you never catch a break, then 5 years down the line some guy hears some other guy bragging about it in a bar-room or a jail-cell and the whole thing is wrapped up thru sheer stupidity. I hope that might be true for Angela, I really do."[176]

Why is this important? Because it narrows the scope of Mildred's struggle. The original premise suggests that the main dramatic conflict occurs between a bereaved, working-class mother and a police department who are on some level indifferent to her struggle to find justice for her daughter; thus the dramatic premise of the piece is at once political and universal. It is political and universal in as much as we know that in places around the world poor young women experience horrific violence and murder in high numbers, and yet often these crimes attain a level of political and cultural invisibility, and are not adequately dealt with by governments and police forces which devalue and disregard those same lives. Mildred's struggle for justice for her daughter automatically becomes a political struggle in as much as it is directed against a broader, more universal injustice; Mildred is Mildred, but she is also the Mothers of the Plaza de Mayo in Argentina, she is mother to the thousands of young first nation women who have been

murdered or gone missing in Canada, yet whose faces remain undefined and invisible; she is the spirit of the mothers who clamour for justice in Mexico's murder ground Ciudad Juarez – where the images of kidnapped and killed young women stare out with muted eyes from posters strapped to telephone poles.

But some way into the film we discover that there is no institutional sexism or indifference on the part of the local police; the crime goes unsolved simply because they haven't "caught a break". At once Mildred's fight for justice is denuded of its universal and political implications, and the film becomes a more saccharine affair. The role of the police chief himself is no longer adduced from its basis in an authoritarian state institution which helps perpetuate both class and patriarchal oppression; he is not someone grappling with the contradictions inherent in his social function – and so he becomes unmoored from the social world in which he operates. As a result Chief Willoughby is transformed into a paragon of justice and virtue which exists outside society and in abstraction. The letters delivered after his death manifest his pure goodness and nobility, and provide the catalyst by which Dixon discovers his humanity and unites with Mildred in order that the dramatic contradictions in the film achieve their resolution. Dixon does not grapple with the contradictions of his own historical past – the racism and the violence – he merely has his redemption handed to him by way of letter. Mildred ceases to struggle against social and institutional forms of injustice; once she understands the unblemished template of goodness which Willoughby represents (a revelation also delivered by letter). It is Willoughby's goodness which, in turn, absolves the police department of its social character – i.e. a character derived from the broader forms of oppression at work in class society more generally. Willoughby, then, is transformed into an almost saintly figure which resolves the political and social contradictions which underpin *Three Billboards'* aesthetic landscape at the start of the film; Willoughby acts effectively as

a *deus ex machina* bringing resolution from the outside.

This is clear when you consider the way the film starts and the way the film ends. At the start of the film you have a poor white woman, struggling to get some visibility for her murdered daughter, fighting against the prejudice and conservatism of the town in terms of its police department and clergy – but by the end of the film this same woman is sat in a car with one of the police deputies, and they are preparing to go off, in order to hunt down and kill a suspected rapist (not the one who murdered her daughter). They make casual quips: "You sure about this...About killing this guy? /Not really. /You? /I guess we can decide along the way."[177] That "I guess we can decide along the way" wreaks of the laid-back indifference, the casual swagger, of the all-American action hero in his prelude to violence; it is something which could have been uttered by Schwarzenegger or Stallone. By this point the whole tone of the film has changed; now it feels more like a buddy cop action comedy with a revenge motif. The sense of loss and isolation which is inspired by the spectacle of those billboards on a desolate country road; their haunting words of recrimination, the presence of the disembodied and the dead against the backdrop of a desperate mother's struggle – all this is phased out in favour of something far glibber and less serious. The film itself is "schizophrenic" – that is to say it contains within itself two films with the poorer one eventually overwhelming the better one.

What would *Three Boards* have looked like if the writer and director had stuck to the premises and aesthetic of the first part of the film? Firstly, the character of Willoughby would not have been bumped off in order to be canonised. The cancer story is a tremendously effective one, but would have worked better if it had been played out for the whole film; that would have allowed for a more serious treatment of the issue, but also it could have acted as an effective metaphor for the misogyny, racism, brutality and indifference which was part and parcel of local

police enforcement. The notion of those social ills as a wasting but invisible disease consuming the society from the inside. As Mildred struggled against the police force and the conservative forces in the community more broadly, her bravery might have helped the dying police chief finally see some of the practices of injustice and repression endemic to the institution he is the head of. Mildred's sacrifice might have brought him over to her side, and his redemption could have come from forging a relationship with her, and taking her part against the broader community – even if such a struggle would, more likely than not, have had an unhappy ending. We would be dealing with a film which fully encompassed authentic realities and social contradictions, playing them out with searing inevitability, and the characters would have grown out of such social contradictions, imbuing their actions with a realism and pathos which would have lingered long after the credits had faded to black. Such a film would have been a slower film, for sure; it would have been less dramatic in terms of action, and perhaps the black humour would have been a little more understated – but it would have been, potentially, an incredibly powerful and truthful work of art. In an era when remakes are ten a penny, and are rarely as good as the original – think *King Kong* or the recent *Ghostbusters* for instance – here is a film which would benefit from a remake almost like no other. Perhaps, however, it is because the film eschewed this kind of follow through in favour of a more snappy, fast-paced second half that it was so commercially viable in the first place.

In any event *Three Billboards* remains important in terms of its failure, its squandered potential, especially for any investigation into the art of writing and the nature of film more broadly. Firstly, this film throws light on the most fundamental task for any writer; that is, to unspool the thread of necessity which runs through both character and plot. Aesthetic skill lies in the ability to create characters which are grounded in fundamental

social-historical contradictions and whose lives attain a richness and fullness such that, after a while, it feels as though you – the writer – are simply a passive observer, merely recording the details of those lives as they unfold out in front of you in the form of an independent existence. In the case of *Three Billboards*, the film's beginnings are pregnant with such necessity, and the characters step forward as authentic and true, and what makes this so fascinating is that you can see the precise points – the moments of rupture – when the writer breaks with the aesthetic logic he himself has called into being.

The second important consequence flows from this; the moments when the aesthetic necessity is broken tend to be those moments when the social contradictions behind a character's motivation or struggle are absolved, and as a consequence that character becomes depoliticised. So, for example, when Dixon goes from being an extreme individual expression of institutionalised racism and police brutality to a more amiable and bland hero – the social contradictions which set the basis for his character – the contradictions of race and class in the American South – are dissolved; at which point his character loses its authenticity and literary power – a direct result of it being depoliticised. This is quite significant in as much as it shows that profound writing is a profoundly political act – albeit unconsciously so; the depth of aesthetic authenticity is immanently and organically bound up with the social and political contradictions which moor the character to the broader world; the political and the aesthetic, therefore, must be fused in a full and harmonious unity. Naturally this does not mean that the writer must invest characters with his or her own political agenda, or that the characters themselves must be drawn in accordance with some "politically correct" or "progressive" set of politics; if their motivations are impressed on them from the outside by the conscious political instincts of the author there is a real danger of creating something lifeless or didactic. But in

denuding character of its organic political inflection – and thus the social and historical contradictions which underwrite it – one loses aesthetic integrity, and the character is in danger of being downgraded to a cartoon-like shell; a parody or paragon of good or evil, its human content excavated and banished, in favour of the sensational, the arbitrary, the faddish or the transient. To paraphrase Aristotle, we are all of us political animals.

Chapter Ten

The Sopranos: All that Comes to Be is Worthy of Perishing

The cover for the boxset of season 5 of *The Sopranos* is a work of art in itself. In the distance it shows a bleak, darkened horizon, the skeletal outline of a bridge crossing the melancholy blue of a vast waterway, and the dying embers of a blazing sun which is about to slip out of sight once and for all. In the foreground stand various figures, the central characters of the series which tells the story of the New Jersey based crew the Sopranos. All of the characters are decked out in black, from the lugubrious, menacing mob boss Tony Soprano and the shadowy figures of his criminal associates, to his sister and children who are crouched by his feet sitting on an old wooden barque which has been marooned in the mud. The sense of the elegiac and the funereal is compounded by the fact that the mud stretches out further still, and in its damp, sooty silt a series of bodies are framed – crooked, contorted – the victims, both past and present, of the Soprano crew's ongoing battle for power and prestige.

The cover is decidedly modern, film noir-ish almost, but at the same time there is a flavour of Greek mythos and classical tragedy too – the sense of fate and the furies, and their invisible but interminable grasp, as they pull even the most powerful and hubristic destinies ever closer to the all-consuming darkness of that awaiting mud. And this contradiction, the one between the archaic and the modern – fissures through the show more generally (which is why the cover does such a fine job). There is a scene – toward the end of the fifth series – in which Tony Soprano's daughter (Meadow) is confronted by her boyfriend Finn regarding her family's way of life and all its violent underpinnings. Finn has had a part-time job working on a

building site run by friends of Meadow's father – and has been witness to an incident of casual but horrific brutality on the part of Tony Soprano's colleagues leaving him aghast and upset. The actor, Will Janowitz, does a fine job of conveying the nervy trauma which the young man is in the grip of. From a respectable, modern middle-class Italian family, he is unable to assimilate what has happened, for it is so out-of-kilter with his everyday experience as a somewhat privileged, liberal college student, studying in his father's footsteps, desperately hoping to become a dentist.

Meadow's reaction is telling; the darkness in her eyes simmers, and she gazes at her boyfriend with a sudden flash of contempt. "You know you talk about these guys like it's an anthropology class," she says softly, "the truth is they bring certain modes of conflict resolution from all the way back in the old country and the poverty of the Mezzogiorno where all higher authority was corrupt."[178] On the one hand, Meadow's response is self-serving. Like Finn, she is a bright young college student, primed to enter a world of middle-class respectability; generally speaking, she holds to the same set of modern and politically progressive sensibilities as he. But she endeavours to rationalise the problematic aspects of her father's world with a veneer of romanticism – perhaps as any child would, if they felt at a more protean level their own origins being called into question. At the same time Meadow's dark, almost gothic description does hint at the core of *The Sopranos'* dramatic power more broadly; for it is very much the case that the Soprano mode of life is an archaic structure which has been imported from a different time and grafted onto modernity.

The fossilised sense of etiquette which the gangsters so meticulously observe – the relentless ceremony from the kissing on the cheeks, to the gathering together of "families" for banquets, to the cutting of the hand which marks the moment an underling in the hierarchy becomes a "made man" – all of

this seems to indicate a certain decadence, an antiquated mode of life which is particularly susceptible to entropy and decay. And this is significant. For despite the power and the fury of its individual actors, the Soprano business is often at odds with the modern world, struggling to adapt, weighted down by a legacy of tradition and outmoded prejudice, which increasingly threatens both its solvency and its efficiency. Tony and his colleagues are in different parts courageous, vicious, sadistic, brutal, cunning, loyal and acquisitive, but nevertheless the operation as a whole is always in danger of foundering, for the existence of these figures who still dress in the dapper, dark suits and raincoats of the heyday of *La Cosa Nostra* in the early twenties appears as something of an anomaly lodged in the frenetic flow of twenty-first century modernity. *The Sopranos* exploits the tragedy but also the farce which stems from this. It is hard not to recall with a smile, for instance, the scene when Tony's "nephew" (actually a second cousin and also a "made man") Christopher is spiralling out of control on drugs – and his older, more seasoned criminal colleagues are inveigled into taking part in an "intervention" for his benefit. The middle-aged mobsters mutteringly acquiesce but from the start they are utterly flummoxed by the procedure; they sit back warily in their black suits perched like stiff crows on the edges of the group circle, at which point they are asked to read aloud their feelings about the impact Christopher's drug use has had upon them – a request which is met unanimously with looks of gaping horror. When the stilted, disjointed words from these flinching, uncomfortable men eventually do arrive – the volatile young man who is the subject of the intervention at once says the wrong thing, and the whole scene immediately descends into sprawling violence.

The theme of psychotherapy is more than just a comic device, however; it is key. It becomes an exemplar of the modernity which the Sopranos are compelled to confront and yet lack the resources to adequately engage with. This is, of course, most

clearly demonstrated through the relationship of Tony Soprano and his psychiatrist Doctor Melfi. At the outset of the series it is revealed that Tony has been having panic attacks which cause him to pass out, and, as boss, it would prove detrimental to his position if his subordinates were to witness one of these – fatal, even, if any of the rival crews got wind of such weakness. Grudgingly, Tony Soprano accepts the hospital recommendation to seek therapy. The sessions he has with Dr Melfi range from the volatile to the sentimental, but throughout Tony Soprano remains evasive and sceptical, not just for the knowledge that he must keep the true details of the horrors he has inflicted under his hat, but for the underlying cultural sensibilities he is in the grip of – the sense of unreconstructed masculinity whereby the revelation of interior feeling is a taboo sign of terminal weakness and a lack of character. In the very first episode Tony Soprano appeals to the heavens in exasperation:

> Let me tell ya something. Nowadays, everybody's gotta go to shrinks, and counselors, and go on Sally Jessy Raphael and talk about their problems. What happened to Gary Cooper? The strong, silent type. That was an American. He wasn't in touch with his feelings. He just did what he had to do. See, what they didn't know was once they got Gary Cooper in touch with his feelings that they wouldn't be able to shut him up! And then it's dysfunction this, and dysfunction that, and dysfunction...vaffancul![179]

The outburst concludes with a swear word spat with contempt – "vaffancul" – which in this context probably translates as something like "fuck it" – but it is no coincidence that he reverts to the language of the old country, for this is a diatribe against modernity more generally – the breakdown of tradition, the rise of the atomised individual of modern capitalism, the pure ego which, bereft of social bonds, inevitably turns inward setting the

basis for the plumbing of the depths of the human psyche. The sudden strident curse – that deliciously expressive "vaffancul" – is Tony Soprano's attempt to put the modern ego back in its box, to revert to the strong silent type personified by Gary Cooper. But while he is strong – while he is a physically hulking presence – the Soprano boss is not so powerful as to escape the gravity of his own epoch. Part of the tragic element of his sessions with Dr Melfi lies in the fact that the Soprano chief goes some way to adapting himself to a more modern and humane existence; much of what he says is sentimental bluff designed to gloss over the true ghastliness of some of his more bloodthirsty actions, this is true – but every now and then, a moment of genuine understanding, genuine compassion, seeps through. When one of Tony Soprano's capos beats in the brains of a young woman in the car park of the strip club where she works, the mob boss – who has exchanged a couple of gruff but kind words with her in the days before – is appalled such that he breaks one of the most fundamental laws of Mafia protocol – to never strike a "made" man. He sets upon the weazily psychotic Ralph Cifaretto with terrifying fury but what is even more shocking is the indifference of the Soprano crew to the callous murder of the kind-natured girl. When his friends manage to pull Tony Soprano off the bruised mob underling, one of his lieutenants, Paulie Gualtieri, is outraged that Cifaretto has cursed his boss out during the course of the attack – "cock sucker was way out of line!" At the same time Gualtieri seems entirely oblivious to the horrific act of violence which has ended this young woman's life and caused the fracas in the first place. Soprano remarks softly, ruefully – "Twenty years old, this girl" – at which point his underboss finally makes some kind of acknowledgement – "Yeah, that too."[180]

Later, in conversation with Dr Melfi, Tony Soprano tentatively approaches the incident but dresses it up in a different form – "A young man who worked for us...Barone sanitation, he...

he died." Melfi inquires further, only the Mafia boss is laconic and unforthcoming – "You don't know him. He died, that's all. Work-related death." Finally, he adds in a soft whisper which almost breaks with pathos – "It's sad when they go so young."[181] The achievement here is very much down to the late, great actor James Gandolfini, who somehow manages to make this seamless transition from one scene to the next, from dead-eyed murderousness to a moment of heart-breaking tenderness. But it is also accorded to the rhythm and writing of the character more generally; each time Tony Soprano's better nature is in danger of breaking through, the logic of his criminal existence and the traditions of masculinity which he has inherited at once weld him to a more brutal and atavistic set of behaviours. The need for empathy, for emotional depth and sensitivity, isn't wholly lacking on his part, and yet, more often than not, it is strangled at birth by the broader realities of his existence. Such a tragic dichotomy is made manifest most profoundly in the case of Tony Soprano's son Anthony Junior (AJ). His son is softer, kinder, spoilt, unambitious, passive and introverted. For much of the time Tony Soprano is ashamed of him, the boy seems so distant and weak in comparison to himself, and yet there are moments when an almost elemental sense of love and compassion bursts through. When AJ, in a funk of despair, makes a half-hearted suicide attempt by attaching a brick to his leg and then plunging into the family pool, his father is the one to rescue him, and Tony Soprano's shocked incomprehension as to why the young man would do such a thing suddenly breaks into the most moving paternal tenderness, as father cradles son in his arms, his voice breaking – and it is as though the adult AJ was no more than a helpless infant again – "Come on, baby. It's OK, baby."[182]

The scene is incredibly moving, but what really lends it a tragic tinge is what happens a few episodes down the line, when the plot trajectory has entered into a terminal freefall, when the Soprano clan have been pulled into an all-out war with a rival

outfit, and all the portents are in place to suggest that both the Soprano crew and its charismatic leader are not long for this world. Tony Soprano's two closest lieutenants have already been shot (Silvio Dante and Bobby Baccala) and on a dark evening the mob boss arrives at the family home in order to evacuate his wife and children, while he himself goes into hiding. When he informs AJ of the decision, the young man, still in the grip of a powerful depression, hesitates and whimpers. The rage which flickers in his father's eyes suddenly ignites, he grabs his boy, wrenching him from the bed like a rag doll, dragging him across the room and flinging him toward the wardrobe, at which point Tony Soprano begins to tear down clothes, allowing them to flutter and fall on the prostrate, sobbing form of his son. What is key to the scene is that the father's anger has been actualised by the fear and helplessness of his child. Tony Soprano's masculine disgust for such vulnerability on the part of the boy galvanises his rage and leads to an act of real brutality against AJ. The tragic element, then, comes from the fact that Tony Soprano's role as a father placed him on the edge of some kind of redemption only a few episodes before, when he rescued and consoled his child, but once again the logic of events has seen the father revert to a more callous and brutal paradigm. The sadness is enhanced, of course, by the creeping awareness that this is to be one of the final encounters father and son are to have.

What *The Sopranos* does so masterfully is to show how the destiny of an individual protagonist and that of his epoch more generally is locked into an inevitable and tragic freefall, hurtling toward oblivion, for both individual and epoch are bound organically to an antiquated mode of life which is unable to survive the shock of the modern day, and the form and outline of an alien future. In the second episode of the first series, the mobsters are lounging about in the backroom of the Bing – the strip club where they do much of their business. There is something indolent about the scene; the men, in their suits, in

the gloom – drinking and smoking, playing cards and counting money. They are talking about nothing in particular; one man, flicking through a gossip magazine, wonders – "What if they had cloned Princess Di?" – while another makes a joke about blowjobs and an associate's mother. It is as if they have too much time on their hands and are whiling away that time in a stupor of listlessness and boredom. In the background a TV screen flickers. A talk show programme has alighted on the subject of the Mafia. The voice of one of the commentators is audible: "You know," it says, "the heyday, the golden age or whatever of the mob? That's gone, and that's never comin' back."[183] Again, what one encounters here is a telling example of "To Hellenikon" – or "the Greek Thing" – for the TV in the background has, at the very beginning of the mobster epic, articulated exactly and explicitly the situation of the Sopranos, and thus hinted at the inevitability of their downfall. And what is this other than the voice of Delphi uttered in the idiom and guise of the modern day – through the television rather than the temple? The difference, perhaps, lies in the fact that those living in antiquity took the oracle's pronouncements with grave seriousness, patiently trying to decipher their meanings, but in the world of the Sopranos, the mobsters who are only half listening barely bat an eye.

It is probably fair to say that *The Sopranos* has a good deal in common with the cowboy films and comics of yesteryear. Eric Hobsbawm writes about the gauchos of Argentina, and how their historical destiny was sealed by the fact of modernity; "so in the Argentina of Sarmiento, the tragic element in this struggle was clearly seen: for the progress of civilisation implied the destruction of values that were recognised as noble, heroic and admirable, but historically doomed".[184] According to Hobsbawm the fabled notion of the American Wild West – its aesthetic power – was constructed on this kind of model, the fading image of a more chivalrous time, bound by certain *machista* traditions and modes of conduct. But Hobsbawm is also at pains to note

that such accounts are largely fictitious; the reality was, in fact, far more prosaic – "the invented tradition of the West is entirely symbolic...local Western newspapers were not filled with stories about bar-room fights, but about property values and business opportunities".[185] But what gives *The Sopranos* its artistic integrity and a powerful sense of authenticity is this – not only does the writer demonstrate the inexorable, inevitable trajectory by which a more antique mode of life passes from the scene – but at the same time, unlike the legends which surround the Wild West, he is never tempted to idealise it; in fact David Chase goes out of his way to reveal not only the casual brutality of mob life, but also to show the hypocrisy and egoism which so often pervades it. Tony Soprano may have been acculturated to respect notions of family honour and blood ties but these inherited traditions are nearly always interrupted by a callous self-interest of a more modern sort.

To his "nephew" Christopher, the mob boss describes the importance he places on the family connection in that trademark husky whisper brimming with intensity: "I'm gonna rely on you more and more, 'cause you're the only one I can fully trust. Sil and Paulie...they're old friends, but you're one thing they're not....Blood. You're gonna lead this family into the 21st Century."[186] At the same time, however, this doesn't stop him, some episodes later, from moving against Christopher in a scene of such pronounced sinisterism it is enough to make the viewer shudder. Christopher has once again succumbed to drugs, and has crashed his car with Tony Soprano in the passenger seat. Relatively unscathed, the mob boss is able to exit the car, and by this point is aware that the disorientated Christopher is once more under the influence. Outside the car, he (Soprano) types in the first two numbers of the emergency services on a mobile phone, before pausing, regarding his nephew slumped over the wheel, and those eyes seem to flicker and then narrow and then deaden – the audience in that moment at once aware of the

calculation which has taken place inside his head. Christopher's drug problem makes him too much of a liability, especially in a period of time when the FBI prey upon every possible weakness in order to procure informers. Slowly, methodically, the huge bear of a man leans in toward the lanky frame of his youthful underling, before placing two fingers on his nose, suffocating him, snuffing out his life.

In the confrontation with modernity, then, the communal values which should sustain the Soprano way of life often collapse into nihilism, and this is another of the great themes the show brings out, demonstrating with powerful artistic verve how the corrosive corruption of Tony Soprano's criminal enterprise erodes the ethical life of those closest to him, eating into every moral certainty and revealing a gaping, ravening blackness beneath the cracks in existence. In a superbly crafted and intensely powerful scene, Carmela Soprano, the mob boss's wife, is plagued by guilt for she is aware that her husband's business involves more than just "waste disposal" and that – by virtue of the mansion, the trinkets and the dresses – she herself has been made complicit. At a point of tremendous inner turmoil, she seeks psychiatric assistance. Her encounter with the psychiatrist takes place in a softly lit room by a fireplace, the shadows creeping across the walls; her doctor is a small, austere man – the lines of time etched into his wrinkled countenance; and whereas before the psychiatrist occurs as a clear cypher for modernity (think Melfi in her modern, suave business suits), this wizened, grave old figure is more like a Father Confessor. Indeed, the whole scene has a decidedly Graham Greene flavour; in that small gloomy room the light flickers mournfully as Carmela – a committed Catholic housewife – engages in a desperate battle for her mortal soul. At first she tries to rationalise the role of her husband, and vicariously her connection to him – "He's a good man. He's a good father." The psychiatrist comes back, softly – "You told me he is a depressed criminal, prone

to anger, serially unfaithful...is that your definition of a good man?"[187] Gradually the psychiatrist unravels all the ideological rationalisations Carmela has cultivated in an *amour-propre* – the outward front of respectability and artifice she presents to the world – the psychiatrist remorselessly strips this away, before delivering his devastating, damming verdict in that same voice, soft, interminable:

> You must trust your initial impulse and consider leaving him. You'll never be able to feel good about yourself, never be able to quell the feelings of guilt and shame that you talk about as long as you're his accomplice....Leave him. Take only the children. What's left of them and go...I'm not charging you because I won't take blood money. And you can't either....
>
> ...One thing you can never say that you haven't been told.[188]

The warning provides Carmela with an almost transcendental glimpse into the horror on which her existence and privilege is based, and at this point, bereft of all further rationalisation, she is only able to respond in a broken whisper – "you're right. I see".[189] But the truly shocking thing is how easily – despite this consciously articulated, new found awareness – Carmela returns to the normal patterns of her day-to-day routine, living with her husband, and enjoying the "perks" his lifestyle provides. The weight of her religious traditions, the impetus of her own private conscience, the grave warning her psychiatrist has provided; in the long run, these things simply don't carry the moral heft which is required for her to break away from her complicity, and as her value system reveals itself as little more than a fading façade, what pertains in the aftermath? A lower middle-class lady of the house inflicted with an inferiority complex – her wounded feelings balmed by the fact that she is in the type of elevated financial position which allows her to attend

fund-raisers and galas, and so bask in the company of her social "superiors". The Gucci handbag, a $50 000 necklace, a beach house, an expensive watch. Nothing else but these. This, then, is nihilism of the purest, bleakest variety, for the violence which it affects is not carried out against the body but against the soul. Carmela's ethical and religious values have collapsed; in the words of Nietzsche, for her God really is dead and it remains only to include Dostoevsky's famous caveat: Now anything is permissible. It is small wonder that AJ, her son, lounging about the house, goes from being a happy, mischievous child to a young adult gripped by a severe depression; it is not the typical but temporary funk a teenager might slip into but a full blown existential crisis which endangers his very life, and at its core nestles the type of nihilism which he has absorbed organically and wholesale from his mother and father. The writer goes out of his way to emphasise this: "There is no God," mutters AJ in an argument with his parents and then later, echoing the words of his grandmother, he says morosely, "[i]t's all a big nothing."[190]

But the ultimate collapse into nihilism occurs, of course, in the final scene of the masterful series. It is a deceptively simple set piece. Ostensibly it shows the Soprano family gathered around a table in a fast food restaurant, music from a jukebox playing cheerfully in the background. They are talking amiably, only the scene then cuts to black for a few moments before the end credits start to role. It provoked frustration and disappointment in equal measure when it was first shown, for it was felt the series had ended with a vague whimper rather than a definitive bang. A closer analysis, however, reveals what is perhaps the most shocking and revolutionary conclusion to have ever graced our screens, providing, as Ben Shiparo would argue, a key "example of the show's nihilism".[191] The same repeated sequence of shots shows the family eating from a distance, the bell of the restaurant door ringing, Tony Soprano looking up at the door, and then the image of what Tony Soprano sees. So for example,

the bell rings, Tony Soprano looks up, and you see Meadow entering the restaurant – just as Tony Soprano is seeing her in that moment. In the very final moments, the bell rings, Tony Soprano looks up – and when we should be seeing whatever he sees, when we should be seeing who is coming through the door from his perspective – instead there is just a blank blackness. Of course, you are in fact seeing what he sees, in as much as he has ceased to see – for he has, in that very moment, been murdered. It is revolutionary, technically speaking, because we lack the external details of the murder, the assailants, the gunshot, the body bleeding into the floor. But from an aesthetic perspective, that moment of blackness is infinitely compelling, asserting an uncanny, disturbing and truly intimate dramatic power, because as he is being murdered, you too are experiencing it; it is the moment when the underlying nihilism of the show not only envelops its lead character – but also the audience who are watching – in its blackness.

Chapter Eleven

Dark Night of the Soul: The Historical Spirit of Goya's Great Art

In the late-fifteenth century, Spain was at something of a crossroads. The Black Death had decimated peasant populations across Europe more than a century before helping to create the basis for a crisis in the feudal mode of production, which also saw the demand for peasant labour increase and the bargaining power and mobility of peasants expand. In the period which followed peasant revolts broke out across Europe: 1381 in England, 1358 in France, in Hungary in 1515 and the Great Peasant War in Germany in 1524-5. Much of these revolts and civil wars were part and parcel of the way in which peasant labour was increasingly seeking to extract itself from the most oppressive forms of feudalism – specifically the legal and political form of serfdom which bound the peasant to the land and bolstered and enshrined seigneurial rights and powers. Of course, these struggles also fed into the revival of the great European cities and the creation of new industries and urban workforces as the towns sucked in the increasingly mobile labour from the countryside. The feudal aristocracy rooted in the countryside sought to stymie such elemental shifts and changes in the patterns of rural labour, to secure their own vast chunk of the product of peasant production, by enforcing antiquated feudal laws with the furious violence of those ruffled by the winds of change. Nowhere was this truer than in Northern Spain where feudal lords attempted to make absolute the "bad" or "evil" customs, a set of legal rights evolved in the fourteenth century which entitled them to imprison peasants on a whim and dispose them of their property. As the economic crisis which had wracked European feudalism deepened throughout the

fifteenth century the Catalonian lords attempted to reinvigorate the "evil" customs as a way to control the flow of peasant labour and to increase their own diminishing incomes.

In 1462 the peasants to the north revolted. They used the burgeoning tensions between the nobility and crown which had flared up into open warfare that same year. The peasants took the side of John II, then King of Aragon, but after winning the 10-year war the king failed to honour his obligations to the peasants that had supported him and they continued to languish under a welter of seigneurial obligation. In 1484, however, the peasants rebelled once more and 2 years later the king in question, Ferdinand II of Aragon, would issue a legal decree which effectively ended the conflict and would allow for the end of the "evil" customs in return for a one-time payment made by the peasant to the lord. While the feudal system itself pertained, the Catalan peasantry had achieved a greater level of rights over their smallholdings, and in addition, serfdom was effectively ended with the peasant family no longer bound by bloodline to a particular estate.[192] The War of the *Remences*, as it came to be known, was particularly significant for, unlike England's more famous Peasant's Revolt which was decisively defeated, it represented a successful peasant insurrection which reshaped fundamentally the political landscape. In setting the basis for more mobile peasant labour untrammelled by the worst excesses of serfdom, it also set the basis for an expansion of urban industry with an increased workforce; it created the possibility of a rural bourgeoisie which could begin to exploit more vigorously the more mobile form of peasant labour in terms of moneyed rents and lease holdings; in other words it was a step toward the development of a nascent capitalism. And it was in this sense that fifteenth century Spain was at a crossroads. Whereas the pockets of capitalism which developed on the land in the north Netherlands, England and France were eventually able to break through into a fully blown capitalism

with the respective revolutions of 1568, 1642 and 1789 – despite the precociousness of northern Spain's early development, the country as a whole was thrown back into feudal darkness for the several centuries which followed.

Why did this happen? Part of the answer lies in the way in which Spain dealt with the economic crisis of feudalism more broadly. In 1469, in the period of the *Remences*, the regions of Castile and Aragon were united through the marriage of Isabella and Ferdinand, and in 1492, those same Catholic monarchs would drive the last of the moors from Granada creating the basis for a single Spanish state. The economic crisis of European wide feudalism, then, also encapsulated the period which inaugurated Spanish absolutism – the period in which the Spanish crown opened up the Americas and set the basis for a global empire. The influx of riches which arrived from the Americas, the silver mines, the gold, the vast pools of indigenous labour which were readily exploitable and expendable in the most brutal and voracious manner – all helped to satiate the economic crisis and, in turn, fill the coffers of the state to the point of overflowing. It was a period of time in which the royal court appointed hundreds of emissaries often on an ad hoc basis which was determined by sycophancy and cronyism rather than any professional assessment of skill and ability. A whole crust of indolent aristocratic privilege grew around the core of an all-powerful absolutism which was funded by the riches flowing in from the New World, and in such a context the nascent bourgeoisie was tethered to the type of parasitism which essentially rendered them an adjunct of the powerful feudal state. Rather than allow the lucrative profits from their investments abroad to penetrate the processes of production on the domestic front, galvanising technological development and working practices – the stillborn bourgeoisie was very much infected with the feverish desire for title and conspicuous consumption which was the provenance of a bloated aristocracy. As John H Elliot observes, this created the:

contempt for commerce and manual labour, the lure of easy money from investment in *censos* and *juros* (taxes and mortgages), the universal hunger for titles of nobility and social prestige – all these, when combined with the innumerable practical obstacles in the way of profitable economic enterprise, had persuaded the bourgeoisie to abandon its unequal struggle, and throw in its lot with the unproductive upper class of society.[193]

The development of a global imperialism on the part of a feudal economy as a way to escape its own inherent contradictions led to a stifling of capitalist development which would pervade the centuries to come. The early Spanish bourgeoisie tethered to the aristocracy became fully infused with the state imperial project – from the Americas to the Philippines – and the booty which was extracted was then funnelled back into the luxuries which were being produced by the more developed industries in much of Europe; the profits from such expenditure inevitably being cycled into northern European capitalism via the great merchant banks of the period. Spain itself, though the seat of a mighty empire, nevertheless retreated into a deeply rooted provincialism which was the product of economic stagnation and which left an imprint on the character of a people who remained fragmented in a patchwork complex of feudal polities. This inevitably flowed into the forms and contours of popular culture stamping the plebeian masses with a very special type of character. The eighteenth century marked the era of the *majo* and the *maja*, the man or woman of the lower classes who nevertheless dressed in elaborate rich billowing cloaks or dresses, walked with a strutting swagger or a mincing prance. Such men and women expressed a revolutionary temper not so much in terms of a unified and coherent class instinct – for they tended to disdain labour in favour of an eloquent, indolent life of pleasure and adventure where they could find it – but rather in terms of a

fiery and poetic soul, a rebellious individualism, a hot temper along with a prickly sense of pride, a theatrical disposition somewhere between the romantic and the furious. They were a quixotic combination of the radical and the reactionary; riotous to the point of insurrection and yet at the same time devoted to aping the ostentation and finery of aristocratic glamour. They were perhaps most characterised by *a joie de vivre*.

Francisco José de Goya y Lucientes was fascinated by the *majos* and *majas*, perhaps sensing in them an animation and life which was in some way quintessentially Spanish. Some of his earliest oil paintings were devoted to his depiction of them. Goya showed them at rest – as in the 1777 oil on canvass *The Paraso*, which depicts a young woman in a rich billowing gold and azure dress sitting on the ground in a forest with a small black dog nestled into her lap. Her *majo* companion is holding a tawny green parasol over her, shading her, and the shadow falls across her face, her wide dark eyes gazing out at the viewer – mysterious and yet provocative – almost with a hint of amusement. Goya depicted them at the marketplace selling their wares, as in the 1779 oil painting *The Crockery Vendor*, which shows two luminous *majas* kneeling before a selection of gleaming crockery which has been laid out on a blanket in the marketplace. The young dandy who is reclining before them is more enchanted by them than the items they are endeavouring to hawk, and he is gazing into their faces raptly. He has his back to the viewer, and he is cast in shadow, which makes the light-riven figures of the *majas* all the more magnetic and compelling – flanked as they are by a moving horse and cart which is larger, weightier and also swathed in dark. Goya showed the *majos* and *majas* on their own terms, as in the 1777 oil painting *A Walk in Andalusia*, where a group of *majas* and *majos* are congregating in a forest glade. One of the men peeks out with incredulous eyes from underneath a saucer like sombrero, another standing by a tree glances surreptitiously in the same direction; their gazes

trained on the same object, the beautiful *maja* woman in the middle of the clearing whose arms are open wide, and she is gazing up – her dark eyes and full smile struck by the moment of the light. This is more than just a celebration of male desire and female sexuality; the central *maja* – in the openness of her body language, her sapphire dress crossed with a rich red ribbon and the simple happiness in her expression – becomes a cypher for the joy and vitality and playfulness of the *majo* existence more broadly.

Goya himself had come from a family of modest means; born in 1746 in the small village of Fuendetodos, his father had been a gilder specialising in decorative craftwork. It was perhaps inevitable that his own life would have been woven very closely with the interests and culture of the plebeian masses. He was captivated by the guitar music of the *majos* (who had cultural influences from the gypsies of Southern Spain) but most of all he enjoyed the popular spectacle of the bullfight. Indeed, the only picture in which Goya himself appears and does not seem brooding or introverted is a picture where the young artist is depicted in the midst of a bullfight, waving expertly the matador's flowing cloak. In *Fight with a Young Bull*, 1780, Goya's youthful face is turned toward the viewer flushed with a boisterous sense of confidence, and in the midst of all that movement – all that life and danger – the artist seems utterly at home. It was said that he spent a lot of time with bullfighters in his youth and even went as far as signing one of his letters with the moniker *Francisco de los Toros* – Francisco of the Bulls! But although Goya came from a plebeian background of humble origins, his mother's family had aspirations to nobility, such that the rather simple brick cottage that Goya grew up in was owned by them and stamped with a confected aristocratic crest. Goya's background, then, provided him with three important themes: the technical and artistic influences he absorbed from his father, the master crafter; the experience of the life and culture of the

plebeian masses; and a driving ambition which came from the more aspirant well-to-do elements on his mother's side of the family. These influences coalesced into the shape and contour of his early career: alongside his fascination with the *majos*, the young man was keen to ingratiate himself with the aristocracy and even royalty itself. When he was around 5 years of age the family moved to the nearby town of Zaragoza and it was here, as a precocious adolescent, where he would study under the painter José Luzán, before he eventually moved to the nation's capital of Madrid where he would apprentice for the neo-classicist painter Anton Raphael Mengs. Mengs was popular with the royal court, but already Goya showed himself capable of exhibiting a strong streak of "majo" stubbornness, clashing with his master. In the 1760s he submitted entries to the Royal Academy but was rejected. His ambition, however, remained undaunted, and he upped sticks and left for Rome in order to imbibe the Renaissance masters first-hand. How the plebeian artist was able to fund such a trip remains a question shrouded in mystery; some biographers speculate that he travelled to Italy as part of a bullfighting troupe, others suggest he worked as a street performer there; the actual historical record is depressingly scant of detail, but if anything, the sudden flight to Rome represents on Goya's part again the spirit of the "majo" – impulsive, reckless, curious and adventurous.

The years which followed would be the most stable period of Goya's life. He worked with the Aragónese artist Francisco Bayeu y Subías, whose sister he also married, and it was this connection which at once began to open doors. Bayeu was a member of the Royal Academy and a director of its tapestry works, and thus, in 1777, was able to provide Goya with a commission for tapestry works for the Royal Tapestry Factory. This commission was not particularly lucrative or prestigious but it did provide the foot-in-the-door which Goya had so desperately sought. It was also important in as much as it allowed the young Goya access to the

prolific royal collection of paintings by Velázquez, and he would further shape and hone his own technique by making engravings, copies of the old master's works. From this point onward his career began to take flight, and soon the young man was painting counts and princes, before, in 1789, he was appointed court painter to Charles IV himself. The 1788 painting *The Duke and Duchess of Osuna and their Children* is perhaps typical of the period. In a dark, elegant suit embossed with a red sash, the Duke's eyes are kindly but serene; his arm rested on his wife's shoulder, his other arm flowing downward holding his small daughter's hand. He is standing a little behind the others who are foregrounded; in this image he is quite literally the backbone of his family, the silent provider, the benevolent and powerful presence behind the scenes. The duchess is the centrepiece of the scene; she is surrounded by a gaggle of precocious cherubic young children whose porcelain faces and wide eyes speak of a soft-toned wonder. Their hair is painted in delicate, diaphanous wisps filtered with light and it seems almost halo-like in its texture. The duchess' dress is similarly fine; a grey-silver gauze which seems to rest on her with the lightness and insubstantiality of a cloud – the children gathered close, melting into its ethereal light. The duchess' expression is serious, her intelligent golden-brown eyes touched with a hint of melancholy. In terms of the visible trinkets of wealth on display, Goya's painting is rather modest and tactful; the clothes that the family are wearing are discrete and intimate and not overwhelmed with gaudy adornment. But the painting is nevertheless a peon to nobility; these are elevated people; humane and wise – you get the feeling that the benevolent protective light which flows from the parents will not just help nurture and water their beautiful glowing children, but will also expand outwards into the country more widely, raising the Spanish people up in its gentle glow. It is a very good painting, and, of course, a miraculous example of the most subtle propaganda.

Critics have often said that this period, Goya's earliest, is characterised by a light-riven optimism which accords with a career that is in the ascendant; the patronage of the royal family, an increasing demand on the part of the great and the good to have their portraits painted by him and his own interjection to the very highest levels of "celebrity" society. The amendment to this which nearly always follows is that the period of horrendous illness in 1793 – which nearly claimed Goya's life and left him stone deaf – opened up a portal through which darker, more macabre forces were then channelled. But while it is certainly true that from the paintings of *Los Caprichos* onwards – the set of works which were completed in the aftermath of his illness – there intrudes a deeper element of darkness, of the grotesque even – it must also be recognised that the early paintings are not without their ambiguities. In the 1776-7 painting *The Injured Mason*, Goya depicts the lower classes in a way which is at odds with the vibrant clashing colours and cocky swagger of the *majo* lifestyle. Here he shows us two labourers carrying away an injured man. Behind them the skeletal outlines of a building in progress emerge out of a background of sallow yellow cloud. The men are dressed in dark shabby clothing. This is a picture of gentle camaraderie, for sure, but it is also a depiction of suffering and hopelessness; while the two men who are still on their feet have clear and distinguishable features the injured man is slumped, his head a ball of shadow hanging slackly from his neck, and you can't really see his face at all. Perhaps he is close to death. Or perhaps he is already dead.

In the painting *Winter* of 1786-7, Goya depicts a scattering of peasants making their way through a barren snow-streaked land, past the icy darkness of a still river. A single skeletal tree is blown ragged by the dark icy air, and the peasants grip the thick white fabrics they have wrapped around their heads as a meagre form of protection against the implacable, deathly wind. A couple of animals linger; a small dog, braced by the

cold, glances at the ragged humans – in the background a donkey seems to lose the will to move, sinking slowly into the snow under the burden of the massive leather satchel which is draped over its back. In this picture the men and animals alike are beasts of burden, the weight of a remorseless and infinite natural world pressing down on them, rendering them small, finite and hopeless. In this scene as well, to the despair is added a gentle sense of lonely camaraderie. The men persevere in the snow. It is interesting to think that the Goya of these paintings, so attuned to the suffering of the lower ranks, was at the same time the aspirant, monarchy-friendly Goya who in the same decade would buy his own carriage. Carriages were luxury vehicles, status symbols, a way to look down on those who – like the peasants in the painting – were condemned to make their pilgrimages on foot, people who were disparagingly referred to as members of the "gente de a pie" class. With the purchase of a carriage, Goya had both figuratively and literally *arrived!*

But even in those paintings which seem to be an open and unambiguous celebration of "the happy life", the paintings of aristocrats or joyous *majos*, even in these paintings, one can sometimes detect a deeper streak of pessimism. In *The Crockery Vendor* the *majas* selling the crockery are beautiful, vital and bathed in light, but next to them is an altogether more incongruous figure – an old crone with withered skin of parchment brown, hunched over staring toward some invisible point. The crone represents, perhaps, the inevitable fate which the youthful, vital *majas* are rushing toward even though in the moment of their most perfect youth they remain utterly unaware of it. The sky above is tinged with melancholy blue and a vast wreath of grey-dimmed cloud. In *Fight with a Young Bull* Goya's outfit is full of burgeoning colour – pinks and purples – while from above that same eerie twilight blue, and above that, great reams of darkening cloud. Even in *A Walk in Andalusia* where the *majos* are congregating in the light and that beautiful *maja*

stands luminous and with arms outstretched – from up high, the trees and their foliage form great black shapes looming over the smaller figures of the people – and again, the strange melancholy blue of the forlorn evening sky. In all three of these pictures, and many others from the same period, we have a depiction of people in a brightly lit foreground who are filled with joy or vitality and whose being exudes a playfulness, a youthfulness, a fundamental sense of innocence. But move a little toward the periphery and you see that dark forces are beginning to amass; the darkening tenor of the sky, the thick black shapes of trees – the fragile light-riven innocence of the human actors is being menaced by a palpable shift of tone in the scene; you have the distinct feeling that a great change is on the horizon, that a long black night is about to draw in.

Of course, that great change did come, and with it, for Spain, the longest and blackest of nights. In 1789 the French Revolution broke out. The decadent regime of Spanish absolutism reacted to the battering, buffering winds of change by battening down the hatches and intensifying its repression. Charles' minister, Floridablanca, responded to the revolution by clamping down on the press in a vain attempt to insulate the Spanish peninsula from the forces of world historic change which were now in motion on the other side of the Pyrenees. The population tended to regard the decadent Bourbon monarchy with a combination of deferential respect, lurid, salacious interest and a prickling, wary hostility. The apparatus was rotting from the head down; corruption and nepotism were manifest, and in the early 1790s the name of Manuel Godoy was on the lips of much of the population. A minor noble who would rise to the position of prime minister in 1792, Godoy was synonymous with court intrigue and illicit favour, and it was said that he owed his career trajectory to the queen herself, whom, rumour had it, was also his lover. The rather pious, limp king, Charles IV, resembled so many of his befuddled brethren in as much as the absolute power

of his political position seemed to correspond to an absolute meagreness and want in terms of his human personality; he had scant ability *vis a vis* statecraft, had little interest in the art of shaping governmental policy in accordance with idea and innovation – instead his political outlook was entirely defensive, seeking only to preserve and enshrine the vast privileges that his dynasty had for centuries enjoyed. And he seems to have watched with glazed eyes as the queen appointed her favourite Godoy to the highest political office in the land. Perhaps such indifference stemmed from a sense of his own dullness, his lack of corners, his marked incapacity to deal with the problems of governmental bureaucracy with anything more than the petulant demand generated by an all-powerful parasite "because I wish it to be, so it must". Or perhaps the business of his wife and his First Minister better allowed the king to retreat into the hazy arcadia of a never-ending series of hunting trips conducted under blue Spanish skies; a flabby, chinless man cocooned from the demands of change and time by the ever-thinning mirage of a venerable and timeless absolutism.

And although he sought and secured royal esteem and royal favour, Goya couldn't but show the royal family in this kind of light. In one of his most famous masterpieces, *The Family of Charles IV* (1800), Goya paints the royals using the same interplay of light and dark; the subjects at the centre of the scene are bathed in light, but as we move further out into the periphery the shadows draw in. In his depictions of the *majas* and *majos*, however, this technique works to induce an air of tragedy; the innocent joy of the men and women – dancing, playing music, gambolling and flirting – is undercut by the melancholy sadness which comes from a sense that this is an epoch which is about to pass from the scene. In *The Family of Charles IV*, the emotional effect is somewhat different. The human actors in the centre ground are again illuminated but this does not reveal the human qualities of warmth, playfulness and joy. Rather Goya has used

the light to show them in their full pomp; the queen's dress is laced with lattice textures of gold, ivory and emerald, a series of bejewled necklaces flow downward from her neck across her bust, her bouffant hair stacked high and burdened with yet more silver. And yet her face is entirely pedestrian; self-satisfied and complacent, she looks out at the viewer with a rather cold and haughty stare. The clothing of her husband too is encrusted with jewels – star-shaped explosions of silver are overlaid by the standard silk sashes of glittering reds and blues. Whereas his wife's gaze is clearly defined by a sharp sense of arrogance, the king's eyes are hazy and indistinct, his gaze trained on some middle-point outside of the scene. His facial features are weak and flabby, his body is portly but at the same time formless and indistinct; even though he is physically in the room with his family, it seems his mild, vague thoughts are elsewhere entirely. The king seems distinctly un-present, *he is presence less* which, of course, is an effective and ironic comment on his involvement in the day-to-day running of the state. The queen is the real force in this painting and between her and her husband there is a stretching gulf of space. Between them as well stands a small boy, perhaps the only sympathetic character in the piece; he looks uncertain, his wide dark eyes mournfully taking in a world whose pomp and cold etiquette he is barely able to fathom.

There are 13 people in the large chamber, including the artist in the background peering out, and above them from the far left to the centre right is hung a vast framed picture, the details of which are obscure. There appear to be some bodies, some faces, but these giant figures are occluded in the swirling darkness, and that darkness seems about to smother the real people who are gathered together in the foreground. One of the royal women has her face turned back toward it, the expression on that face is not visible, already shrouded in shadow, but she is the only one who seems to be aware of the encroaching darkness. And yet she is herself faceless. The others, with their ossified stares,

their rigid postures, their clothes forming hardened carapaces of jewels and silver – they are as fossils, rudely unearthed on the beach, about to be washed away by the rushing remorseless tides. And still they gaze out, proud, preening and oblivious.

The element of intruding darkness in Goya's early period was, I think, an augur of sorts – the premonition of a bleak future, an end of days – in which a whole epoch would pass from the scene. But with the advent of the French Revolution such a prophecy started to manifest, to become the reality. The French Revolution was the death rattle which passed through the decadent and ossified Spanish monarchy, bringing out its most grotesque and repressive features, for it became most rabid in the moments when it was brought face to face with its own impending destruction. At home the state apparatus became even more brutally repressive, and abroad the Spanish crown declared war on the French Republic with the intention of restoring Bourbon power in France. A shadow had spread across the Spanish landscape, and from above great dark clouds flashed with lightning. Add to this, Goya's own spiritual and physical crisis, the period of severe illness which left him without his hearing. The sounds of conversation, of music, which his rather gregarious "majo" nature had so beloved, had now been sucked from the world and in their place a silence, muted and eternal. If the early period in Goya's work hinted at the oncoming darkness of an ominous future, then the works he creates in the mid-1790s help him to record the blackness which is emerging from the fissures and cracks of the present – the increasing turmoil and degeneration of a society creaking under the pressures of war, political crisis and a corrupt, murderous absolutism which hangs over the country like a curse. In the oil painting *Yard with Lunatics* Goya brings us into the courtyard of an asylum. At the top of the picture there is a sliver of pale mauve sky, but much of the image is taken up by the great dark walls of the building. They are little more than walls of shadow, for their texture is indistinct – one of soft-hued

darkness – you cannot see the brickwork, the corporeal details of the concrete and so on. And yet, despite this, they seem to blot out the light. The lunatics who are behind the walls are cast in almost total shadow. Two muscular, tortured naked bodies grapple from within the gloom like titans, though we cannot tell whether the two madmen are crushing one another to death or locked in a teary, hopeless embrace. Other faces contort from within the shadows; demented, rictus grins or mouths made unnaturally wide with shrieks of terror or strange joy. Of course, this painting was done in 1794, the year after Goya had been struck deaf, and I think that the absolute separation of those men from the broader world by those walls provides a poignant and moving insight into Goya's own inner psychology, for his deafness must have felt like a wall which had fallen – forming an implacable barrier between the darkness and chaos of his inner thoughts and the rushing life of noise and conversation which burbled and bubbled onward in the outside world.

But the lunatics are perhaps also a metaphor for Spanish society more generally; cosseted behind the Pyrenees, and locked into an atavistic form of feudal medievalism – the Spanish people were to some degree buffered from the ideological currents of reason, modernity and enlightenment which were passing across much of the rest of Europe. The famous sketch, *The Sleep of Reason Produces Monsters*, suggests something similar. The black and white etching shows Goya slumped over a desk, his head in his hands, clearly fast asleep, but above and around him the air is packed with a host of flapping, flying spectres; there are black bats hovering from up high, wings open, about to swoop down and there are grey owls with open beaks and wide demented eyes drawing close. At the bottom of the scene there is a large cat, sleek and sinister, gazing ominously from the floor, watching the slumbering form of the artist. The inscription "The sleep of reason produces monsters" is written out in white on the side panel of the desk, and the various animals have a gothic

monstrousness to them; medieval and demonic, it is as if a bottle has been uncorked, and a host of malevolent spirits have been released, beating the air with their spidery black wings. And this, I think, is Goya's point; in a society which hasn't been touched by the rationality and scientific spirit of the enlightenment, the most monstrous and grotesque forms of superstition, primitivism, fear and prejudice are released unbounded and with shrieking force. *The Sleep of Reason* is part of a series of sketches – *Los Caprichos* – from the years of 1787-8. The title itself "The Caprices" hints at their thrust; they reference the arbitrary, haunting acts of violence, greed and suffering which inflict a world whose fundamental tenets are underpinned by ancient religious dogma and the random and unworldly noble power constituted through decadent blood legacies; "capriciousness" is in this way opposed to the lofty universalism which was being preached by the great enlightenment rationalists of the age. Goya's critique of religion is bitter and palpable; in one of *The Caprices* (*What a Tailor can do!*) Goya sketches out a beautiful young woman, on her knees, her lips parted slightly, her hands clasped in prayer, and her eyes gazing up beseechingly at the figure of a monk who is looming over her. But the cowled, cloaked monk is no monk at all; underneath his robes are the gnarly, rustling dead branches of a stunted tree. In *Witches in the Air*, an oil painting done in the same period, we see a man on a small lonely patch of brown, bare ground and above him a wall of absolute black. From the infinite dark, there are a trio of semi-naked figures; well sculptured, wearing long pointed hats whose strange, other worldly colours shine in the black – the sinister trinity are hovering in the air several feet above. In their arms they are clasping a body, a body which is writhing in pain as they press their mouths to it, sucking its blood. The man underneath has pulled his cloak over his head; hunched over he appears to be staggering away from a nightmarish vision which is almost too monstrous to comprehend. In both *What a Tailor Can Do!* and

Witches in the Air one can detect an undeniably Marxist theme, that of alienation. In both works, Goya is not just providing us with the depiction of supernatural actors (the tree-monk, the witches) but rather endeavouring to show their relationship to the human beings in the picture in and through the transmission of a terrible, nightmarish dread. The woman is prostrate before the religious figure, the man is cowering before the troika of witches floating above him. Both pictures show how the objects of religious devotion and the superstitions which have hardened over the ages attain a nightmarish existence which looms over the people who have called them into being. In these works, the productions of the human mind achieve a ghostly life. The gods and monsters which ignorance and superstition calls forth attain a surreal and uncanny objectivity – the phantoms of the imagination are unleashed only to hold their creators in a strange and terrible form of bondage.

The French Revolution, swamped and besieged by the old bastions of feudal absolutism, entered a more militarised phase which eventually culminated in the Bonaparte dictatorship and the march of its armies spreading out across Europe like a wave of ravenous ants. The sense of fear and corruption in the Spanish royal court grew ever more stifling, and in the panic-stricken atmosphere the frightened, power-hungry royals began to devour one another alive. A better motif for a Goya painting would be difficult to find. Firstly, the crown prince Ferdinand started to move against Maria Luisa and her consort Godoy who had, to all intents and purposes, taken power for himself in Madrid. Godoy was loathed by the people, so Ferdinand's gambit had some popular support, but at the same time the ruthless young pretender to the crown entered into sly discussions with France, offering to marry a member of the Bonaparte family, in order to garner Napoleon's support for his claim. The flip-side to this was that Charles IV, Marisa Luisa and Godoy had also cosied up to Napoleon, in an attempt to use the French emperor as a

buffer against the building discontent of the Spanish population itself. In line with this, the royal couple (whichever permutation of it you choose) had accepted large numbers of French troops into the capital in order to garrison – a manoeuvre which failed to improve their standing with a population which was already explosive in mood. In 1808, in Aranjuez, the powder caught and the explosion occurred. Aranjuez was, then, a town a few miles out of Madrid, much of it comprising royal estates, and the members of the monarchy could retreat there when the hustle and bustle of the life of the capital became too intrusive. On 17 March 1808, crowds thronged the streets of the town descending on Godoy's mansion, breaking through the doors; stirred up by the propaganda of Ferdinand's agents, the mob was intent on murder. Godoy was the focus of such anger, not just because he was malicious, conniving and corrupt in the fashion of the upper layers of the aristocracy as a whole, but because he was seen as a traitor – someone who had opened the doors of Spain to French incursion, setting down a welcome matt which would invite foreign domination.

Charles IV was in possession of a certain spiritual numbness. The type of indifference which had worked its way into his blood through decades of absolute power; a power which had been expended in the pomp and ceremony of a never-ending series of royal parades and the perpetual and monotonous bloodletting of a thousand forest creatures in and through the spectacle of the royal hunt. Charles' spiritual psyche was spent by the years and years of the unadulterated luxury of feudal absolutism; he lacked both direction and drive, for his life's achievement had not been won by his own effort and resourcefulness but by the simple and involuntary event of having been slopped out of his mother's womb. His existence had narrowed into a meagre, pitiful set of interests which involved turning away from a world whose complexities and contradictions could only ever give to him a dull, throbbing headache, making him yearn to escape life

– to retreat into his rural idyll which offered the same kind of gentle comfort as a hazy benumbing drug. His son, however – the crown prince Ferdinand – had a very different psychological complexion. Ferdinand was characterised by extreme sharpness; he was prickly, proud, quick to take offence, vengeful and driven by both a sense of extreme ambition and extreme inadequacy. He thought not a jot about the national destiny of Spain in the context of an encroaching French power. He was cognisant only of his own rising star; the insatiable need to attain the highest seat in the land – to survey all others from above, to have the ability to satisfy any petty grievance against some perceived foe by striking them down, marshalling the lightning of absolute power; while at the same time being shielded from every danger, every consequence. He was in equal measure vicious and cowardly. In his book *Bastards and Bourbons*,[194] José María Zafala draws on the testimony of the queen's priest, Fray Juan Almaraz, who recounted that the queen, on her deathbed, confessed that all her children were in fact illegitimate. Whether this is true we will perhaps never know, but what is the case is that Charles IV and Maria Luisa deliberately isolated their eldest son from any role in government even when he had come of age, preferring to repose all their faith in Godoy instead. Perhaps Ferdinand sensed with the prickly suspicion which was his nature that even his "progenitors" did not like him well enough to trust him with the destiny that he felt should have been his by rights. Perhaps Ferdinand sensed instinctively that the system of feudal absolutism was itself in the process of perishing; that the power which consumed his daily thoughts and ambitions was in danger of evaporating before his eyes. For sure, Ferdinand held organically all the enmity and spite which one might expect from the last born of a dying breed. So when he had the chance to seize the throne for himself, he didn't hesitate. Using the momentum of the riot which had taken place in Aranjuez, Ferdinand was able to install himself as king. Many of the people cheered his

action, for they felt they had discovered in him a true Spanish leader who would disdain the French and finally drive them from the country.

But although Ferdinand very deliberately cultivated such an image he had, of course, already made overtures to Napoleon in order to secure his power from behind the scenes. The real problem with such manoeuvrings was that Ferdinand himself was now dealing with a master of them. Napoleon adroitly fostered his connection with Ferdinand, and the master of military strategy now placed himself in the role of a disinterested arbiter, offering to help smooth out and resolve the dispute between the displaced and shell-shocked father and the Machiavellian, power-hungry son. In such a role, of course, Napoleon was able to play them both; he first pressured Ferdinand to renounce the kingdom in favour of his father, then he got rid of the unfortunate Charles IV and installed his brother Joseph Napoleon on the Spanish throne. But even Napoleon himself had overlooked an essential ingredient in this power politicking game. The Spanish people themselves. Because Napoleon had been so preoccupied with the decadent dynasty above, he had failed to recognise the danger of the broiling power from below. Karl Marx would write:

Thus it happened that Napoleon, who, like all his contemporaries, considered Spain as an inanimate corpse, was fatally surprised at the discovery that when the Spanish State was dead, Spanish society was full of life, and every part of it overflowing with powers of resistance...Seeing nothing alive in the Spanish monarchy except the miserable dynasty which he had safely locked up, he felt quite sure of this confiscation of Spain. But, only a few days after his coup de main, he received the news of an insurrection at Madrid. Murat, it is true, quelled that tumult by killing about 1,000 people; but when this massacre became known, an insurrection broke out in Asturias, and soon afterward

embraced the whole monarchy. It is to be remarked that this first spontaneous rising originated with the people, while the "better" classes had quietly submitted to the foreign yoke.[195]

As Marx describes, the French invasion excited a most incredible upsurge of resistance on the part of the Spanish population which led into a vicious, ferocious war in which the highly organised, modern and battle-hardened armies of the French were combatted by sporadic pockets of resistance which broke out across Spain. In the villages, towns and cities – peasants, priests, nobleman, shopkeepers, land labourers and artisans all morphed into the type of elusive force which could strike French troops at will, camouflaged by the wilderness of the *tierra* – the dark mountainous crags of the rugged and wild rural stretches, the gloomy crepuscular shadows of the forests. It was the type of resistance force which could melt back into the indigenous populations seamlessly and without a trace. The war was, for all intents and purposes, the first guerrilla war of the modern period. It was also a civil war because a significant proportion of the upper classes and some of the radicals had allied themselves with French interests both culturally and politically; these *petimetres* styled themselves in a refined continental opposition to what they regarded as the crass, insular and indigenous "*majo*" mindset. For this reason the fighting was particularly brutal – the sheer fury wrought from the advent of foreign occupation was such that it threatened to tear the very fabric of Spanish society asunder. It was from such a context that Goya produces the etchings which comprise the famous *The Disasters of War* series made in the decade from 1810-20 and alongside these, a number of stark, stunning oil paintings which elucidate many of the same themes. Perhaps one of the most famous of the latter is *The Third of May 1808* which was painted in 1814. This painting commemorated the outset of the war. After Napoleon had sequestered both kings (Charles IV and Ferdinand VII)

with plans to inter them back in Paris, the people of Madrid rose up on 2 May. The uprising was swiftly crushed, but the repression which followed was even more senselessly brutal. Death sentences were handed out to civilians carrying weapons of any sort and hundreds of prisoners were executed on the spot. It was this which Goya captured in his iconic scene; a group of haunted, dishevelled men cornered against a great mound of earth, surrounded by the slumped, bleeding bodies of their fallen comrades, and before them a phalanx of French soldiers whose faces aren't visible, but whose tense braced uniformed bodies seem almost mechanical – seem to flow into the long rifles they have trained on the cornered, corralled human beings who are clutching their faces with terror. A single lantern illuminates the scene and its strange nocturnal light reveals the central figure, a "*majo*" type Spaniard with a billowing white shirt who is gazing out at the French with an expression of wide-eyed anguish, his arms raised up and out to the sides. Here Goya's sympathies are unequivocally with the Spanish people, and despite the strong element of anti-clericalism which runs through much of his work, the artist is clearly mobilising the Christ story in the figure of the martyr – his arms outstretched, almost as if he is being crucified. And yet, there are no angels in the sky, there is only the skeletal outline of some ruined buildings in the background and above the same infinite black. If this "Spanish" Christ is about to be executed, in Goya's world there is no supernatural force to bring him back from death; there is only death itself, as bleak, infinite and absolute as the empty darkness of the sky above.

In their stark, shaded black and white hues, *The Disasters of War* sketches are also profoundly modern in their grim nihilism. But though they are modern – indeed some critics have been tempted to call them the original example of "war reporting" – nevertheless they are not what might be described as propaganda. One can't say that Goya is agitating unambiguously in favour of one particular side. Certainly there are bleak scenes involving

French soldiers shooting, hanging, stabbing and even castrating defenceless, ordinary Spaniards. But there are also scenes of French soldiers, prostrate and helpless on the ground, in the moment before a grimacing, bloodthirsty Spaniard brings down the axe. And although there are a few scenes which depict the heroism of Spanish resistance, particularly *What Courage* where a Spanish woman climbs over the bodies of her fallen comrades in order to light a cannon – this type of scenario is few and far between. More frequently Goya depicts the assaults, robberies and rapes which ordinary people, maddened by bloodlust, carry out against one another in the feverish, febrile and hallucinatory landscape of a nightmare civil war. It is often difficult to tell for which side the victims in these scenes are giving their lives. Some critics have suggested that such aesthetic ambiguity comes from the fact that Goya himself didn't demonstrate a clear political commitment to one side or the other; indeed he served the French king Joseph Bonaparte in much the same way he had served his Spanish predecessors; a feat which testifies to both Goya's ambition and knack for political compromise.

But in his art, one feels, compromise was something of which this great genius was wholly incapable. *The Disasters of War* sketches carry such a modern, fragmented, atomised tone of nihilism – in which no side emerges decisively as a universal and ethical good capable of carrying the society forward into better, more benevolent times – precisely because of the historical conditions and character which underpinned the Peninsula War itself. Goya understood very well the benefits of enlightenment rationalism just as he comprehended the decadent deadweight of the contradictions of the feudal absolutism under which Spanish society was languishing. But such enlightenment rationalism was being carried forward at the point of a bayonet by a massive foreign invasion. It was inevitable that the majority of the Spanish population should fight this brutal incursion with all the courage and ferocity available to them. And yet, the struggle

for liberation was tainted by the backwardness of Spanish society as a whole. Since the time of the *Remences* onward, the Spanish peasantry had often seen in the monarch a venerable and benevolent power bestowed on Spain by God – a paternal, patriarchal and divine presence on earth which was given to intervening on the side of the poor and the vulnerable. Though every single strand of the Bourbon monarchy had utterly debased itself, conducting filthy, behind the scenes deals with Napoleonic France, nevertheless once they had been outmanoeuvred by Napoleon himself, the scheming Bourbons now appeared to the Spanish feudal imagination as traditional, romantic heroes laid low by a grotesque and foreign interloper. In such a context the power of the church and its ancient institutions was reawakened with a great energy and vigour. The struggle for Spanish independence, then, was inexorably bound to a process of feudal revival in which some of the worst barbarisms and superstitions were brought to the surface, exploding through the cracks.

In other words, there was no scenario in which the war could be brought to a positive conclusion. Either it would result in the bourgeoisification of Spanish society, the capitalisation of the market, the end of feudal tariffs and guilds and the comprehensive destruction of clerical power – but such a modernisation would arrive at the cost of a brutal foreign occupation and the dictatorship of a French emperor – or the Napoleonic forces would be justly and rightly pushed back, in which case the feudal world would reassert itself with a vengeance. The existential darkness of *The Disasters of War* – the sense those sketches provide of an individual unmoored, left to wander a nightmarish terrain of random, senseless horrors; such nihilism is, I think, the product of the fact that Goya had intuited aesthetically the bleak nature of the socio-historical contradiction which underpinned the Peninsular War and the hopeless impasse which Spanish society had been driven toward. In one of the last series of etchings from *The Disasters of War*, Goya depicts an

old man in rags kneeling in the dust. His haunted eyes stare up from the large skeletal sockets of a famished, wizened face. In the murky darkness above, the embryonic outlines of grotesque leering faces are taking shape in the gloom. There is nothing more. Goya titles this threadbare sketch with a description of haunting inevitability – *Sad presentiments of what must come to pass*.

In the event, the French occupation was eventually beaten back. The Portuguese and the British led by Wellington provided valuable assistance in terms of both men and ships. In 1812, to the wintery north, the bulk of Napoleon's *Grande Armée* was about to burn itself out in the vast snowy wastelands of the Russian empire, and this would mean a massive withdrawal of troops from Spain itself. But above all, it was the guerrilla resistance spearheaded by the Spanish population which was decisive; the attempts to organise Spanish troops into battalions of the traditional type and send them against the more militarily sophisticated French in open battle were invariably disastrous but the guerrilla tactic tied the French troops down over a sizeable terrain helping to exhaust and demoralise them, thus facilitating Wellington's counter offensive of 1813 which would at last drive the invaders from the country. Naturally, the members of the high aristocracy who had colluded and collaborated with the French sensed which way the wind was blowing and became patriots once more, devotees of the Bourbons, the "true" legatees of Spanish sovereignty. At the same time, a current of liberalism and reformism began to flow through the battered, collapsed terrain. In Cadiz, in 1812, a new constitution was created, the first of its kind in Spanish history. It sought to guarantee separation of powers, freedom of the Press, the abolition of feudalism, universal male suffrage and the creation of a parliamentary system of the more modern type. But when Ferdinand returned to Spain in 1814, on a wave of rabid patriotic fervour, the king was able to dismantle the constitution in its entirety. The

liberals hit back through the *Cortes*, the Spanish parliament, with a decree designed to permanently outlaw the Inquisition, but Ferdinand had been emboldened by the most reactionary elements in the vast peasant population and a sinister clergy who were primed to stir up their anger. Ferdinand, the same figure who had made rapprochement with Napoleon, who had even congratulated the French army as it decimated the Spanish population, would now present himself as a ruler who had grown out of the deepest roots of the venerable traditions of a Spanish motherland which had existed for time immemorial. The utter cynicism of such a crooked rebranding was matched only by the ruthless violence Ferdinand launched against the liberal wing of Spanish society; his cowering cowardice in the face of the French threat matched only by his fortitude and bravery when picking up the royal pen and applying the royal signature to the death warrants of hundreds of his countrymen. On his watch the historical clock was sent spinning in reverse. Ferdinand re-established the Inquisition with rejuvenated powers, brought the Jesuits back and suppressed the *Cortes*; he generated a fug of medieval darkness which hung over a cowed and brutalised people, a people whose lives were now overseen by the sinister emissaries of dark religious orders and legions of informers and police spies. If the violence of the Napoleonic invasion opened up cracks and fissures in Spanish society, then the consolidation of Ferdinand's regime allowed the very worst spectres and horrors of the feudal past to come flying through the gaps with unbounded force and horrifying resonance. And it is with this thought in mind that, at last, we turn to Goya's *Black Paintings*.

The first thing to note about the *Black Paintings* – the 14 paintings which Goya made from 1819-23 – is that they are creations which are emanated from the most elemental regions of his nature. For sure, in times gone by, Goya had created highly personalised images. After the illness which rendered him deaf in the 1790s, Goya began to create works which had

not been commissioned, works which were painted only to satisfy his deeper aesthetic impulses. But even works of this kind – like *Los Caprichos* – were nevertheless intended for public consumption; he would eventually bring them before the market – he would, so to say, show them off. With the *Black Paintings* something else is at work. He daubed them across the walls of the residence he had moved into just outside Madrid, a lonely country house on a hill which had earned the strange shadowy moniker *Quinta del Sordo – House of the Deaf*. The art historian Fred Licht says of the *Black Paintings* that they "are as close to being hermetically private as any that have ever been produced in the history of Western art".[196] Goya doesn't even bother to put them to canvass; he simply daubs the images across the walls in the solitude of that gloomy house, and he does so at a time when existence itself seems to be narrowing to a single sliver of light against a backdrop of immense darkness. His illnesses have returned with a vengeance. He is in the final stages of old age. The feudal darkness of the Bourbon regime is pressing down on the country, a creeping deepening shadow gradually swallowing everything. Such darkness had reached the edges of Goya's own life; in 1815 the artist had been summoned by the Inquisition in order to account for a painting of a nude woman, *La Maja Desnuda*, which he had painted so many years before, at the height of his fame and self-belief. He puts the deeds of the *House of the Deaf* in his grandson's name because he fears the regime will seize his property. As he sets to work on the *Black Paintings* the artist paints not for money or adulation, not for career or social ascendency; he paints because he is alone with that darkness, he paints because it is all he has left to him.

And the things he paints are the stuff of nightmares. Over 2 decades before Goya had painted *The Meadow of San Isidro*, a bucolic scene which shows Madrilenians encamped in the country fields outside the city, picnicking, dancing and reclining under the late afternoon light. Goya would return to this setting

for *A Pilgrimage to San Isidro*. Now the fields and the skies are depicted in faded charcoal blacks. Streaking and twisting across them in a single snaking line are a group of pilgrims clad in dark colours, and as the line of people moves closer to the foreground, they move from being sinister shuffling shadows to figures whose twisted, clenching, grimacing faces are illuminated by a sick yellow light in all their contorted fury. Some of them are playing the guitar, some of them are crying out with shrieking mouths, some of them are gumming their jaws and clenching their fists, some are known by the whites of eyes which have rolled back into the top of their heads. All the colour has been sucked from this world and the otherworldly pleasure on those grotesque faces is simultaneously the most intense form of human suffering. It is a procession of lunatics and madmen which has formed in a demented union in the context of a social collapse and the absence of either reason or God.

And from the void there comes monsters. As in the famous *Saturn Devouring His Son* which shows the old titan unkempt; vast, ragged, sinewy, dirty and naked, he is more animal than god – his white, thick, dirty hair streaking down around his face in a shabby mane. He is gripping the corpse of his son in his massive bony, knuckly hands; having already chewed of its head, the blood is now dribbling down the decapitated torso. The titan's eyes are wide, demented and in some way unseeing. Monsters abide. In *The Fates* Goya depicts the Greek deities more in the manner of medieval witches; again a darknened scene pervaded by sallow yellow and charcoal black – a thick forest and mountain range – and the immortal women, hideously ugly with macabre grins, flying across the air above. This is a sense of death unbounded, touching everything – the trees, the mountains, the skies; a strange grotesque funereal atmosphere of rich gothic beauty and gothic horror. A landscape at the end of the world. A shrieking, lonely hopelessness.

And speaking of hopelessness it is now we come to *Fight*

with Cudgels. Here there are two men set against each other, set against the wild landscape and a perishing blue sky with vast towers of churning grey cloud. The shadows are just starting to fall. The two men have cudgels, and are beating each other with them over and over. One of the men's faces is already drenched with blood, one single eye dull and unseeing, as he raises his club to hit the other man again and again, locked into an inevitable, monotonous cycle of violence which neither of the men can break. They are both sinking into some kind of mire, and yet still they lash out, still they strike at one another. They are Spaniards – poor people dressed in ragged clothes, but the scene has an almost mythological resonance; one could almost believe that they would be striking out for eternity, locked in their perpetual combat, were it not for the sludge that they are clearly sinking into. Again the painting has an intensely apocalyptic quality. It has a very modern feel too; it is able to depict the quintessence of civil war, the horror which opens up when society begins to lose its cohesion, to fissure and fragment, and neighbour turns on neighbour. When you look at this painting, it is hard not to call to mind the scarred concrete of the bombed out streets of Sarajevo in the early nineties or the plantation fields of Rwanda in the same period littered with bodies.

For me, perhaps the most incredible painting in this series is *The Dog*. Here we see the small gloomy head of a dog, its body invisible, immersed in some kind of substance, quicksand perhaps, or some other material. The material rises upwards in a diagonal wave becoming almost a wall of thick muddy dark before which the dog is struggling. My suspicion is that the substance in which the dog is immersed is a thick muddy water. Its head looks upward to a sky which is smeared a dirty ochre colour without any features or definition beyond this. The author Vladimir Nabokov described life as "but a brief crack of light between two eternities of darkness".[197] A similar effect is captured in this painting. The dog's tiny head represents a

small sliver of life, of flaying, diminishing movement, trapped between two great plains – the infinite, indistinct sepia vault which looms above, and the thick, muddy, bottomless shadow which is engulfing it from below; the dog is that infinitesimally small moment of the finite existence set against the universe and the incomprehensible vastness of eternity. In many ways this is a painting which captures something of what Kant described as the "noumenal", the infinite dark matter which lies behind the curtain of the universe and which the pure reason of the finite, fallible scurrying individual life proves incapable of ever penetrating. The sense of the solitude and isolation of the individual life caught under the vast and implacable cosmos in this painting is almost entombing. And yet, the eye of the dog catches what little light there is in a soft, silver glint. It is only a dog and yet it is so much more. There is something unbearably moving and something profoundly human in its struggle. It is a work of strange genius.

The *Black Paintings* are Goya's most significant works and also his most powerful, not simply because of the hallucinatory and nightmarish tenor of their eerie and otherworldly beauty, but because such beauty captures in its aesthetic the most elemental contradictions of Spanish society; the contradictions between rational enlightenment and religious medievalism, national liberation and foreign oppression, autocracy and liberalism, and most of all feudal absolutism in a context of bourgeois modernity. But the *Black Paintings* capture these contradictions as they are compounded under the white hot pressures of civil war and revolution, intensified and sharpened by the historical process to the point at which they burst asunder, cracking the semblance of the social world, and through the fissure arrives the very worst excesses of the past; from within the very midst of modernity there is an eruption of the forces of the twelfth or thirteenth centuries – a series of spectral horrors released with unbounded force casting their long dark shadows across

the terrain of a shattered world. The meaning of the *Black Paintings* lies in exactly this; they capture in the guise of eternity the culmination of the tragic trajectory which Spanish history passed across and they do so because Goya's own individual life, small in the scheme of things, was buffeted by those same historical forces; they raised him up in his youth as the most prestigious court painter before he was struck with deafness and the country was laid to waste by invasion and civil war, when finally he was confronted by the nightmarish aftermath from the lonely solitude of a twilight existence which was on the verge of being snuffed out by the menacing and revived forces of deepest, darkest reaction. Goya's *Black Paintings* are the most personal, the most intimate of his oeuvre, but for that reason they are simultaneously his most intensely historical; his individual existence becomes the aesthetic barometer for the great shifts and dark currents which had taken place and which had been played out across the historic panorama.

In the event, the dark, reactionary forces which had been unleashed by the Peninsular War and embodied in the grotesque regime of Ferdinand VII were not able to extinguish the life of Spain's great artistic genius. In 1823, the royalist regime enacted yet another purge against the liberals which caused thousands to flee the country. In 1824 Goya joined their ranks, going into hiding for a period of months, and then emigrating to Bordeaux in France where he would live until his death some 4 years later. In the words of a friend, Goya was "deaf, old, slow and weak"[198] and he didn't have a lick of French, and yet in these final years Goya's disposition and artistic work seems to lighten – freed as it had been from the frenzied grip of the convulsions of Spanish society and the long dark arm of the Inquisition. In sunny Bordeaux, Goya reverts to a gentler stage of life; with a fundamental innocence he paints portraits of friends and family members and returns to the sketches which formed such a part of the early period of his art, the images of

toreros doing flamboyant battle with magnificent bulls. From 1825-7 he paints what I consider to be his final masterpiece – *The Milkmaid of Bordeaux*. This is a picture of a young woman whose expression is beautifully mysterious as though she is lost in thought, only at the same time her body in repose – its curling shape, the downward slant of the soft dark eyes – seems to hint at great tenderness. There is nothing of pain or tragedy in this depiction, only great warmth, and inner, intimate feeling. The oil painting uses lighter hues, the azul blues and pastel whites which for so long had been absent from Goya's palate. Behind the delicate, beautiful young woman is the sky – but there is nothing of noumenal darkness in its aspect. Instead, in the far-right corner there is a retreating patch of shadowy cloud, but directly outlining the young woman's head – creating a halo-like effect – is a burgeoning blue fissured with delicate white light. It feels as though a night-time storm has come and gone and now, breaking through, comes the silvery, morning light of a brand new day.

Endnotes

1. Among his rich list of various crimes, Assad *père* had joined the rightest campaign in Lebanon by slaughtering Palestinians in the Lebanese camps and suppressing protests and uprisings in Syria in 1963, 1964, 1965, 1967, 1973 and 1980 culminating in the massacre in Homs in 1982 thereby helping to create the basis for – in the words of Robin Yassin-Kassab and Leila Al-Shami – "an absolute state" – Robin Yassin-Kassab, Leila Al-Shami, *Burning Country: Syrians in Revolution and War* (London: Pluto Press, 2016), p.13.

2. Shamel Azmeh, "Syria's Passage to Conflict: The End of the 'Developmental Rentier Fix' and the Consolidation of New Elite Rule", *Politics & Society*, Vol. 44(4).

3. Louis Proyect, "The Economic Roots of the Syrian Revolution", *The Unrepentant Marxist*, 14 December 2016. Available: https://louisproyect.org/2016/12/14/the-economic-roots-of-the-syrian-revolution/

4. In the same place.

5. US Department of Energy cited in "Syria's Oil Industry", Sourcewatch. Available: http://www.sourcewatch.org/index.php/Syria%27s_oil_industry

6. Shamel Azmeh, "Syria's Passage to Conflict: The End of the 'Developmental Rentier Fix' and the Consolidation of New Elite Rule", *Politics & Society*, Vol. 44(4).

7. Louis Proyect, "The Economic Roots of the Syrian Revolution", *The Unrepentant Marxist*, 14 December 2016. Available: https://louisproyect.org/2016/12/14/the-economic-roots-of-the-syrian-revolution/

8. Myrian Ababsa, *Syria: from Reform to Revolt* – (eds), Raymond Hinnebusch and Tina Zintl, "The End of the World: Drought and Agrarian Transformation in Northeast

Syria (2007-2010)" (New York: Syracuse University Press, 2013).

9. Middle East Editorial, "Syrian Police Attack Marchers at Funerals", *New York Times*, 19 March 2011. Available: http://www.nytimes.com/2011/03/20/world/middleeast/20syria.html

10. "Syria: Seven Police Killed, Buildings Torched in Protests", *Arutz Sheva* 7, 21 March 2011. Available: http://www.israelnationalnews.com/News/News.aspx/143026#.TskzPVaGiSr

11. "Syria unrest: governor fired", *The Scotsman*, 22 March 2011. Available: http://www.scotsman.com/news/syria-unrest-governor-fired-1-1545094

12. Phil Sands, Justin Vela and Suha Maayeh, "Assad regime set free extremists from prison to fire up trouble during peaceful uprising", *The National*, 17 February 2017. Available: http://www.thenational.ae/world/syria/assad-regime-set-free-extremists-from-prison-to-fire-up-trouble-during-peaceful-uprising

13. "Massacre of Hama (February 1982) Genocide and a crime against Humanity", The Syrian Human Rights Committee, 14 February 2006. Available: https://web.archive.org/web/20130522172157/http://www.shrc.org/data/aspx/d5/2535.aspx

14. For the same reason Assad has been complicit in the cultivation of Sunni sectarianism turning a blind eye to the Sunni Jihadists that waged war on the American Occupation. For more see Gilbert Achcar, *Morbid Symptoms* (US: Stanford University Press, 2016).

15. Sam Charles Hamad in *Khiyana: Daesh, the Left and the Unmaking of the Syrian Revolution* – Jules Alford and Andy Wilson (eds) (London: Unkant Publishers, 2016), p.72.

16. In the same place, p.72.

17. It is more accurate to describe the Free Syrian Army not so

much as a unitary military force but more as a collection of various militias which emerged out of the ongoing process by which the revolutionaries learned to defend themselves against the regime.

18. Riad Mousa al-Asaad cited in "Defecting troops form 'Free Syrian Army', target Assad security forces", *Word Tribune*, 3 August 2011. Available: http://www.worldtribune.com/worldtribune/WTARC/2011/me_syria0973_08_03.asp

19. Loubna Mrie, "The demise of Arab-Kurdish solidarity in Syria", 22 August 2017. Available: https://www.alaraby.co.uk/english/comment/2017/8/22/the-demise-of-arab-kurdish-solidarity-in-syria

20. In the same place.

21. "Syria's crisis: The long road to Damascus: There are signs that the Syrian regime may become still more violent", *The Economist*, 11 February 2012.

22. Mark Boothroyd, *Khiyana: Daesh, the Left and the Unmaking of the Syrian Revolution* – Jules Alford and Andy Wilson (eds) (London: Unkant Publishers, 2016), p.53.

23. In the same place, p.93.

24. Abdel Rahman Ayachi cited in C J Cheevers and Eric Schmitt, "Arms Airlift to Syria Rebels Expands, With Aid From CIA", *The New York Times*, 24 March 2013.

25. Barack Obama cited in Glenn Kessler, "Are Syrian opposition fighters 'former farmers or teachers or pharmacists?'" *The Washington Post*, 26 June 2014. Available: https://www.washingtonpost.com/news/fact-checker/wp/2014/06/26/are-syrian-opposition-fighters-former-farmers-or-teachers-or-pharmacists/?noredirect=on&utm_term=.12bd2ac4f4c5

26. Abdullah Al-Arian, "Obama's 'Arab Problem'", *Aljazeera*, 11 November 2011. Available: http://www.aljazeera.com/indepth/opinion/2011/11/201111894152699898.html

27. Sam Charles Hamad in *Khiyana: Daesh, the Left and the Unmaking of the Syrian Revolution* – Jules Alford and Andy

Wilson (eds) (London: Unkant Publishers, 2016), p.164.

28. Daniel Bayman and Jennifer Williams, "Al-Qaeda vs. ISIS: The Battle for the Soul of Jihad", Newsweek 29 August 2017. Available: http://www.newsweek.com/al-qaeda-vs-isis-battle-soul-jihad-317414

29. Sam Charles Hamad in *Khiyana: Daesh, the Left and the Unmaking of the Syrian Revolution* – Jules Alford and Andy Wilson (eds) (London: Unkant Publishers, 2016), pp.163-4.

30. Mark Boothroyd in *Khiyana: Daesh, the Left and the Unmaking of the Syrian Revolution* – Jules Alford and Andy Wilson (eds) (London: Unkant Publishers, 2016), p.57.

31. Muhammad Khatib cited in Jane Burgess, "Syrian Opposition Fractures", Assyrian International News Agency, 5 January 2014. Available: http://www.aina.org/news/20140105165237.htm

32. Mark Boothroyd in *Khiyana Daesh: The Left and the Unmaking of the Syrian Revolution* – Jules Alford and Andy Wilson (eds) (London: Unkant Publishers, 2016), pp.57-8.

33. Mark Boothroyd in *Khiyana: Daesh, the Left and the Unmaking of the Syrian Revolution* – Jules Alford and Andy Wilson (eds) (London: Unkant Publishers, 2016), p.58.

34. Yasser Munif cited in "Manbij, a Success Story in the Liberated Areas", *The Syrian Observer*, 22 January 2014. Available: http://syrianobserver.com/EN/Features/26544

35. "General strike challenges ISIS in Aleppo town", International Labour Network of Solidarity and Struggles, 23 May 2014. Available: http://laboursolidarityandstruggle.org/site_english/?p=232

36. Sam Charles Hamad in Khiyana Daesh: *The Left and the Unmaking of the Syrian Revolution* – Jules Alford and Andy Wilson (eds) (London: Unkant Publishers, 2016), pp.163-4.

37. Mark Boothroyd in Khiyana: Daesh, *The Left and the Unmaking of the Syrian Revolution* – Jules Alford and Andy Wilson (eds) (London: Unkant Publishers, 2016), p.52.

38. In the same place, p.53.

39. "The Society's Holocaust – Most Notable Sectarian and Ethnic Cleansing Massacres", Syrian Network for Human Rights, pp.27-8, 13 June 2015. Available: http://sn4hr.org/wp-content/pdf/english/The_Societys_Holocaust.pdf

40. Adam Withnall, "Syria: Assad regime kills so many detainees it amounts to 'extermination' of civilian population, UN says", *Independent*, February 2016. Available: http://www.independent.co.uk/news/world/middle-east/syria-assad-regime-kills-so-many-detainees-it-amounts-to-extermination-of-civilian-population-un-a6860876.html

41. "2011 – 2016: Who's Killing Civilians in Syria?" Syrian Network for Human Rights. Available: http://whoiskillingciviliansinsyria.org/

42. Michael Karadjis in *Khiyana: Daesh, the Left and the Unmaking of the Syrian Revolution* – Jules Alford and Andy Wilson (eds) (London: Unkant Publishers, 2016), p.266.

43. Cited in Ruth Sherlock, "In Syria's war, Alawites pay heavy price for loyalty to Bashar al-Assad", *The Telegraph*, 7 April 2015. Available: http://www.telegraph.co.uk/news/worldnews/middleeast/syria/11518232/In-Syrias-war-Alawites-pay-heavy-price-for-loyalty-to-Bashar-al-Assad.html

44. In the same place.

45. Omar Aziz, "'A Discussion Paper on Local Councils in Syria' by the Martyr and Anarchist Comrade, Omar Aziz", TAHRIR-ICN 22 September 2013. Available: https://tahriricn.wordpress.com/2013/09/22/syria-translated-a-discussion-paper-on-local-councils-in-syria-by-the-martyr-and-anarchist-comrade-omar-aziz/

46. In the same place.

47. Mark Boothroyd, "Self-Organisation in the Syrian Revolution", *The Project – A Socialist Journal*, 14 August 2016. Available: http://www.socialistproject.org/issues/

august-2016/self-organisation-syrian-revolution/

48. In the same place.

49. Sam Charles Hamad in *Khiyana: Daesh, the Left and the Unmaking of the Syrian Revolution* – Jules Alford and Andy Wilson (eds) (London: Unkant Publishers, 2016), pp.73-4.

50. Slavoj Žižek, "Syria is a pseudo-struggle", *The Guardian*, 6 September 2013. Available: https://www.theguardian.com/commentisfree/2013/sep/06/syria-pseudo-struggle-egypt

51. Others who drew similar conclusions include Patrick Cockburn, Seymour Hersh, David Bromwich, George Galloway, Max Blumenthal, Glenn Greenwald, Seamus Milne, Jill Stein, Stephen Kinzer and many more.

52. Tariq Ali, "Speech on 28 November for Stop the War Coalition", *YouTube*. Available: https://www.youtube.com/watch?v=Ce47MrGUHMY&feature=youtu.be&t=4m24s

53. Ban Ki-moon cited in Harry Cockburn, "UN chief warns of 'atrocities against large number of civilians' in Aleppo", *The Independent*, 13 December 2016. Available: http://www.independent.co.uk/news/world/middle-east/un-ban-ki-moon-atrocities-civilians-aleppo-a7471056.html

54. Editorial, "Morning Star Statement on the Situation in Aleppo", *Morning Star*, 13 December 2016. Available: https://www.morningstaronline.co.uk/a-6e18-Morning-Star-statement-on-the-situation-in-Aleppo

55. UN Syria envoy Staffan de Mistura cited in Tom Miles, "Aleppo's Jabhat Fateh al-Sham fighters far fewer than UN says–sources", *The Daily Mail*, 14 October 2016. Available: http://www.dailymail.co.uk/wires/reuters/article-3837848/Aleppos-Jabhat-Fateh-al-Sham-fighters-far-fewer-U-N-says-sources.html

56. Louis Proyect, "The Economic Roots of the Syrian Revolution", *The Unrepentant Marxist*, 14 December 2006. Available: https://louisproyect.org/2016/12/14/the-economic-roots-of-the-syrian-revolution/

57. Eric Hobsbawm, *Primitive Rebels* (Manchester: The University Press, 1959), p.39.
58. In the same place, p.32.
59. Diego Gambetta, *The Sicilian Mafia*, (Harvard: Harvard University Press, 1996), pp.146-53.
60. Martin Clark, *The Italian Risorgimento* (London and New York: Routledge, 2009), p.86.
61. See Daron Acemoglu, Giuseppe De Feo, Giacomo De Luca "Weak States: Causes and Consequences of the Sicilian Mafia", NBER Program(s): Political Economy, November 2017. Available: https://scholar.harvard.edu/files/alesina/files/organized_crime_violence_and_politics_9.15.pdf
62. Umberto Santino cited in Daron Acemoglu, Giuseppe De Feo, Giacomo De Luca "Weak States: Causes and Consequences of the Sicilian Mafia", NBER Program(s): Political Economy, November 2017, p.10. Available: https://scholar.harvard.edu/files/alesina/files/organized_crime_violence_and_politics_9.15.pdf
63. David Cay Johnston, "Just What Were Donald Trump's Ties to the Mob?" *Politico Magazine*, 22 May, 2016. Available: http://www.politico.com/magazine/story/2016/05/donald-trump-2016-mob-organized-crime-21391
64. "Sufragio universale e analfabetismoi", *Nuova Antologia*, 46, 237, p.335.
65. Bonomi (1905) "Ivanoe Bonomi cited in Valentino Larcinese, Enfranchisement and Representation: Evidence from the Introduction of Quasi-Universal Suffrage in Italy", London School of Economics and Political Science. Available: http://personal.lse.ac.uk/larcines/enfranchisement_sept17.pdf
66. Valentino Larcinese, "Enfranchisement and Representation: Italy 1909-1913", London School of Economics and STICERD, p.30. Available: http://sticerd.lse.ac.uk/dps/eopp/eopp32.pdf
67. In the same place.

68. Daron Acemoglu, Giuseppe De Feo, Giacomo De Luca "Weak States: Causes and Consequences of the Sicilian Mafia", November 2017, p.4. Available: https://scholar.harvard.edu/files/alesina/files/organized_crime_violence_and_politics_9.15.pdf

69. Valentino Larcinese, "Enfranchisement and Representation: Italy 1909-1913", London School of Economics and STICERD p.28. Available: http://sticerd.lse.ac.uk/dps/eopp/eopp32.pdf

70. Benito Mussolini cited in Ishay Landa, *Fascism and the Masses: The Revolt against the Last Humans 1848-1945* (New York: Routledge, 2008), p.8.

71. Long Good Friday, The (1980) Movie Script. Available: https://www.springfieldspringfield.co.uk/movie_script.php?movie=long-good-friday-the

72. Salvatore Lupo, *History of the Mafia* (New York: Colombia University Press, 2011), p.174.

73. Salvatore Lupo, "The Allies and the Mafia", *Journal of Modern Italian Studies*, 25 April 2008, p.22.

74. In the same place, p.22.

75. In the same place, pp.26-7.

76. Cited in Filippo Sabetti, *Village Politics and the Mafia in Sicily* (Canada: McGill-Queens University Press, 2002), p.170.

77. John Dickie, *Cosa Nostra: A History of the Sicilian Mafia* (Great Britain: Hodder and Stoughton, 2007), p.281.

78. "The Mafia in Sicily", *Sicily Bella*, 2012. Available: http://www.sicilybella.com/sicily-mafia.html

79. Jessica Phelan, "Italian mafia recorded plotting to kill 'troublesome' journalist", *The Local*, 10 April 2018. Available: https://www.thelocal.it/20180410/italian-mafia-kill-journalist-paolo-borrometi

80. John Hooper, "Move over, Cosa Nostra", *The Guardian*, 8 June 2006. Available: https://www.theguardian.com/world/2006/jun/08/italy.johnhooper

81. Lorenzo Tondo, "How Cosa Nostra's 'cattle mafia' is destroying Sicily's farmers", *The Guardian*, 14 October 2017. Available: https://www.theguardian.com/world/2017/oct/14/cosa-nostra-cattle-mafia-sicily-farmers-intimidation

82. Barbie Latza Nadeau, "'Migrants are more profitable than drugs': how the mafia infiltrated Italy's asylum system", *The Guardian*, 1 February 2018. Available: https://www.theguardian.com/news/2018/feb/01/migrants-more-profitable-than-drugs-how-mafia-infiltrated-italy-asylum-system

83. Christopher Beam, "Jobs For life. Death from Overwork in Japan", *The Economist*, 19 December 2007 | Tokyo | From the print edition.

84. Howard French, "Depression Simmers in Japan's Culture of Stoicism", *The New York Times*, 10 August 2002. Available: http://www.nytimes.com/2002/08/10/world/depression-simmers-in-japan-s-culture-of-stoicism.html

85. Émile Durkheim, *Suicide* (London and New York: Rougledge, 2002), p.233.

86. In the same place, p.234.

87. Émile Durkheim cited in Steven Lukes, *Émile Durkheim – His Life and Work: A Historical and Critical Study* (London: Penguin Books, 1988), p.210.

88. Émile Durkheim cited in the same place, p.210.

89. Émile Durkheim, *Suicide* (London and New York: Routledge, 2002), p.167.

90. In the same place, p.160.

91. In the same place, p.177.

92. In the same place, p.239.

93. In the same place, p.239.

94. In the same place, p.341.

95. In the same place, p.341.

96. It should be mentioned, however, that while Marxists regard the instability of market forces as an essential part

of capitalism, Durkheim himself put it down to the fact that the modern economy was still underdeveloped – was still in a state of transition from earlier forms – and once it had been fully actualised its chronic instability – its lack of integration and regulation – would be overcome within its own remit.

97. Karl Marx, *Capital* Vol 1, "1867 Preface to the First German Edition", *Marxist Internet Archive*. Available: http://www.marxists.org/archive/marx/works/1867-c1/p1.htm

98. Leon Trotsky, *History of the Russian Revolution* Vol 1, Ch1 "Peculiarities of Russia's development". Marxist Internet Archive. Available: http://www.marxists.org/archive/trotsky/1930/hrr/ch01.htm

99. Something similar occurred in the aftermath of the Second World War – when the latest forms of corporate innovation and technology were grafted onto a devastated terrain – and this would provide the impulse for the rapid economic upswing which was to be dubbed "the miracle", and would eventually see Japan emerge as the world's second largest economy in 1978.

100. Cited in Neil Davidson, *How Revolutionary were the Bourgeois Revolutions?* (Chicago: Haymarket Books, 2012), p.313.

101. And in culture more broadly. One can perhaps recognise the same tension between the traditional and modern in much of Japanese culture today – crystallised in the works of magical realism by authors like Haruki Murakami, for instance.

102. Christopher Beam, "Jobs For life. Death from Overwork in Japan", *The Economist*, 19 December 2007 | Tokyo | From the print edition.

103. Blaine Harden, "Japan's Killer Work Ethic", *The Washington Post* – Foreign Service, 13 July 2008. Available: http://www.washingtonpost.com/wp-dyn/content/article/2008/07/12/AR2008071201630.html

104. "Japanese Suicide Rate Swells Amid Prolonged Economic Slump", *RTT News*, 26 January 2010. Available: http://www.rttnews.com/1189896/japanese-suicide-rate-swells-amid-prolonged-economic-slump.aspx

105. "Japan's part-timers in full-time trouble", *Black Tokyo*, 3 February 2009. Available: http://www.blacktokyo.com/2009/02/03/japans-part-timers-in-full-time-trouble/#sthash.Uuw5zWyH.LjSYeNZo.dpbs

106. Chikako Ozawa-de Silva, "Shared Death: Self, Sociality and Internet Group Suicide in Japan", *Transcultural Psychiatry*, Sage Journals. Available: http://tps.sagepub.com/content/47/3/392.abstract

107. Patricia Crone, *Meccan Trade and the Rise of Islam* (USA: Princeton University Press, 1987), p.134.

108. Reza Aslan, *No God But God – The Origins, Evolution and Future of Islam* (UK: Random House, 2011), p.27.

109. Karen Armstrong, *Islam – A Short History* (United Kingdom: Modern Library, 2000), p.6.

110. Reza Aslan, *No God But God – The Origins, Evolution and Future of Islam* (UK: Random House, 2011), p.29.

111. In Islam, however, Jesus is considered to be a great prophet but not the Son of God.

112. Reza Aslan, *No God But God – The Origins, Evolution and Future of Islam* (UK: Random House, 2011), p.29.

113. This was especially the case for Muhammad's own clan of the Hashim whose survival was certainly jeopardised by the more powerful Qurayshis.

114. Muhammad cited in Karen Armstrong, *A History of God* (London: Vintage, 1999), p.167.

115. Karen Armstrong, *Islam – A Short History* (United Kingdom: Modern Library, 2000), pp.14-15.

116. Reza Aslan, *No God But God – The Origins, Evolution and Future of Islam* (UK: Random House, 2011), p.29.

117. Tariq Ali, "Mullahs and Heretics", *London Review of Books*

Vol. 24 No. 3, 7 February 2002. Available: https://www.lrb.co.uk/v24/n03/tariq-ali/mullahs-and-heretics

118. William Muir, *The Life of Mahomet* – Volume 3 (London: Smith, Elder and Co, 1961), p.122.

119. Reza Aslan, *No God But God – The Origins, Evolution and Future of Islam* (UK: Random House, 2011), p.107.

120. Avveroes, for example, argued in a delightfully Hegelian way that the masses were able to intuit the truth of God, organically and through allegory, through "pictorial" texts like the Quran, and in this sense his thought had a profoundly democratic content, but in the same moment this was thrown into relief by the decidedly un-Hegelian argument that only an elite group of esoteric specialists could access the rational underpinnings of such truth.

121. So, for instance, his unions with Aisha and Hafsah connected him with two influential leaders of the early Muslim community, Abu Bakr and Umar, while his marriage to Rayhana linked him with the Jewish tribe of the Banu Qurayza.

122. Less so perhaps with pagan religions, and also there were notable exceptions like the Almohads in twelfth-century Spain who denied Jews and Christians freedom of religion, and faced them with the stark choice between conversion or death.

123. In the same period even though the Crusaders were Christian – and therefore acting under the banner of a universal religion – nevertheless the fragmented character of medieval feudalism shone through the religious appendage, as the figure of Christ became more and more totem like, a symbol, a charm, which could be clutched close in the manner of a pagan god of war, and used to deliver victories.

124. Dan Brown, *The Da Vinci Code* (Great Britain: Corgi Books, 2004), p.39.

125. It is little to his credit that the author has sometimes portrayed his fiction as fact in public appearances and interviews.

126. Karen Armstrong, *A History of God* (Great Britain: Vintage, 1999), p.101.

127. Dan Brown, *The Da Vinci Code* (Great Britain: Corgi Books, 2004), p.579.

128. In the same place, p.411.

129. L. Frank Baum, *The Wonderful Wizard of Oz* (Page by Page Books online, 2004). Available: http://www.pagebypagebooks.com/L_Frank_Baum/The_Wonderful_Wizard_of_Oz/index.html

130. Henry M Littlefield, "The Wizard of Oz: Parable on Populism", *American Quarterly*, Vol. 16, No. 1 (Spring, 1964), p.53.

131. Littlefield himself seems ambivalent on this. On the one hand he describes the use of the silver shoes as an ironic illusion to the silver standard, on the other he suggests they are a simple "means" of outlining the "advantages" of the silver standard in a deliberate and effective way.

132. Henry M Littlefield, "The Wizard of Oz: Parable on Populism", *American Quarterly*, Vol. 16, No. 1 (Spring, 1964), p.52.

133. In the same place, p.52.

134. *The Wonderful Wizard of Oz*, Page by Page books online. Available: http://www.pagebypagebooks.com/L_Frank_Baum/The_Wonderful_Wizard_of_Oz/index.html

135. L. Frank Baum cited in "L. Frank Baum's Editorials on the Sioux Nation", *Wally Hasting's Children's Literature Page*, Northern State University online. Available: https://web.archive.org/web/20080813054700/http://www.northern.edu/hastingw/baumedts.htm#top

136. *The Wonderful Wizard of Oz*, Page by page books online. Available: http://www.pagebypagebooks.com/L_Frank_

Baum/The_Wonderful_Wizard_of_Oz/index.html

137. In the same place.

138. In the same place.

139. It is true that at the end of the book the Winged Monkeys are free. But this is not in any sense an act of self-determination but a freedom which is simply handed down to them by a benevolent ruler. How they use this freedom is not described, so it can't really be said to work against the central grain of their characters in the novel and their lack of self-determination.

140. L. Frank Baum cited in Henry M Littlefield, "The Wizard of Oz: Parable on Populism", *American Quarterly*, Vol. 16, No. 1 (Spring, 1964), p.53.

141. Henry M Littlefield, "The Wizard of Oz: Parable on Populism", *American Quarterly*, Vol. 16, No. 1 (Spring, 1964), pp.53-4.

142. *The Wonderful Wizard of Oz*, Page by page books. Available: http://www.pagebypagebooks.com/L_Frank_Baum/The_Wonderful_Wizard_of_Oz/index.html

143. In the same place.

144. Dramatic monologues, of course, had been a feature of ancient Greek drama, so for example when Euripides' eponymous Electra berates her mother's lover for his role in the murder of her father, one is treated to an intimate manifestation of her rage and grief. But the soliloquy involves the type of intimate, dramatic heightened speech which is not directed outwards but is spoken to one's self. In this way it acts as a vehicle for revealing the innermost subjectivity and hidden thoughts of the protagonist.

145. Tony McKenna, "The Song of Achilles: How the Future Transforms the Past", *Art, Literature and Culture from a Marxist Perspective* (New York: Palgrave Macmillan, 2015).

146. Madeline Miller, *Circe* (London: Bloomsbury, 2018), p.6.

147. In the same place, p.74.

148. In the same place, p.172.

149. Homer, *The Odyssey* (England: Penguin Books, 1977), p.346.

150. Plato, "Laws", *The Collected Dialogues of Plato* (Princeton: Princeton University Press, 1973), p.1328.

151. Madeline Miller, *Circe* (Bloomsbury, London: 2018), p.33.

152. In the same place, p.45.

153. In the same place, p.50.

154. Kelsey McKinney, "This isn't about iPhones. This is about women being shamed, objectified, and treated like property", *Vox*, 2 September 2014. Available: https://www.vox.com/2014/9/2/6094509/kate-upton-nude-photo-objectification-feminism

155. Madeline Miller, *Circe* (London: Bloomsbury, 2018), p.127.

156. In the same place, p.127.

157. Aida Edemariam, "Circe by Madeline Miller review – myth, magic and single motherhood", *The Guardian*, 12 April 2018. Available: https://www.theguardian.com/books/2018/apr/21/circe-by-madeline-miller-review

158. Madeline Miller, *Circe* (London, Bloomsbury, 2018), p.213.

159. Hilary Mantel cited in Hannah Furness, "Hilary Mantel: Women writers must stop falsely empowering female characters in history", *The Daily Telegraph*, 31 May 2017. Available: https://www.telegraph.co.uk/news/2017/05/31/hilary-mantel-women-writers-must-stop-falsely-empowering-female/

160. Lucy Scholes, "Circe, Madeline Miller, review: Feminist rewrite of *the Odyssey* turns tale of subjugation into one of empowerment", *The Independent*, 18 April 2008. Available: https://www.independent.co.uk/arts-entertainment/books/reviews/circe-madeline-miller-book-review-the-odyssey-feminist-rewrite-female-empowerment-greek-mythology-a8310691.html

161. John Molyneux, "The Legitimacy of Modern Art", *International Socialism Journal*, December 1998. Available:

http://pubs.socialistreviewindex.org.uk/isj80/art.htm)

162. In the same place.

163. In the same place.

164. In the same place.

165. In the same place.

166. In the same place.

167. Lukács' "unity" of form and content goes back to its Hegelian dialectical origins when he accepts, following Hegel, "content is nothing else than the transformation of form into content, and form itself is a transformation into content". In visual art, the content appears in its immediacy as the form.

168. Marx cited in John Molyneux, "The Legitimacy of Modern Art", *International Socialism Journal*, December 1998. Available: http://pubs.socialistreviewindex.org.uk/isj80/art.htm)

169. In the same place.

170. In the same place.

171. In the same place.

172. In the same place.

173. In the same place.

174. *Three Billboards Outside Ebbing, Missouri*, 2017. Available: https://scriptslug.com/assets/uploads/scripts/three-billboards-outside-ebbing-missouri-2017.pdf

175. In the same place.

176. In the same place.

177. In the same place.

178. *The Sopranos*, season 5, Episode 9. Available: https://www.springfieldspringfield.co.uk/view_episode_scripts.php?tv-show=the-sopranos&episode=s05e09

179. *The Sopranos,* Season 1, Episode 1. Available: https://www.springfieldspringfield.co.uk/view_episode_scripts.php?tv-show=the-sopranos&episode=s01e01

180. *The Sopranos*, Season 3, Episode 6. Available: https://www.

springfieldspringfield.co.uk/view_episode_scripts.php?tv-show=the-sopranos&episode=s03e06

181. In the same place.

182. *The Sopranos*, Season 6, Episode 19. Available: https://www.springfieldspringfield.co.uk/view_episode_scripts.php?tv-show=the-sopranos&episode=s06e19

183. *The Sopranos*, Season 1, Episode 2. Available: https://www.springfieldspringfield.co.uk/view_episode_scripts.php?tv-show=the-sopranos&episode=s01e02

184. Eric Hobsbawm, *Fractured Times* (London: Little Brown, 2013), p.275.

185. In the same place, p.282.

186. *The Sopranos*, Season 4, Episode 6. Available: https://www.springfieldspringfield.co.uk/view_episode_scripts.php?tv-show=the-sopranos&episode=s04e06

187. *The Sopranos*, Series 3, Episode 7. Available: https://www.springfieldspringfield.co.uk/view_episode_scripts.php?tv-show=the-sopranos&episode=s03e07

188. In the same place.

189. In the same place.

190. *The Sopranos*, Season 2, Episode 7. Available: https://www.springfieldspringfield.co.uk/view_episode_scripts.php?tv-show=the-sopranos&episode=s02e07

191. Ben Shapiro, "How 'The Sopranos' Changed America", *Front Page Magazine*, 23 June 2013. Available: https://www.frontpagemag.com/fpm/194120/how-sopranos-changed-america-ben-shapiro

192. Paul Freedman, "Peasant Servitude in Mediaeval Catalonia" Catalan Historical Review, 6: 33-43 (2013). Available: https://core.ac.uk/download/pdf/39108538.pdf

193. John Elliot cited in Neil Davidson, *How Revolutionary Were the Bourgeois Revolutions?* (Chicago: Haymarket Books, 2012), p.559.

194. José María Zafala, *Bastardos y Borbones* (Barcelona:

Plaza & Janés Editores, 2011). Available: https://books.google.co.uk/books?id=RZwUYgURK-0C&lpg=PA1685&ots=h-RkqRj_jy&dq=%22ministerio+de+justicia%22+%22fray+juan+de+almaraz%22&hl=de&pg=PA1685&redir_esc=y#v=onepage&q=%22ministerio%20de%20justicia%22%20%22fray%20juan%20de%20almaraz%22&f=false

195. Karl Marx, *Revolutionary Spain* (Written in August-November 1854. First published in the *New-York Daily Tribune*), pp.396-9. Available: http://ciml.250x.com/archive/marx_engels/english/mecwsh/mecwsh-13_416.pdf

196. Fred Licht. *Goya: The Origins of the Modern Temper in Art* (Michigan: Universe Books, 1979), p.159.

197. Vladimir Nabokov cited in William Boyd, "William Boyd: how mortality shapes our existence", *New Statesman*, 17 July 2014. Available: https://www.newstatesman.com/culture/2014/07/william-boyd-how-mortality-shapes-our-existence

198. Leandro Moratín, reporting in a letter to his friend abbé Juan Antonio Melón, May 1824; cited in Robert Hughes, *Goya* (Alfred Knopf, New York, 2003), p.389.

CULTURE, SOCIETY & POLITICS

The modern world is at an impasse. Disasters scroll across our smartphone screens and we're invited to like, follow or upvote, but critical thinking is harder and harder to find. Rather than connecting us in common struggle and debate, the internet has sped up and deepened a long-standing process of alienation and atomization. Zer0 Books wants to work against this trend.

With critical theory as our jumping off point, we aim to publish books that make our readers uncomfortable. We want to move beyond received opinions.

Zer0 Books is on the left and wants to reinvent the left. We are sick of the injustice, the suffering and the stupidity that defines both our political and cultural world, and we aim to find a new foundation for a new struggle.

If this book has helped you to clarify an idea, solve a problem or extend your knowledge, you may want to check out our online content as well. Look for Zer0 Books: Advancing Conversations in the iTunes directory and for our Zer0 Books YouTube channel.

Popular videos include:

Žižek and the Double Blackmain

The Intellectual Dark Web is a Bad Sign

Can there be an Anti-SJW Left?

Answering Jordan Peterson on Marxism

Follow us on Facebook
at https://www.facebook.com/ZeroBooks and Twitter at
https://twitter.com/Zer0Books

Bestsellers from Zer0 Books include:

Give Them an Argument
Logic for the Left
Ben Burgis
Many serious leftists have learned to distrust talk of logic. This is a
serious mistake.
Paperback: 978-1-78904-210-8 ebook: 978-1-78904-211-5

Poor but Sexy
Culture Clashes in Europe East and West
Agata Pyzik
How the East stayed East and the West stayed West.
Paperback: 978-1-78099-394-2 ebook: 978-1-78099-395-9

An Anthropology of Nothing in Particular
Martin Demant Frederiksen
A journey into the social lives of meaninglessness.
Paperback: 978-1-78535-699-5 ebook: 978-1-78535-700-8

In the Dust of This Planet
Horror of Philosophy vol. 1
Eugene Thacker
In the first of a series of three books on the Horror of Philosophy,
In the Dust of This Planet offers the genre of horror as a way of
thinking about the unthinkable.
Paperback: 978-1-84694-676-9 ebook: 978-1-78099-010-1

The End of Oulipo?
An Attempt to Exhaust a Movement
Lauren Elkin, Veronica Esposito
Paperback: 978-1-78099-655-4 ebook: 978-1-78099-656-1

Capitalist Realism
Is There no Alternative?
Mark Fisher
An analysis of the ways in which capitalism has presented itself as
the only realistic political-economic system.
Paperback: 978-1-84694-317-1 ebook: 978-1-78099-734-6

Rebel Rebel
Chris O'Leary
David Bowie: every single song. Everything you want to know,
everything you didn't know.
Paperback: 978-1-78099-244-0 ebook: 978-1-78099-713-1

Kill All Normies
Angela Nagle
Online culture wars from 4chan and Tumblr to Trump.
Paperback: 978-1- 78535-543-1 ebook: 978-1-78535-544-8

Cartographies of the Absolute
Alberto Toscano, Jeff Kinkle
An aesthetics of the economy for the twenty-first century.
Paperback: 978-1-78099-275-4 ebook: 978-1-78279-973-3

Malign Velocities
Accelerationism and Capitalism
Benjamin Noys
Long listed for the Bread and Roses Prize 2015, *Malign Velocities*
argues against the need for speed, tracking acceleration
as the symptom of the ongoing crises of capitalism.
Paperback: 978-1-78279-300-7 ebook: 978-1-78279-299-4

Meat Market
Female Flesh under Capitalism
Laurie Penny
A feminist dissection of women's bodies as the fleshy fulcrum of
capitalist cannibalism, whereby women are both consumers and
consumed.
Paperback: 978-1-84694-521-2 ebook: 978-1-84694-782-7

Babbling Corpse
Vaporwave and the Commodification of Ghosts
Grafton Tanner
Paperback: 978-1-78279-759-3 ebook: 978-1-78279-760-9

New Work New Culture
Work we want and a culture that strengthens us
Frithjoff Bergmann
A serious alternative for mankind and the planet.
Paperback: 978-1-78904-064-7 ebook: 978-1-78904-065-4

Romeo and Juliet in Palestine
Teaching Under Occupation
Tom Sperlinger
Life in the West Bank, the nature of pedagogy and the role of a
university under occupation.
Paperback: 978-1-78279-637-4 ebook: 978-1-78279-636-7

Ghosts of My Life
Writings on Depression, Hauntology and Lost Futures
Mark Fisher
Paperback: 978-1-78099-226-6 ebook: 978-1-78279-624-4

Sweetening the Pill
or How We Got Hooked on Hormonal Birth Control
Holly Grigg-Spall
Has contraception liberated or oppressed women?
Sweetening the Pill breaks the silence on the dark side of hormonal
contraception.
Paperback: 978-1-78099-607-3 ebook: 978-1-78099-608-0

Why Are We The Good Guys?
Reclaiming your Mind from the Delusions of Propaganda
David Cromwell
A provocative challenge to the standard ideology that Western
power is a benevolent force in the world.
Paperback: 978-1-78099-365-2 ebook: 978-1-78099-366-9

The Writing on the Wall
On the Decomposition of Capitalism and its Critics
Anselm Jappe, Alastair Hemmens
A new approach to the meaning of social emancipation.
Paperback: 978-1-78535-581-3 ebook: 978-1-78535-582-0

Enjoying It
Candy Crush and Capitalism
Alfie Bown
A study of enjoyment and of the enjoyment of studying. Bown asks
what enjoyment says about us and what we say about enjoyment,
and why.
Paperback: 978-1-78535-155-6 ebook: 978-1-78535-156-3

Color, Facture, Art and Design
Iona Singh
This materialist definition of fine-art develops guidelines for
architecture, design, cultural-studies and ultimately social change.
Paperback: 978-1-78099-629-5 ebook: 978-1-78099-630-1

Neglected or Misunderstood
The Radical Feminism of Shulamith Firestone
Victoria Margree
An interrogation of issues surrounding gender, biology, sexual-
ity, work and technology, and the ways in which our imaginations
continue to be in thrall to ideologies of maternity and the nuclear
family.
Paperback: 978-1-78535-539-4 ebook: 978-1-78535-540-0

How to Dismantle the NHS in 10 Easy Steps (Second Edition)
Youssef El-Gingihy
The story of how your NHS was sold off and why you will have to
buy private health insurance soon. A new expanded second edition
with chapters on junior doctors' strikes and government blueprints
for US-style healthcare.
Paperback: 978-1-78904-178-1 ebook: 978-1-78904-179-8

Digesting Recipes
The Art of Culinary Notation
Susannah Worth
A recipe is an instruction, the imperative tone of the expert, but
this constraint can offer its own kind of potential. A recipe need
not be a domestic trap but might instead offer escape – something
to fantasise about or aspire to.
Paperback: 978-1-78279-860-6 ebook: 978-1-78279-859-0

Most titles are published in paperback and as an ebook.
Paperbacks are available in traditional bookshops. Both print and
ebook formats are available online.
Follow us on Facebook
at https://www.facebook.com/ZeroBooks
and Twitter at https://twitter.com/Zer0Books